ARTIST
on the
SPOT

ARTIST on the

published by
FLETCHER ART SERVICES, inc.

distributed by
 VAN NOSTRAND REINHOLD COMPANY
New York ☐ Cincinnati ☐ Toronto ☐ London ☐ Melbourne

SPOT

NORMAN MacDONALD

Published by Fletcher Art Services, Inc., Westport, Conn.

Distributed to the trade by Van Nostrand Reinhold Company, a division of Litton Educational Publishing, Inc. 450 W. 33rd Street, New York, N.Y. 10001

VAN NOSTRAND REINHOLD COMPANY
New York ▪ Cincinnati ▪ Toronto ▪ London ▪ Melbourne

ACKNOWLEDGMENTS:

This book is affectionately dedicated to my folks, whose endless patience must have had something to do with my choice of profession.

Special thanks are due to Bill Fletcher who started it all — Howard Munce, whose ideas were vitally needed and gratefully accepted; my wife, Ria, who manages to double as private secretary, bookkeeper and model; Michael Brodie, Marvin Friedman, Marnie MacDonald, Maggie Roberts, Walt Reed, Robert Greenhaulgh, Ronald Searle, Howard Brodie and the master drawers of the past whose work also appears on these pages.

I should like to thank Bluebeards Castle and Beach Hotels, St. Thomas, Virgin Islands; Cue Magazine, New York; Europa magazine, London; Flying magazine, New York; Geillustreerde Pers, Amsterdam; The Observer, London; De Telegraaf, Amsterdam; Travel and Leisure, New York; Car & Driver Magazine, New York; K.L.M. Royal Dutch Airlines, Amstelveen, Holland, who have courteously given permission to reprint drawings by the author.

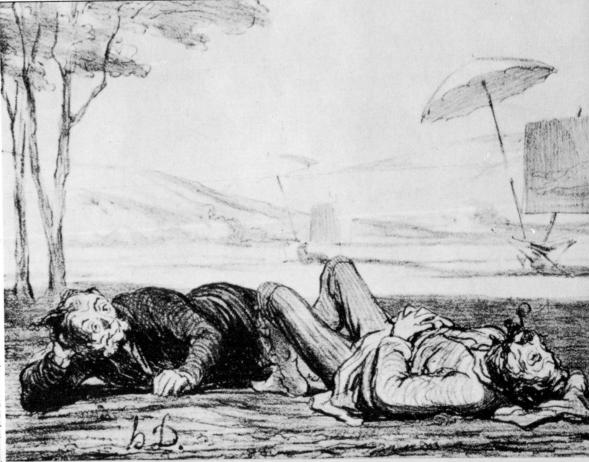

FINE ARTS IN ARIZONA.

Here are a few old boys who preceded you and me in the not-always-gentle art of working on the spot.

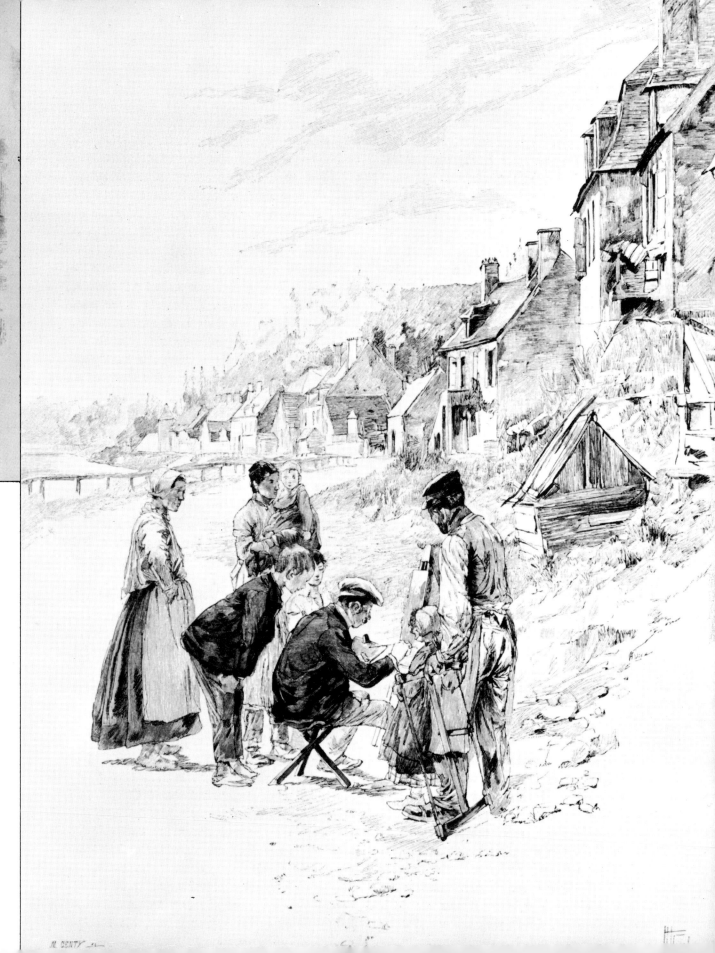

M. DENTY

INTRODUCTION

Beginning with primitive man's first impressions on cave walls, life has been recorded mainly through the medium of art.

The creative process — the transition from original idea to vague beginning to completed result — is the basic element in all art.

In the visual arts, the interpretation of the "vaguest beginnings" is called sketching.

But it is more than an interpretation; it is also an end in itself.

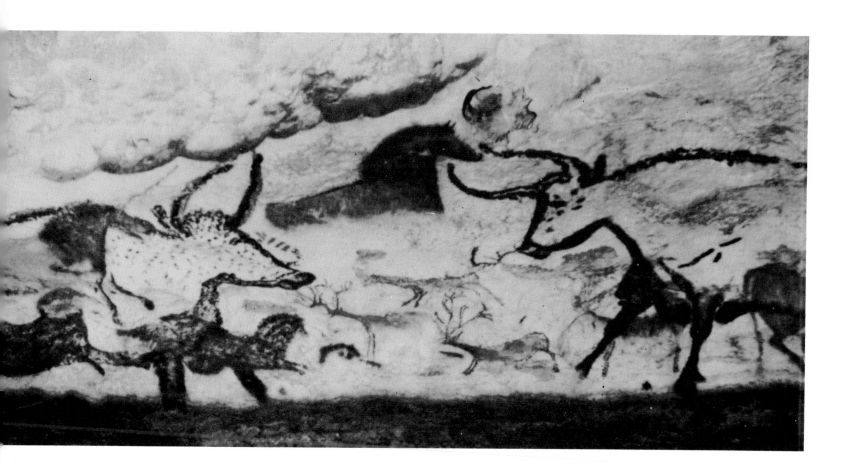

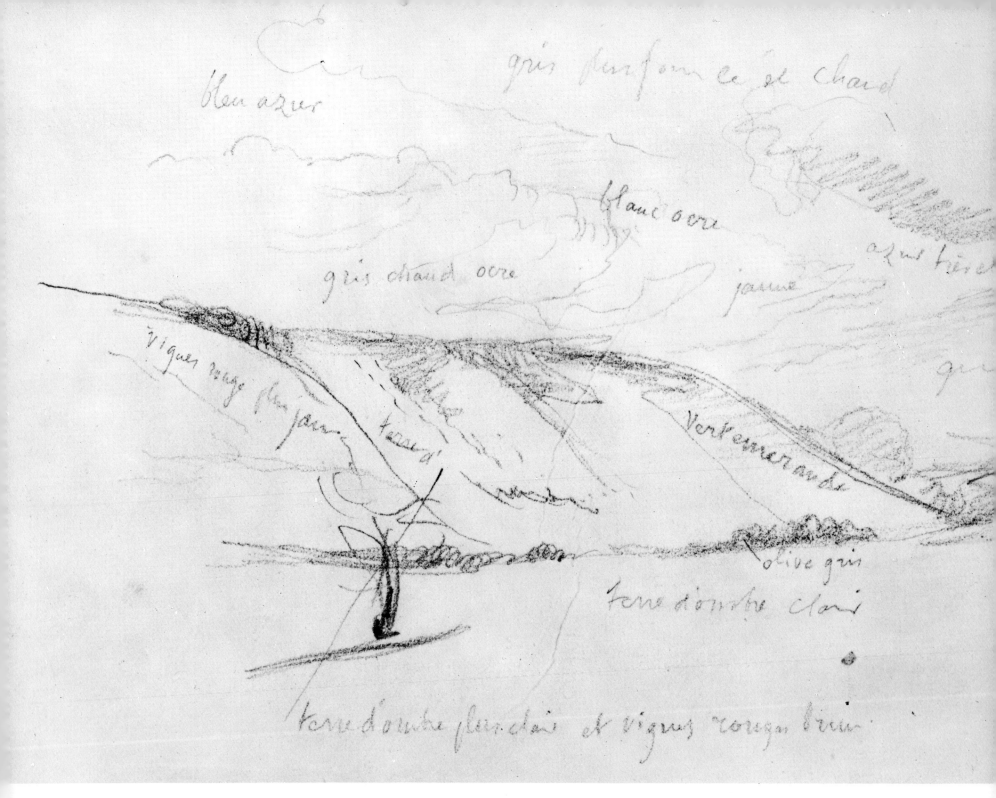

DELACROIX — One of the finest artists of his time has left many studies such as this. Although his notes were very simple, it provided him with enough support to carry on to finished paintings. Most artists develop some type of shorthand.

VINCENT VAN GOGH — Most artists concentrate on some item of drawing.
In Vincent's work he leaned strongly to design and texture.

11

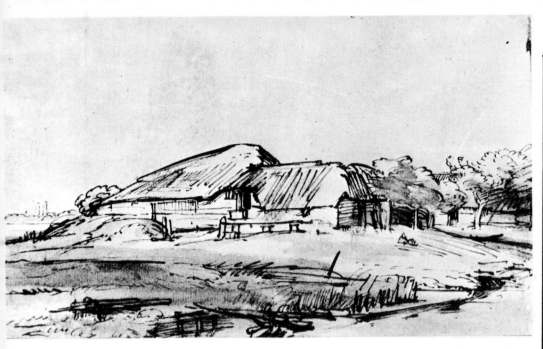

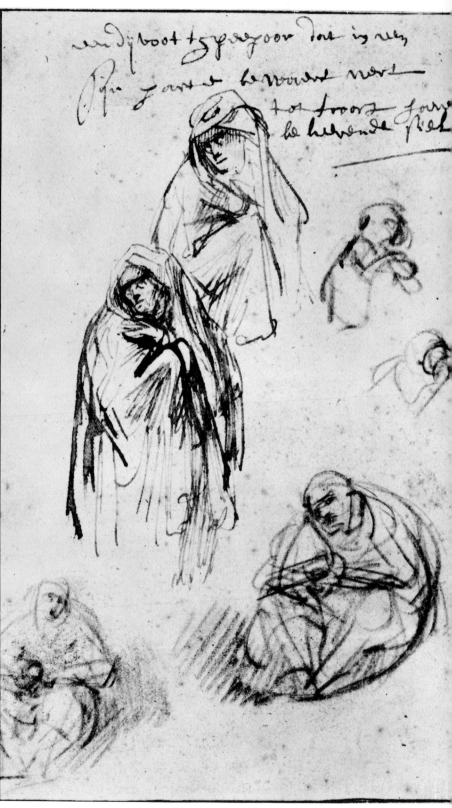

REMBRANDT — Drawing should be enjoyable and natural. What better example than Rembrandt's sketch here, probably made while merrily wandering along a canal road one afternoon.

REMBRANDT AND DEGAS worked equally well in both a sketchy and detailed manner. These samples show one side of each of these two artists.

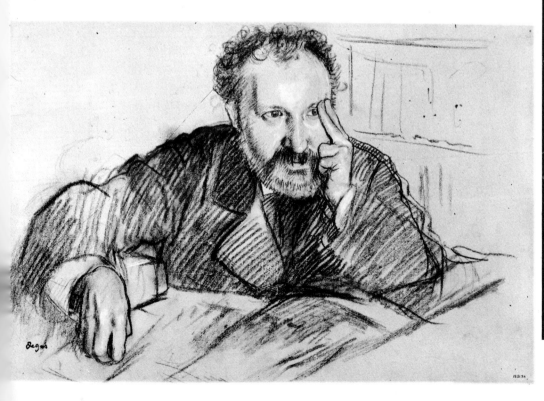

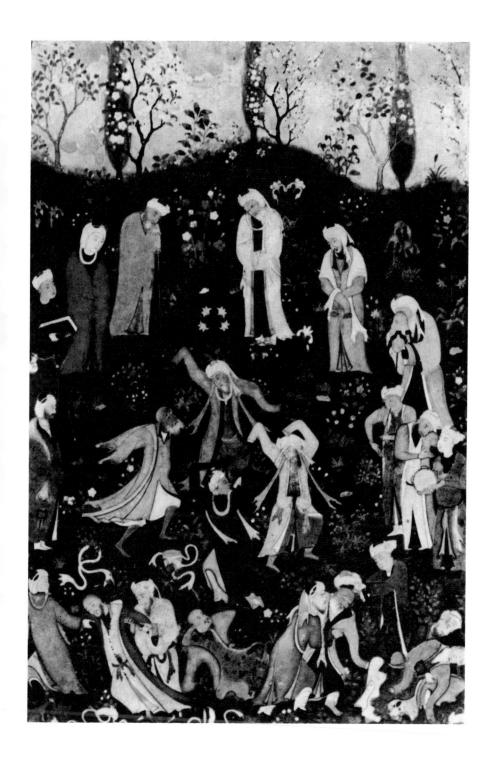

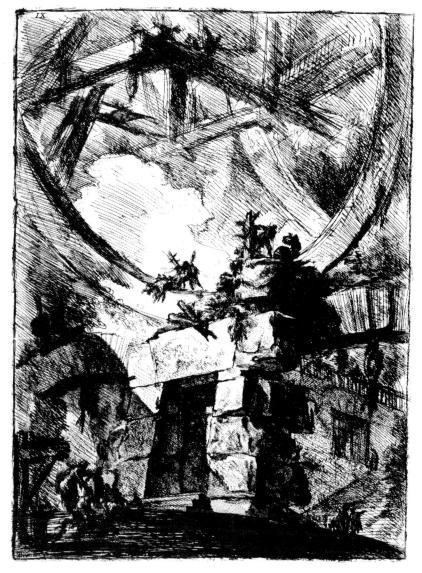

PIRANESI — was an artist of architecture. At times his observations were used only to support his imagination. The imagination has great power and attraction. It is a great compliment when lavished on any one in any walk of life.

Distortion for reasons of story telling is essential in Persian art. Usually the perspective suffers. The result is a two dimensional effect but the story is successful. I use this principle often.

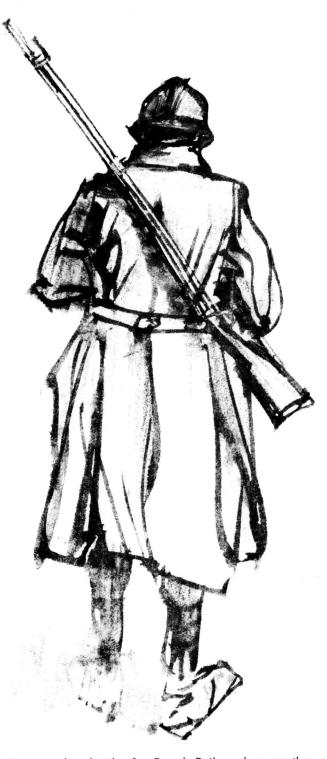

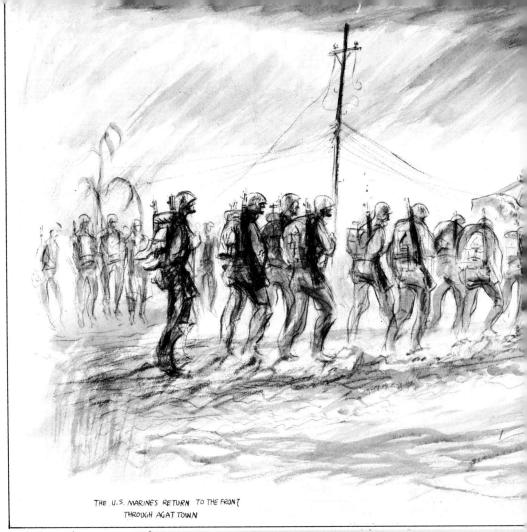

THE U.S. MARINES RETURN TO THE FRONT
THROUGH AGAT TOWN

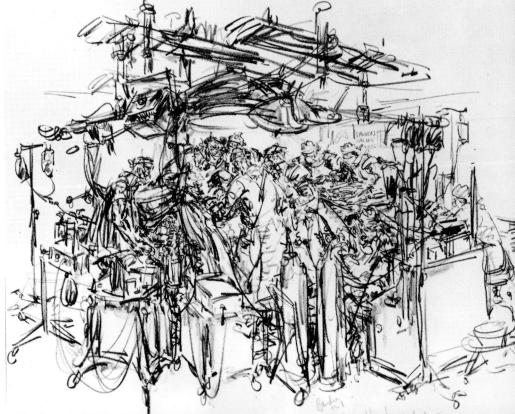

A watercolor sketch of a French Poilu — done on the spot in the first World War by Capt. Harry Townsend, an Official Artist who was assigned to the American Expeditionary Force.

14

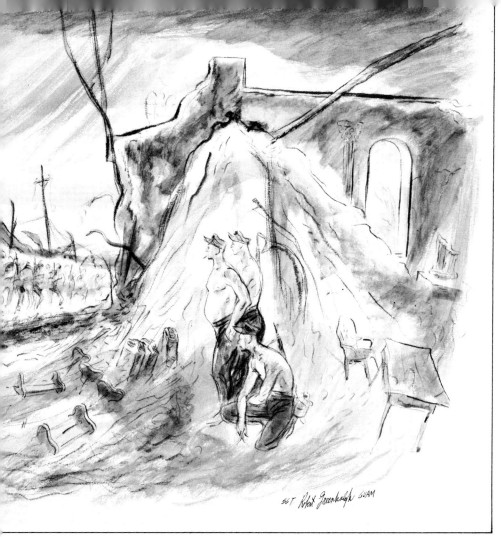

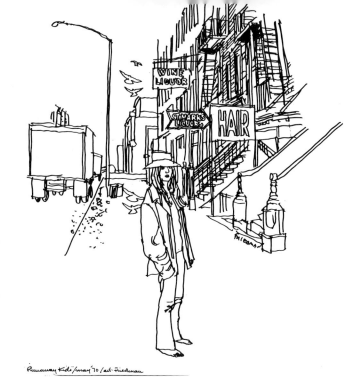

. Robt. Greenhalgh a combat correspondent in World War II did this on-the-spot
rawing of the Third Marines moving up to the front. Yank Magazine Guam October 1944

Whether drawing or painting, Marvin Freedman tries to capture the
essence of the subject as in this case of runaway a kid on the East side.
His work is impressionistic and impressive. ↑

The drawings of Ronald Searle, whether serious or comical, show great
ability. His dexterity of line makes his work a joy to observe. ➡

oward Brodie is a sure and exciting draftsman. This vigorous
erating room sketch was drawn for "Open heart surgery" at Stanford.
s courtroom reporting is often seen on the C.B.S. Television Network.

15

Before proceeding into the rest of this book, I'd like to dwell a moment on its informal format.

I've sought to set down my thoughts, words, beliefs and work in a casual, but meaningful manner.

You will next come upon a section devoted to my methods of observation and distilled style of drawing.

I've broken this down to five basic categories: The Figure, Architecture, Movement, Animals, and Mechanical subjects.

Beyond that, the remainder of the book is devoted to dozens of drawings I've made around the world. Some were done as editorial assignments. Many were done for my pleasure and as study and practice.

Written notes of pertinent facts accompany each drawing.

And along the way, across the bottom of the pages, I have continued to ramble and to talk of all sorts of things that I felt might bring you and me together in order to match ideas and philosophies — to share the pleasures of things well captured and the pangs of the scenes and moments that elude us.

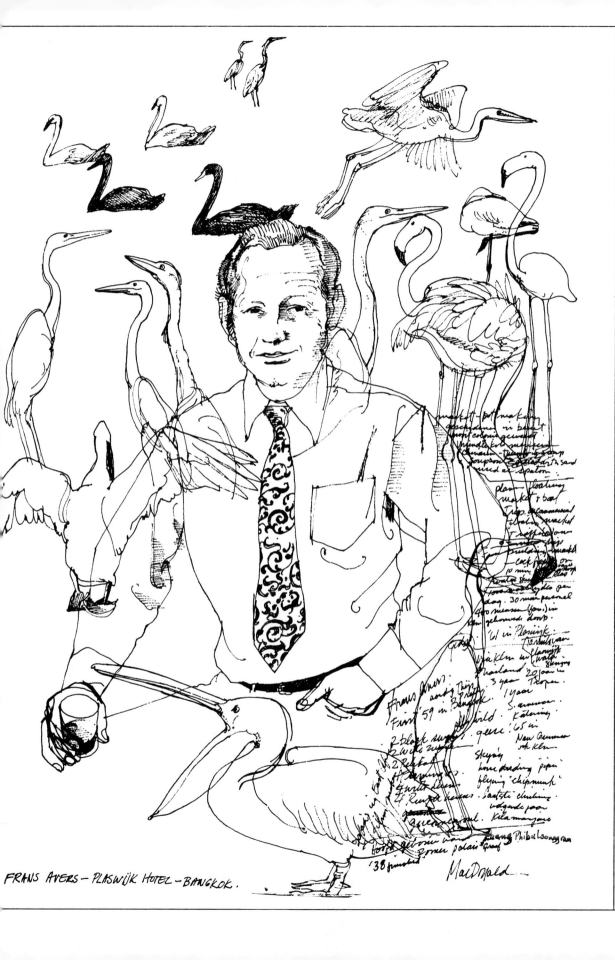

FRANS AVERS — PLASWIJK HOTEL — BANGKOK.

THE FIGURE

The figure is the most attractive subject in drawing and painting. If any subject could hinder you from getting ahead in this profession from lack of ability, the figure would top the list. It's certainly the one subject that requires the most practice to master. Of all the ways to draw people, portraiture is probably the most demanding. Anatomy, attitudes, and likeness are essential if one is to say as much about a person as you can in a picture. The following pages show other aspects of figure drawing.

17

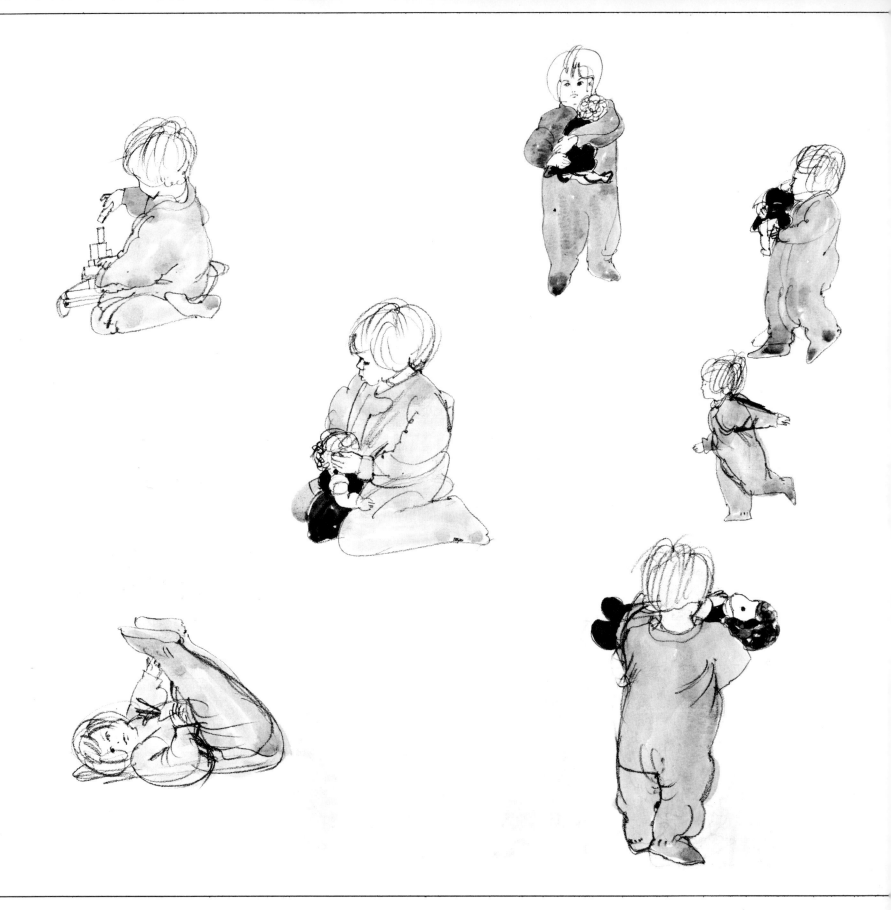

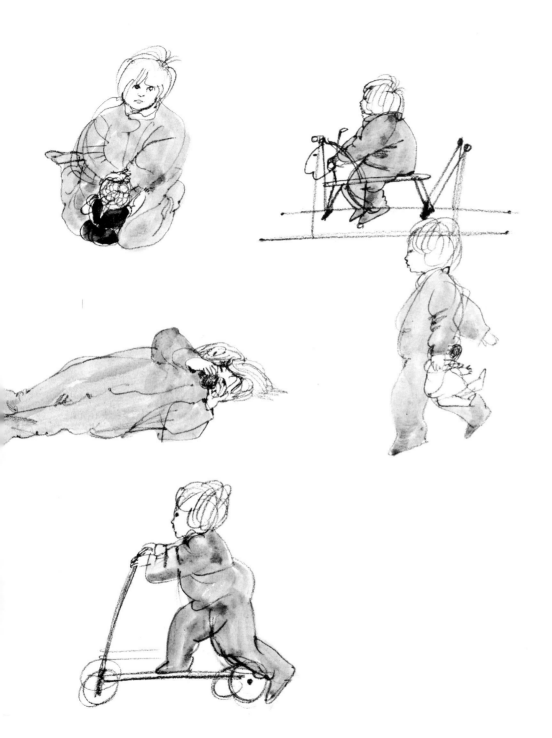

The drawings on these two pages were
made in approximately one hour. It's an
exercise in drawing people in movement.
There are no rules other than to draw
as quickly and carefully as possible, a test
requiring all your attention. The purpose
is to train your eye to catch and hold a
gesture. The exercise is also to remember
the gesture so that you can finish it after the
person has gone on to do something else.

19

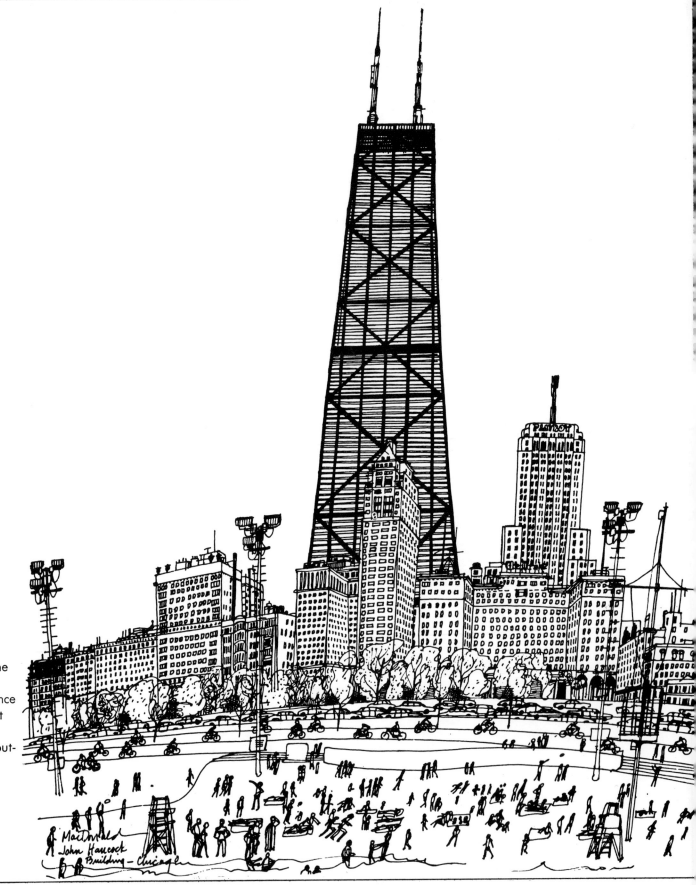

In this drawing I wanted to show the people as being ant-like compared to the skyscrapers. The trouble was that the people were so small there was no chance to draw any detail. I remembered at art school we used to use the stick figure to help draw gestures. Being a much out-dated method, I nevertheless proceeded to draw them in this fashion.

20

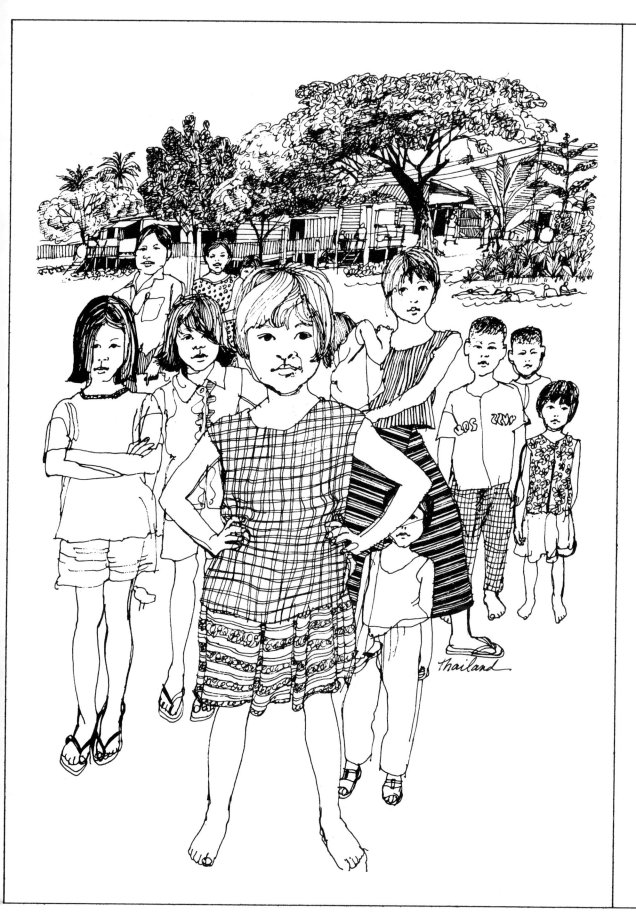

Thailand

The difference from one figure to the next prompted me to do this drawing. No two children resembled each other in the slightest. One was bolder than the rest and got her rightful place in the picture. She then promptly took charge of posing the rest of the children, so I really can't take full credit for the drawing. When you are prompted to make a drawing, there is a reason why. Make this stand out in your drawing. If you are successful it will be recognized.

21

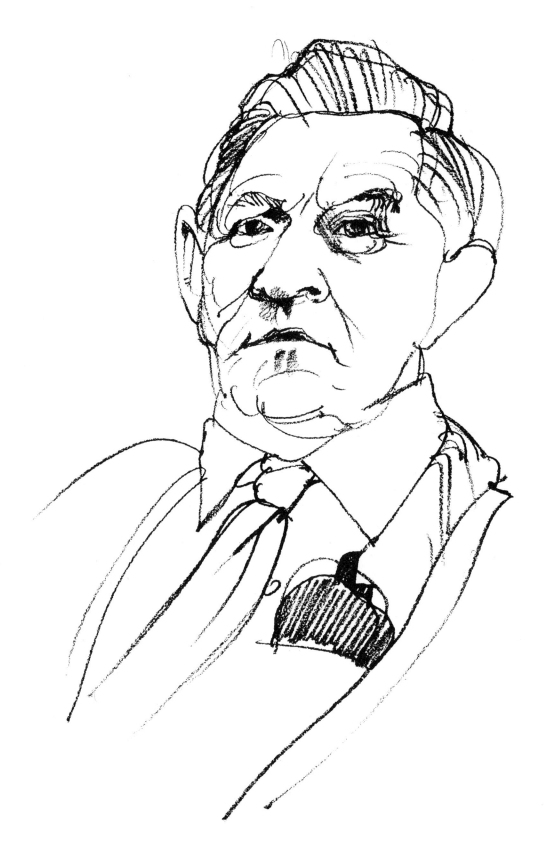

At a time when I was doing nothing, I picked up a pencil and made these sketches. I could say they were made for no reason at all. A contradiction? Maybe, but then drawing for the fun could be the best reason of all.

22

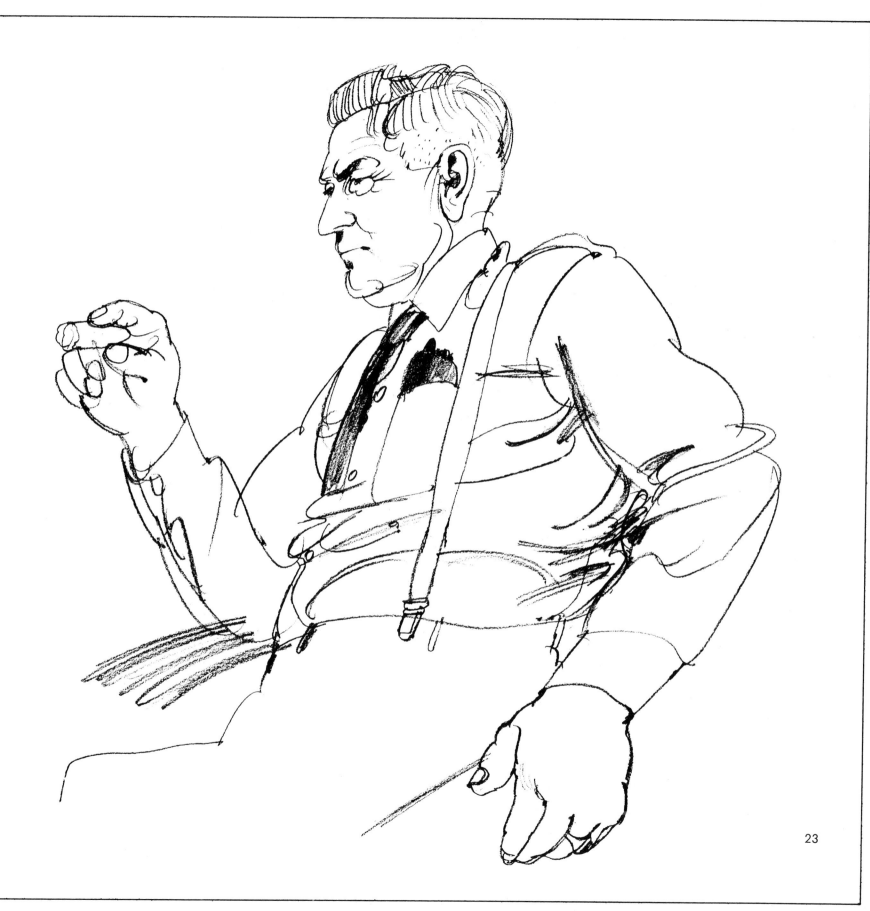

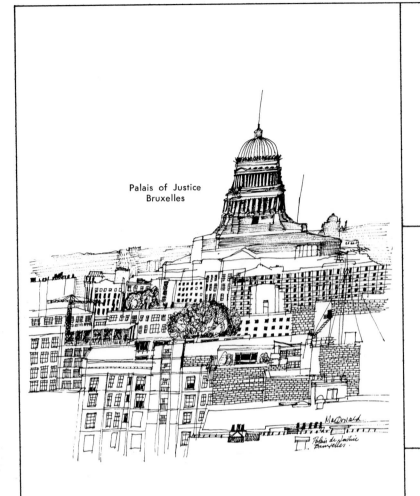

Palais of Justice
Bruxelles

ARCHITECTURE

The look of a city depends chiefly on who's looking. Yet looking is only the source. The image is far from complete. When I reach the manual stage (drawing), something happens that seems to be lost in translation. My eye has always made better pictures than my hand. Changes occur while drawing; many times they are necessary to clarify what the eye sees. You have to accept and take advantage of these modifications.

24

Buildings, towns and cities are drawn from simple shapes. No matter how complicated the scene, keep looking for the basic shapes — they're there. Look at houses on your street. Think away the detail and you will always find the basic forms.

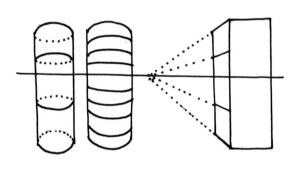

Perspective is most important when drawing architecture. It will give depth to the picture and reality to objects. Get to know the rules of perspective. This knowledge will give you an advantage when drawing on the spot. You will be able to recognize the direction of lines without squandering time trying to figure out why.

Looking at a city, especially from a height, is really looking at a vast area of overlapping shapes. This is as important as perspective when creating depth.

Look for the variety you find in one building compared to the next. Be aware of the straight, rigid pattern of line and shape found usually in modern architecture as opposed to more of a soft look to older buildings. Combine both kinds to get the look of a city.

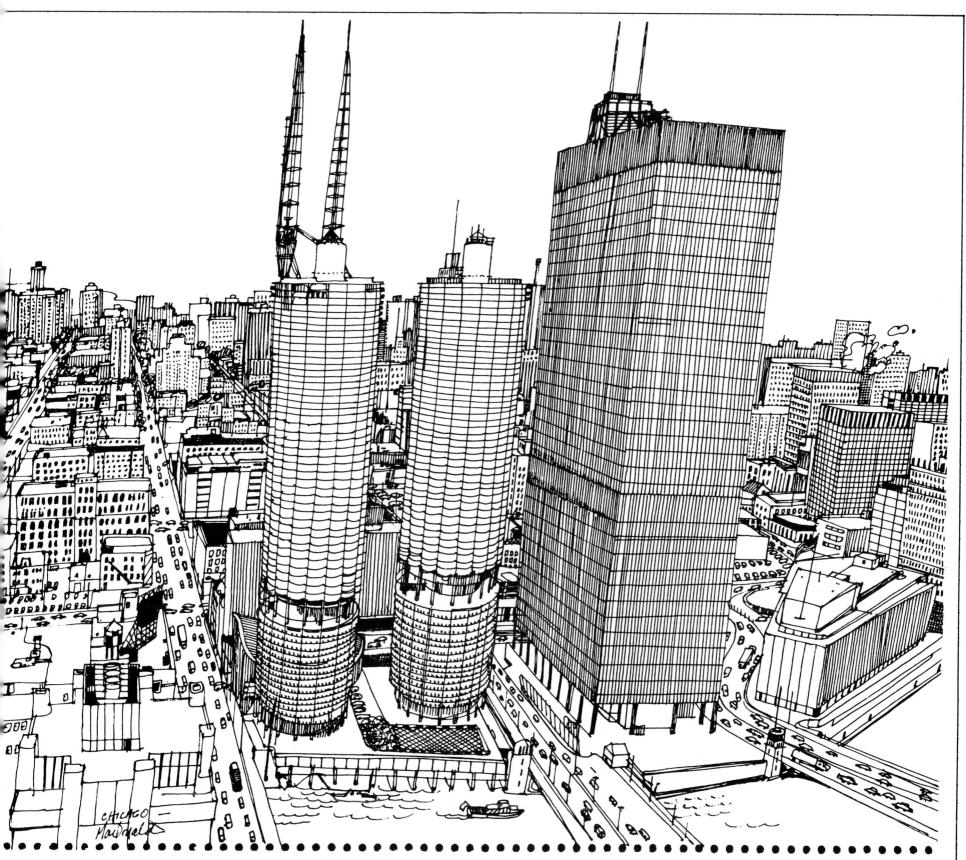

This drawing was made from the library of the civic centre in Chicago. Although the drawing is complex, I have used only the four points mentioned to the left.

The first thing you notice about O'Hare airport (Chicago) is the amount of window space.
I used this as the basic idea for a drawing to show the interior and exterior in one drawing.

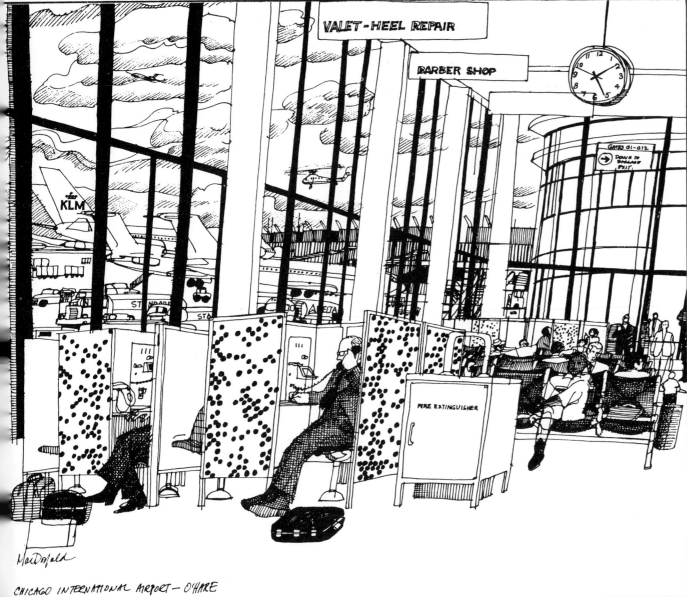

CHICAGO INTERNATIONAL AIRPORT — O'HARE

In its simplest form, an interior is kind of looking down a tunnel. The drawing opposite covers only the part of the interior indicated in this diagram.

People waiting and people contacting other people are common to most airports. The row of telephones in the waiting lounge became important elements in the picture.

"Revolution in the streets — The computer takeover." With this title
I was asked by the London Observer to draw a street scene showing
elements controlled by computer. The list is too numerous to mention.
The best solution was to draw from different places and combine them
into one picture. In the diagram to the right you can see how many
places were brought together into one composition.

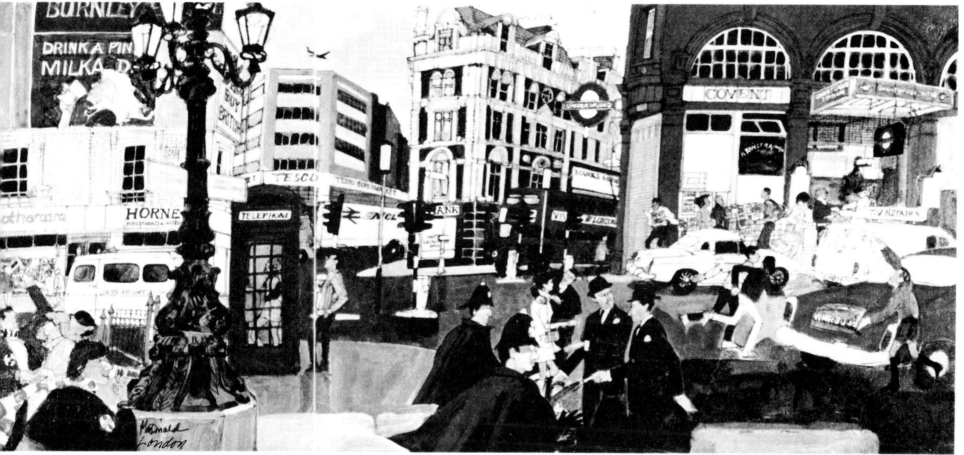

Overlap is important here to create depth in the picture.

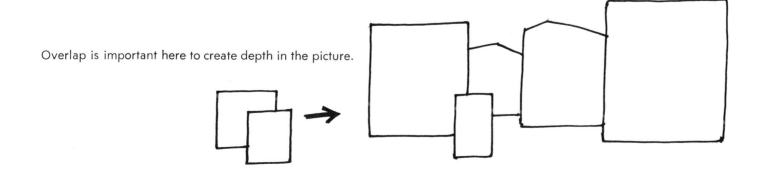

27

This photo shows the Tokyo Tower.
I was sitting much closer while drawing so
I had more of a feeling of looking up.
In a subject like this, planning is especially
important. Here's how I started: I used
the observation stage half way up to as a
starting point. From there I was able to
draw upwards and downwards.

Sometimes architecture resembles sculpture more
than a building. The Atomium in Bruxelles is such
an example. Leaving Bruxelles travelling north, I
saw this structure towering over the trees. I
promised myself the next time I passed that way
I'd make a point to stop and draw. Always go back
to record something that intrigues you. ➡

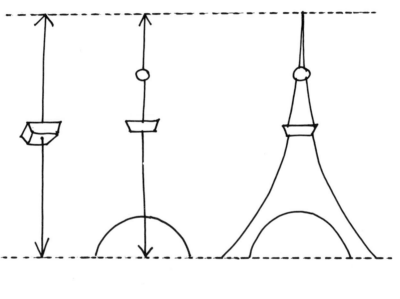

This tower is complicated in structure but
there are definite basic lines. Use these as
a starting point.

As I was leaving the scene, I walked by a
large screen used for a golfing range.
I stopped and drew it into the foreground.
This was **real** Tokyo.

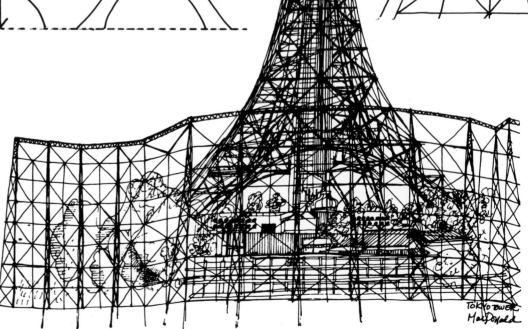

Tokyo Tower
MacDonald

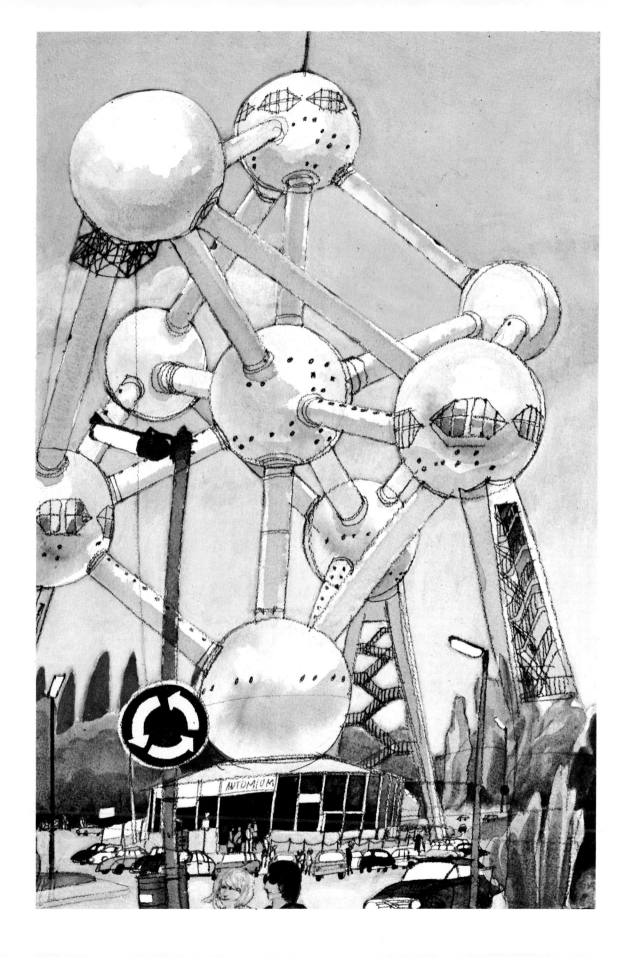

MOVEMENT

Artists of the impressionist period trained
their eye to catch the split-second movement.
They mastered the gesture. The camera
goes further and records action so fast that
it is unnatural when compared to
observations made by the human eye.
The movie camera comes close but action,
being disorganized, must be studied and
assembled to fit a plan.

30

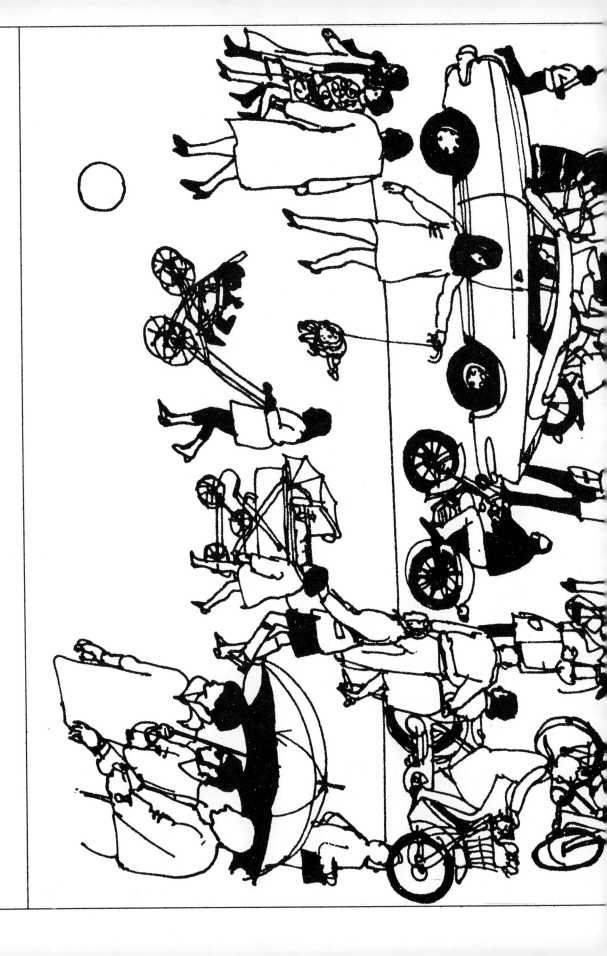

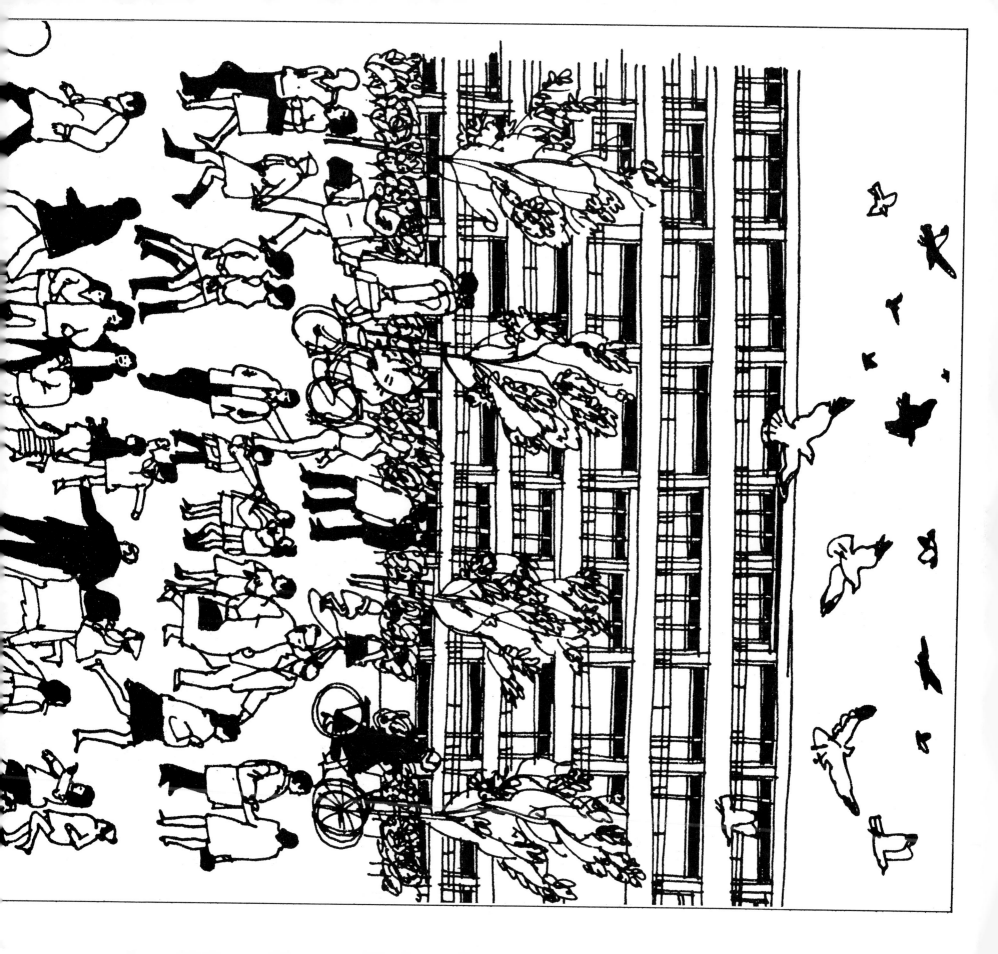

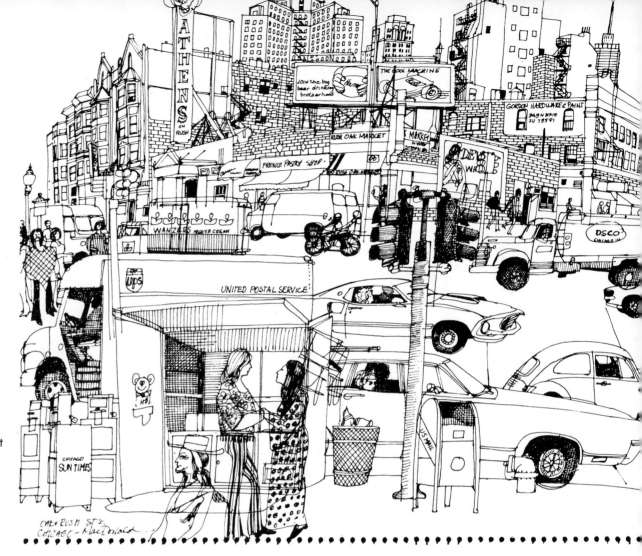

In this drawing I wanted to bring all the ingredients of city life into the drawing, especially the movement. Movement doesn't have to be observed at 1/500 of a second. You can take your time and study it over a period of time. This will give you a chance to design it the way you want, and not be forced to accept the action at a fraction of a second.

If I drew this picture from one spot, **(A)** the background would hardly be visible. Objects in the foreground would be blocking the view. By moving to a second position **(B)** and lowering the foreground in the composition, you give yourself more room to show what's going on.

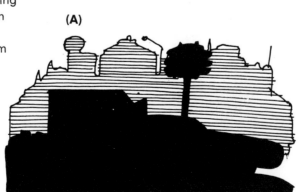

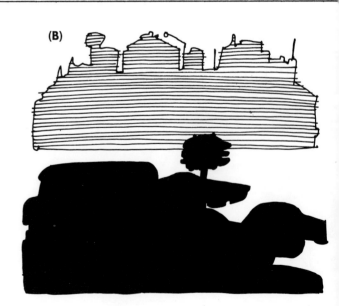

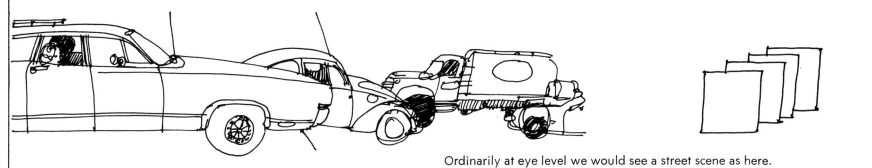

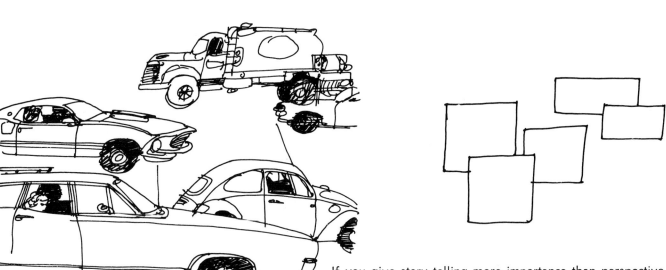

Ordinarily at eye level we would see a street scene as here.

If you give story telling more importance than perspective, as in this drawing, you are able to show or tell more about the subject.

This shows how the drawing fits together. You can see that movement can't be simply accepted. Planning is essential.

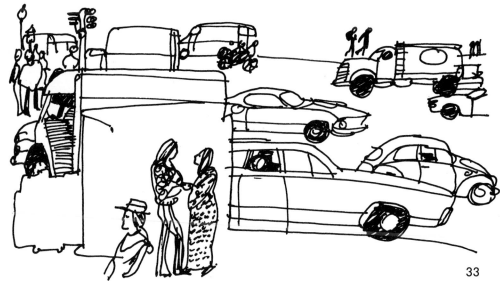

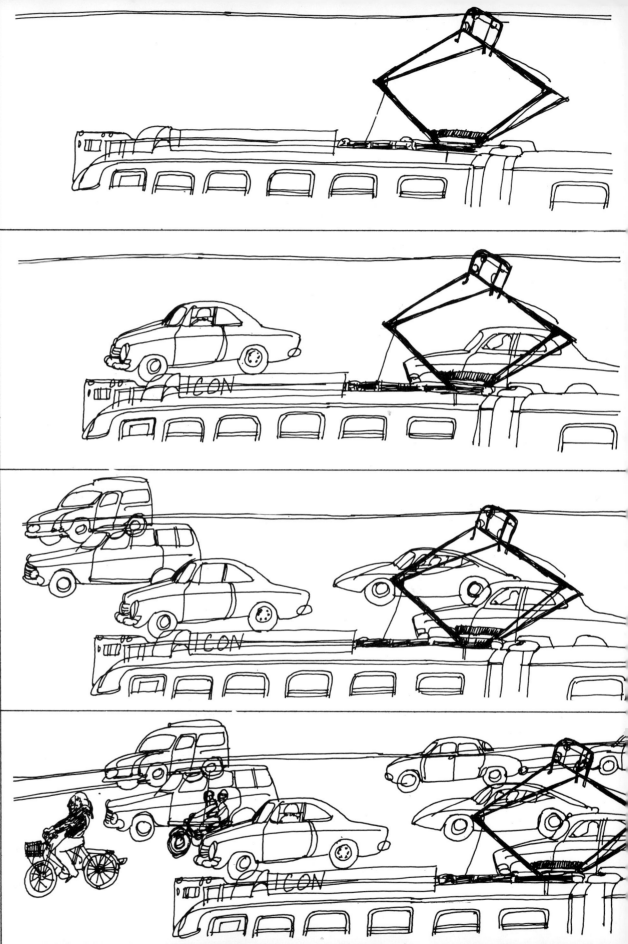

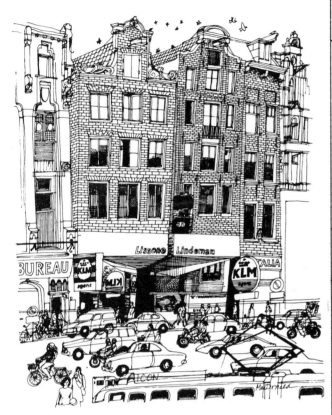

This scene follows the same principal of showing movement as did the drawing of Chicago on the previous spread. The stages of development were made after the completion of the drawing. However, it shows exactly how I started with the street car and the progression of additions.

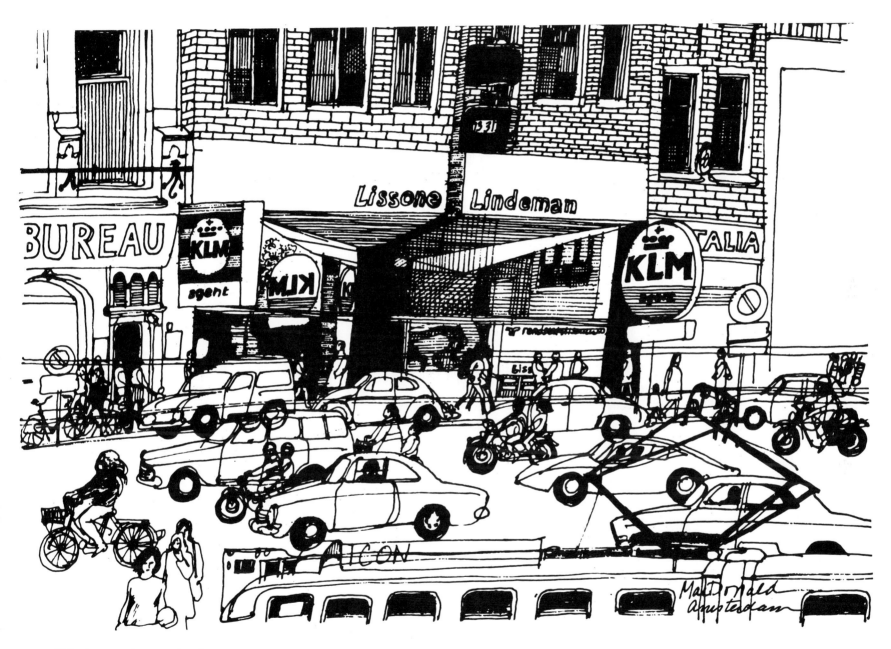

This closeup shows a detail.

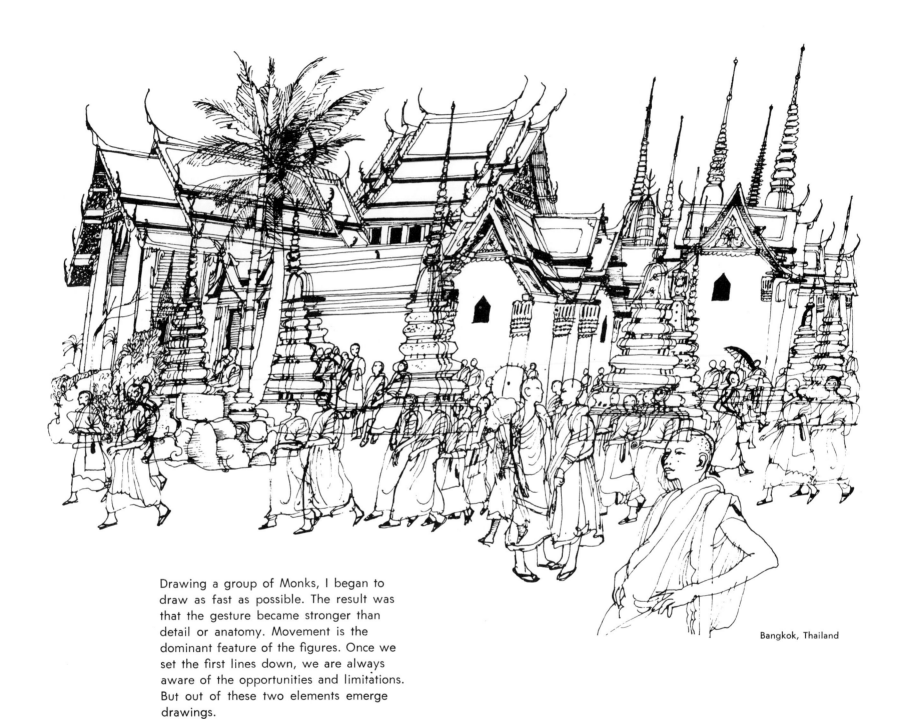

Bangkok, Thailand

Drawing a group of Monks, I began to draw as fast as possible. The result was that the gesture became stronger than detail or anatomy. Movement is the dominant feature of the figures. Once we set the first lines down, we are always aware of the opportunities and limitations. But out of these two elements emerge drawings.

This blown up section shows how a drawing can change character. The line becomes ragged and abstract. Many artists draw very small then blow the drawing up photostatically. Like looking through a magnifying glass, you are startled that the lines and shapes are more than what you thought they were. ➡

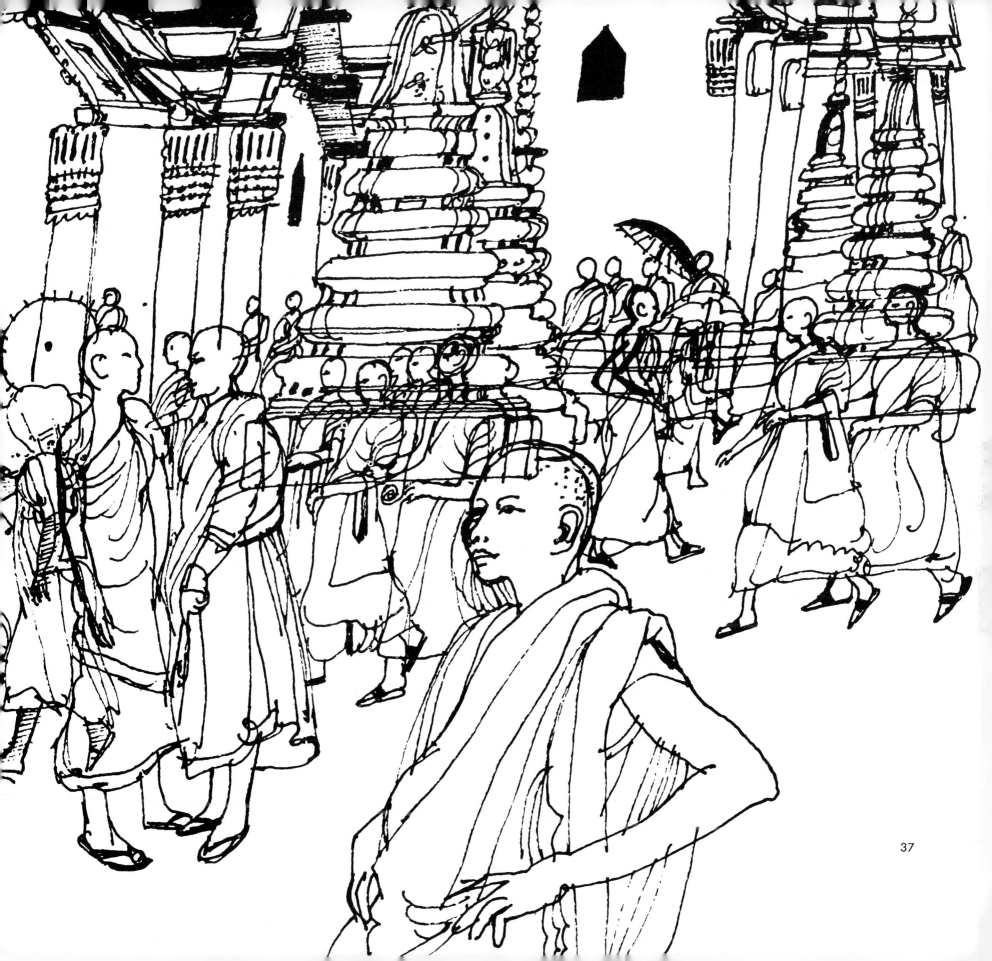

ANIMALS

The animal kingdom is endlessly varied in size, shape, and species yet they have habits and characteristics much like those of humans. There is a reason why we use phrases as "roar like a lion", "graceful as a swan", "walks like a duck", etc. We are really using animals to describe people. Just as with drawing people, look for some characteristic feature of the animal which will describe it best. It may be the way it sits, relaxes, walks, and eats. If you are close to a farm or zoo or have pets, you have all the opportunity you need to draw animals.

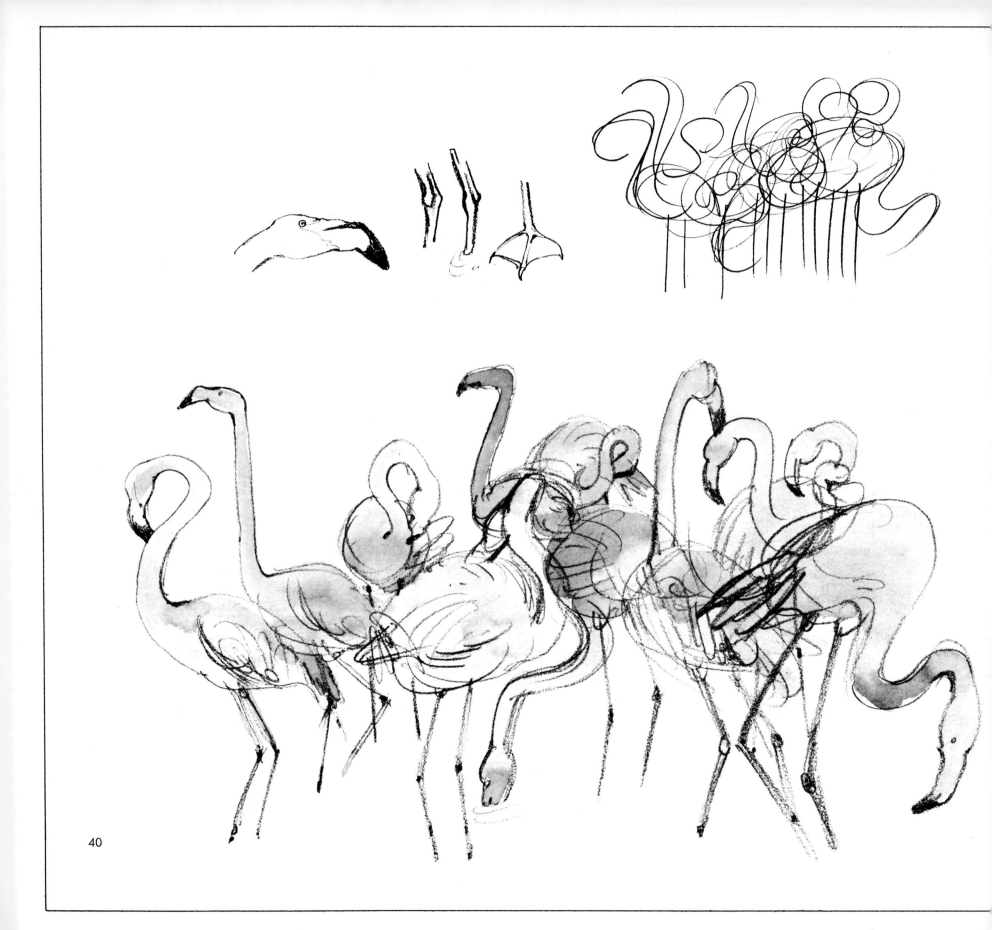

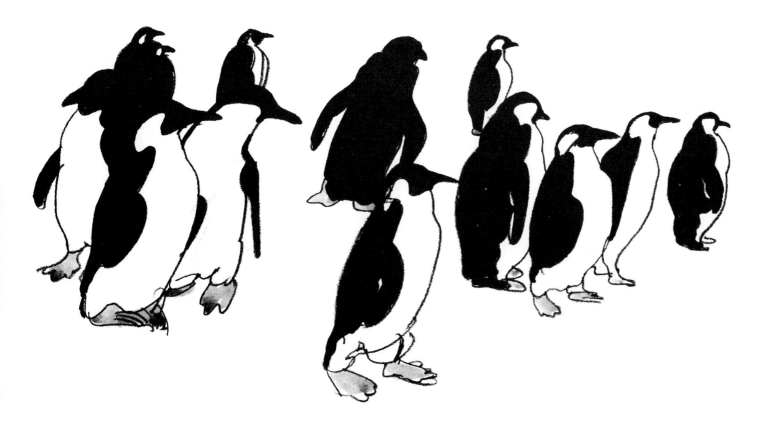

It's not difficult to see what to draw when watching flamingos. The long graceful necks and long skinny legs are important features. Their graceful movements when eating and grooming are equally important. As shown in the diagram here, it's the graceful movement of line, rather than the attention to detail that brings out the important features. It may be a good idea to begin with some sketches.

Penguins on the other hand are awkward and comical. It is also one of the creatures that most resembles the human. When watching them it's difficult to think of them as not being able to think and talk to one another. The penguin is sturdy and some types have strong black and white shapes.

41

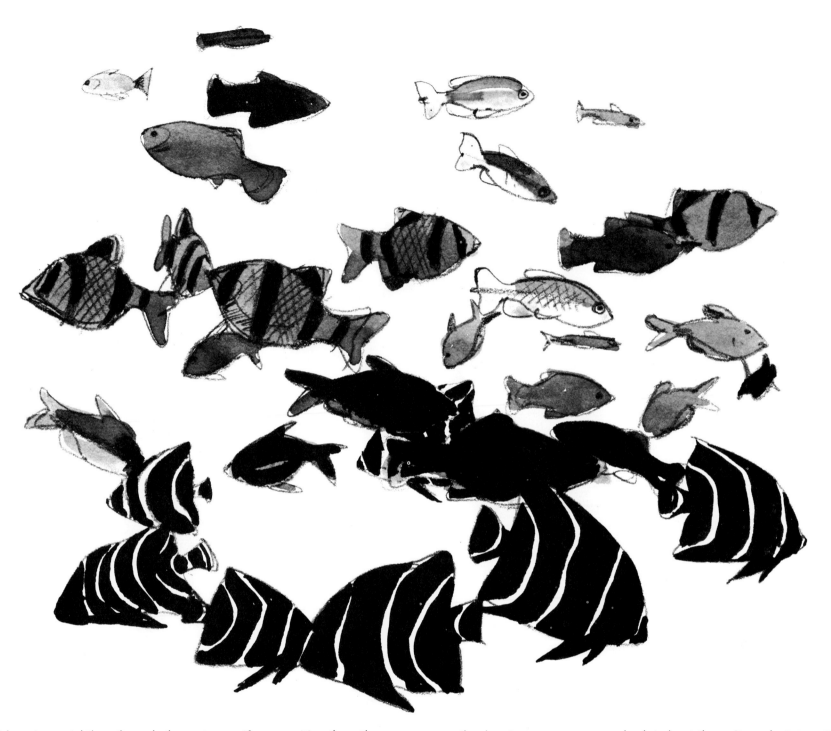

Fish swim weightless through the water, so if you position them the same way on the drawing paper you reveal a lot about them. It can be interesting as you can draw them again and again as they swim around. Study the shapes and detail so you can distinguish one kind from another.

42

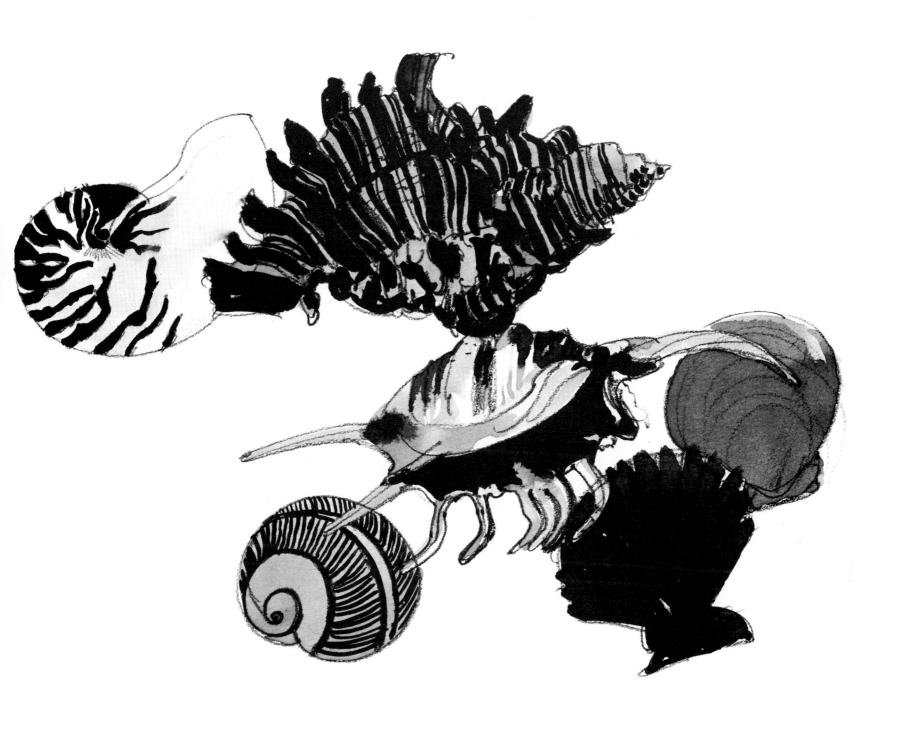

Shells are another kind of fish — or were. Shells have the advantage of not moving, so you are able to make a detailed study of them.

The drawing was kept very simple. I wanted
nothing to compete with the black and white shapes.
It was made with 4 or 5B pencil. The black was
made with magic marker.

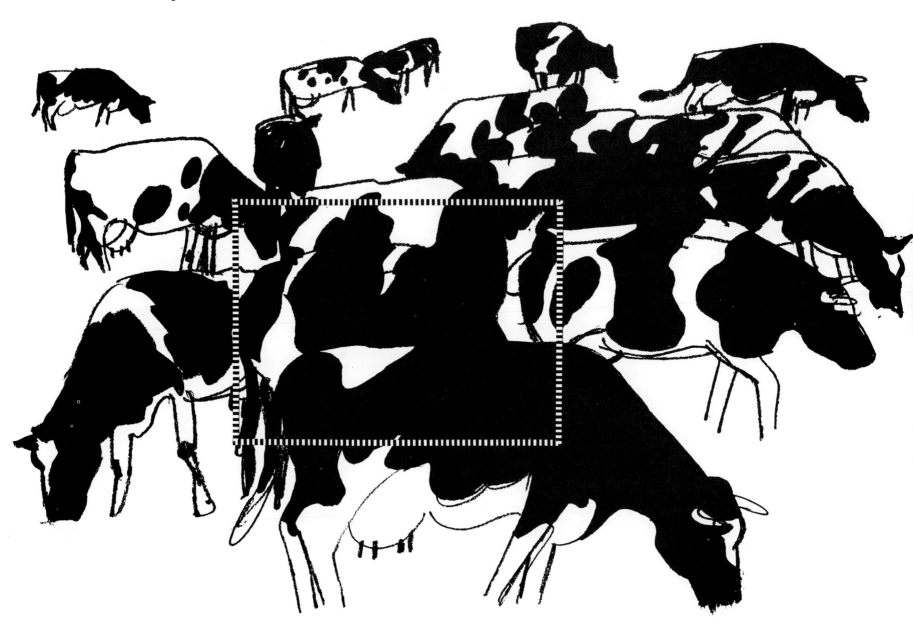

The abstract quality of the black and white shapes interested me when I drew these cows. I tried to keep them abstract. In the area below you can see how the shapes alone take on their own abstract quality.

Note how the overlapping and size variations of the animals are used here to create depth.

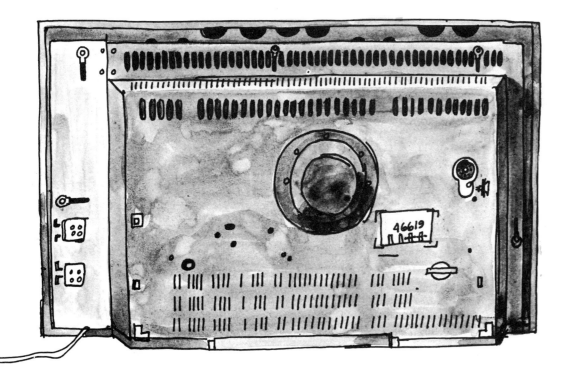

MECHANICAL SUBJECTS

When drawing the back of my television set or a doubledecker bus in Hong Kong, the problems of mechanical subjects are essentially the same. You are in essence **building** the subject again. Being limited by the dimensions and parts, you seek out your opportunities for an interesting drawing. There is an endless range in this type of subject. Some can be quite simple while others are very complex. This latter can present a real test to your patience which is essential to good drawing.

Hong Kong busses are interesting in that they are both British and Chinese in character. This bus is really a long line of busses which stopped and departed as I was drawing. The many stages were made in the studio after the drawing was finished. They do however show an accurate development. I'm not suggesting that you follow these steps, as you will no doubt develop your own method; I'm suggesting that it's easier to make a drawing starting with the basic forms and shapes.

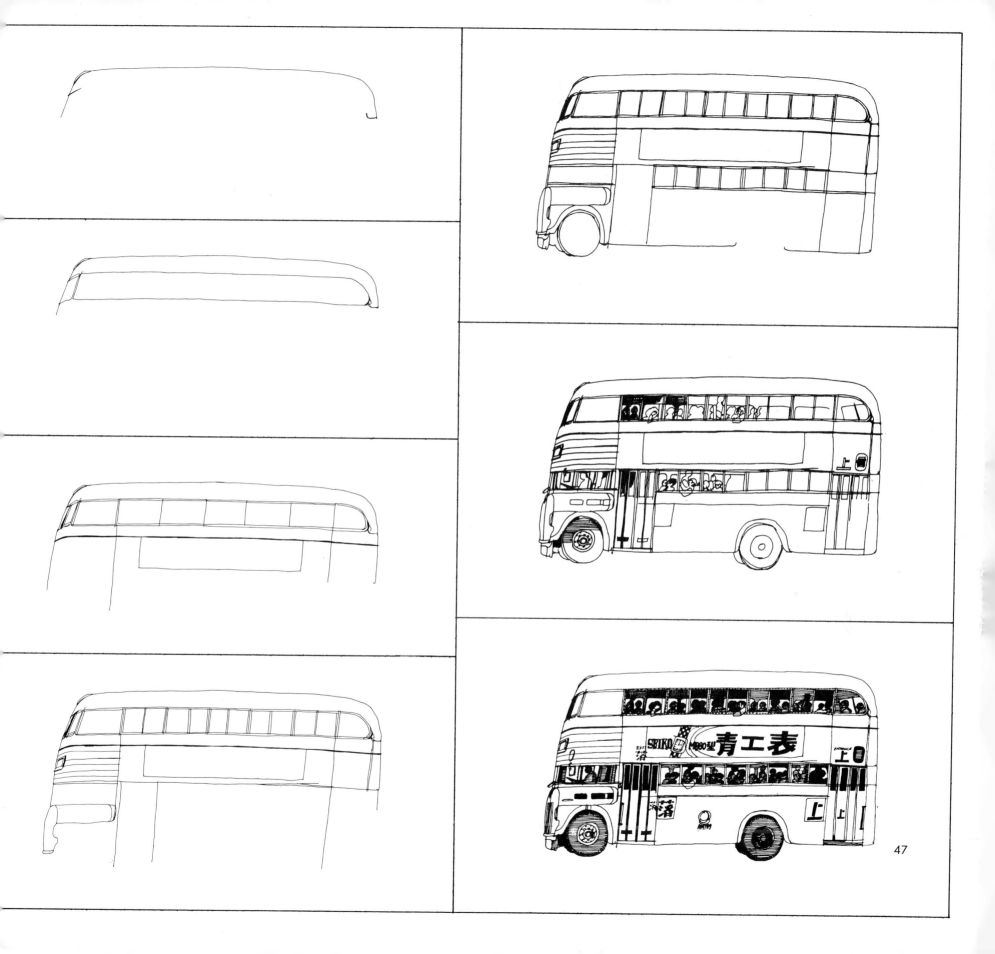

47

This is the thumbnail sketch made while studying the boats for a possible drawing.

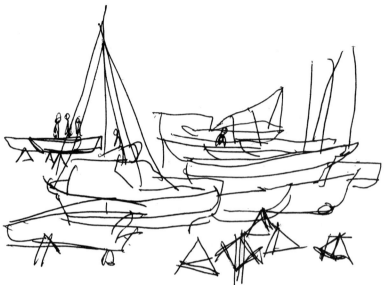

The many stages of the drawing shown here (made after the drawing was completed), show not only the stages in development but also give you an idea how many times I changed position during the drawing. Each stage was made from a slightly different view (based on the pre-sketch). A camera could not produce a picture as complete, yet I have not added anything that was not there. I only allowed myself to look around the corner and compose elements according to my own judgement.

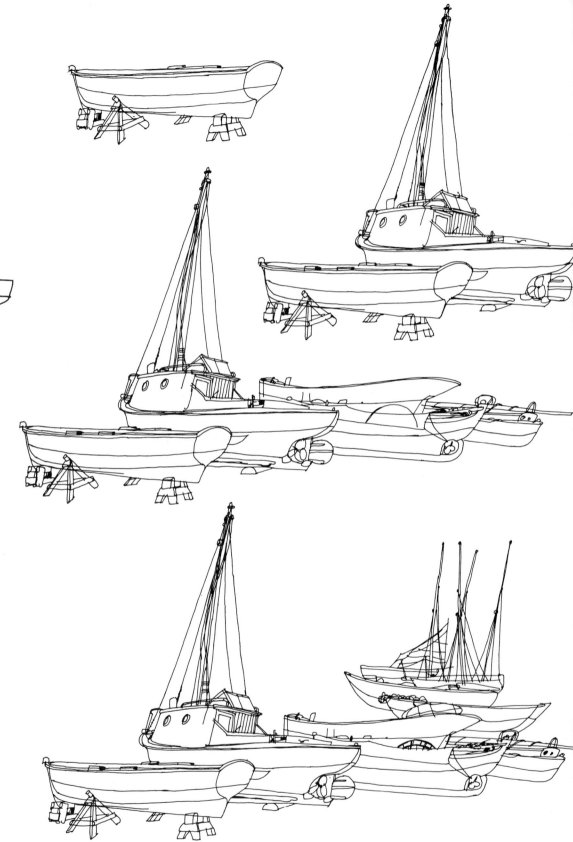

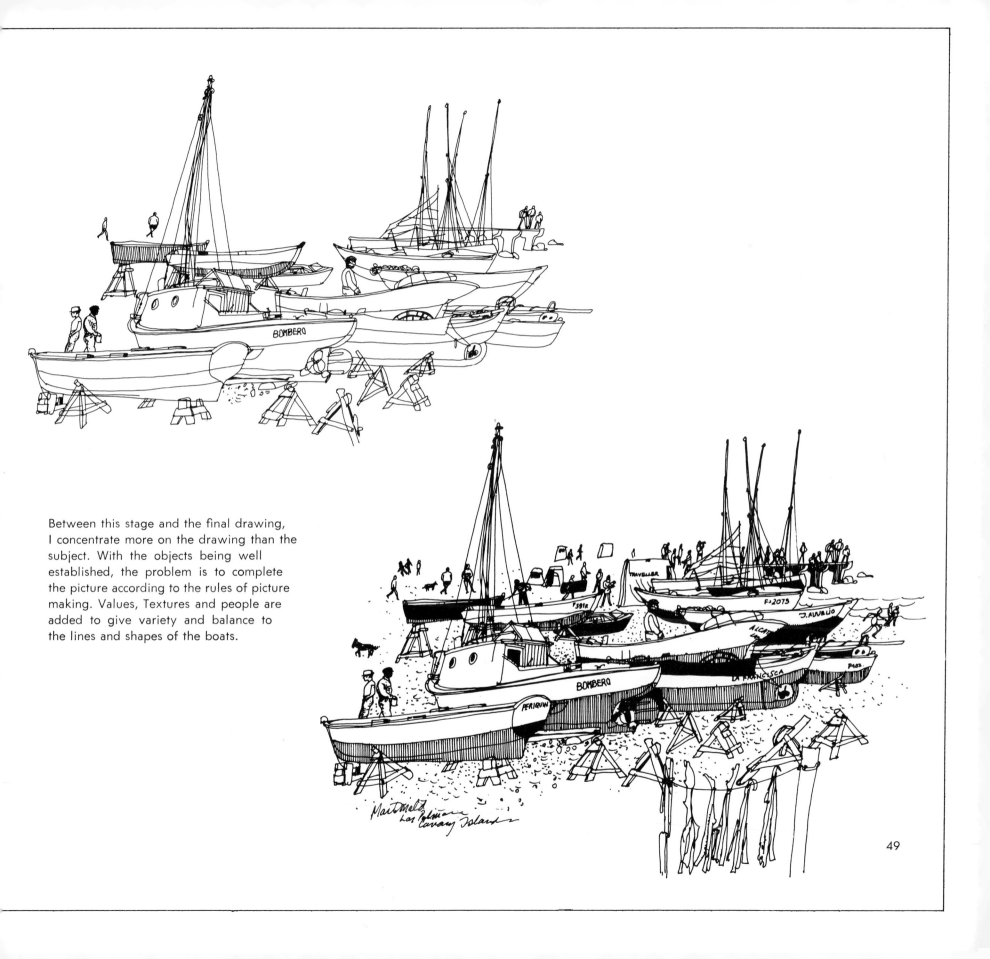

Between this stage and the final drawing, I concentrate more on the drawing than the subject. With the objects being well established, the problem is to complete the picture according to the rules of picture making. Values, Textures and people are added to give variety and balance to the lines and shapes of the boats.

49

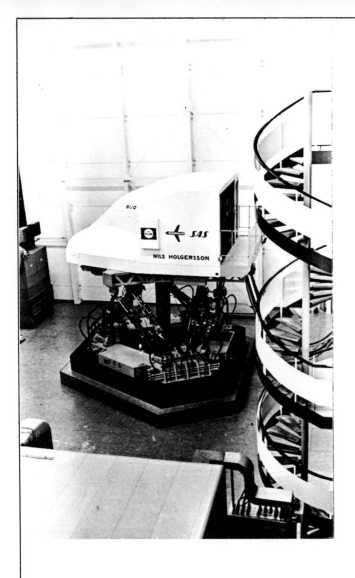

This is a flight simulator for training pilots to fly the Boeing 747. The upper part is moveable and can create any situation and sensation of flying. I made this drawing at Schiphol Airport, Amsterdam. After studying the inside and outside, I made a quick sketch, sitting on the circular stairs (see photo). The drawing was made on a bond sketch pad. Here you can follow the many stages of development.

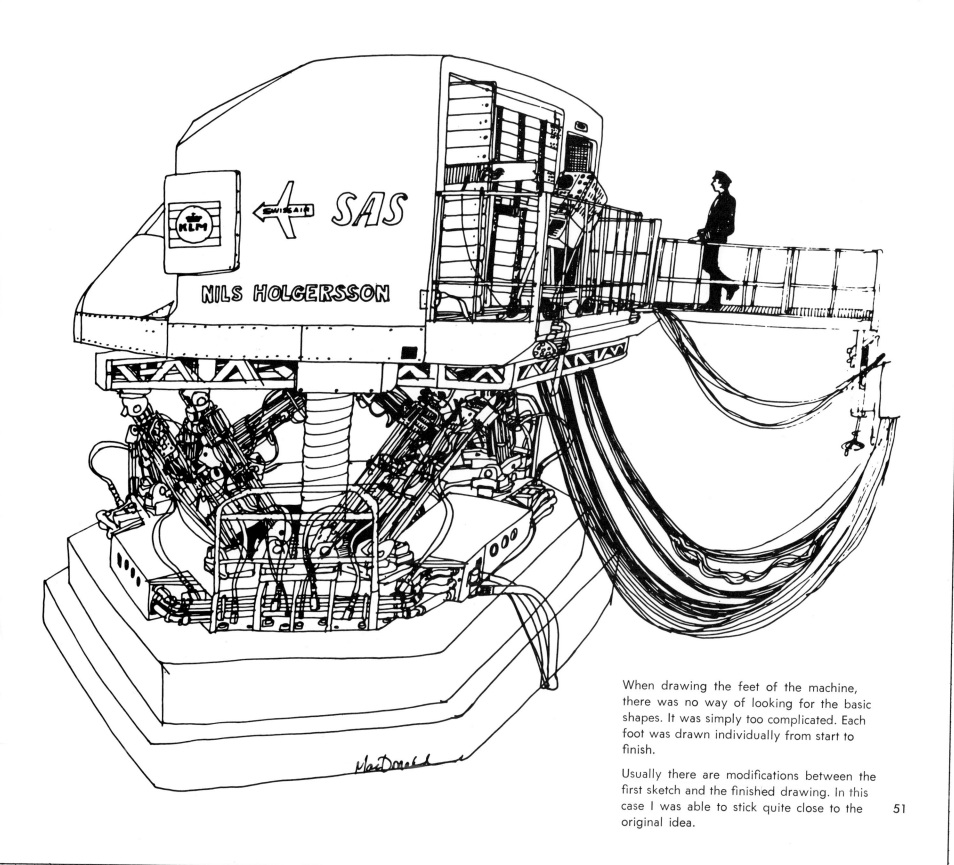

When drawing the feet of the machine, there was no way of looking for the basic shapes. It was simply too complicated. Each foot was drawn individually from start to finish.

Usually there are modifications between the first sketch and the finished drawing. In this case I was able to stick quite close to the original idea.

51

Drawing is not always successful. There is something in us that says yes or no. If that something says no, don't hesitate to flip the page and start again as I did here. Nobody will know.

A **person's approach to drawing** has to be an extension of himself, an individual way of thinking and living. It should be as natural as writing one's name. Although I have a farily good idea what I want to accomplish when beginning a drawing, I try to let things happen as I proceed. Unexpected changes and developments have had the greatest influence on my work.

I draw the way I live. "Fate" influences my final product more than any planned effort. Not that I sit around and wait for things to happen — I have as many goals as the next person and work hard to reach them. But my original plan is formed only to increase the chances of coincidence, to save time and to avoid fumbling.

In my opinion, good art is better today than in any other period in the past.

I think artists today have stopped worrying about being classicists, romanticists, impressionists, cubists or "ists'" of any kind. The worthy artist is simply trying to be himself!

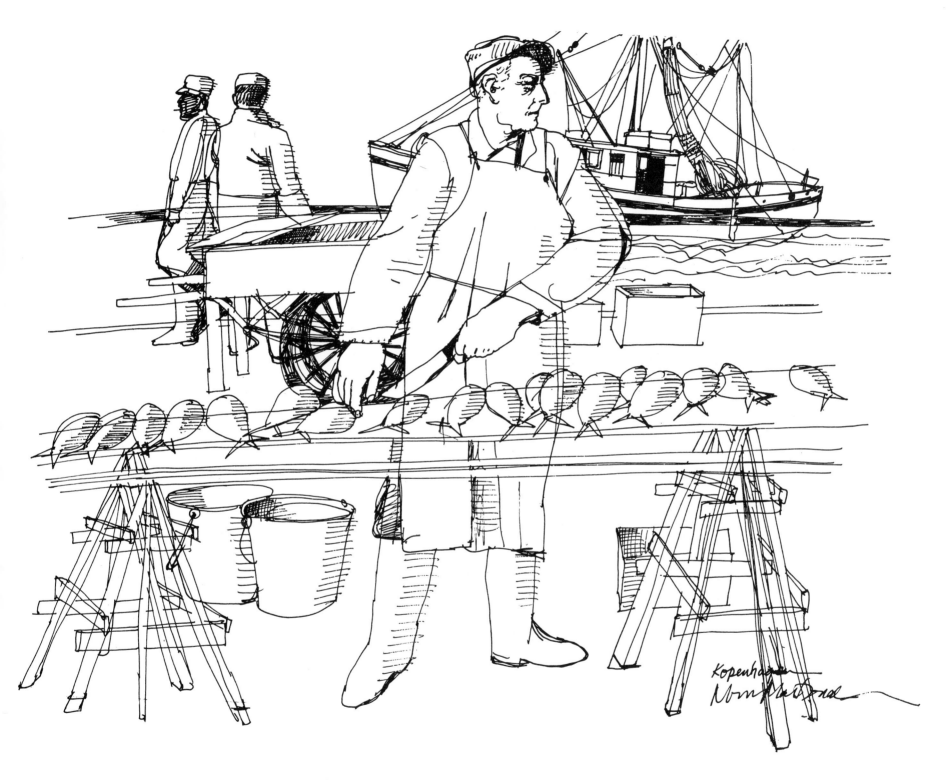

Kopenhagen

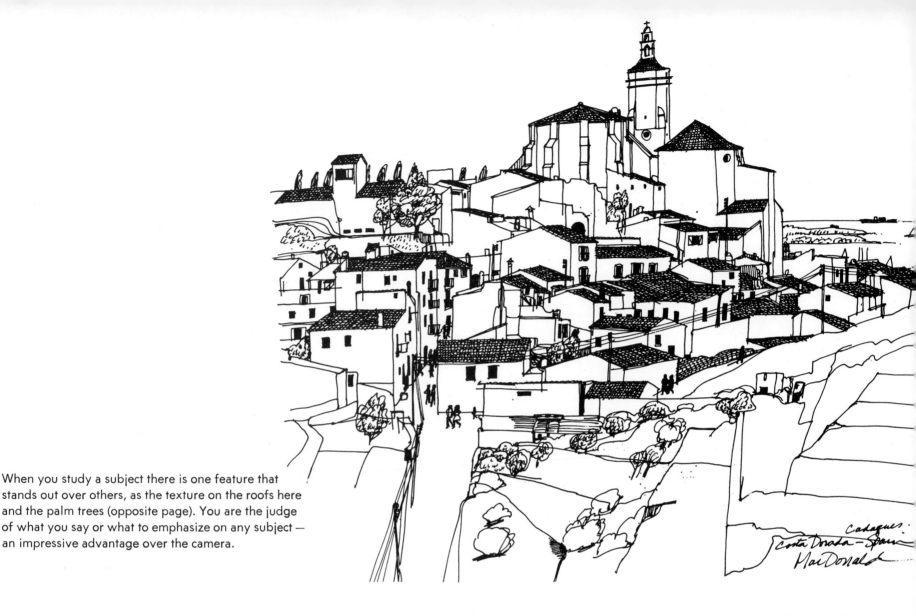

When you study a subject there is one feature that stands out over others, as the texture on the roofs here and the palm trees (opposite page). You are the judge of what you say or what to emphasize on any subject — an impressive advantage over the camera.

This is not to say that one should ignore the past — it would be folly not to take advantage of the knowledge and discoveries of the great talents that have gone before us. But one should remember that the great ones were **individuals.** They absorbed the best of what went before them — then spent their lives emerging as **themselves.**

This is my aim also — I worship the best of the past — but I don't blindly accept **all** the past simply because it's old. And I'm afraid many people do: witness how many museums and collectors acquire works of art as they might antiques — simply because they're old and novel. And when the media report the acquisition of a rare work they seldom dwell on its artistic worth — only its monetary value. Art talk should differ from Wall Street talk.

I spend a great deal of time in museums and I recommend museum study for several reasons, partly as a way of keeping humble — but more importantly because it's a kind of religion.

A visual connection with the past becomes a form of worship.

When we study 15th Century religious works, we see the artists' storytelling ability and also marvel at their methods of communicating — whether painting on walls or panels.

54

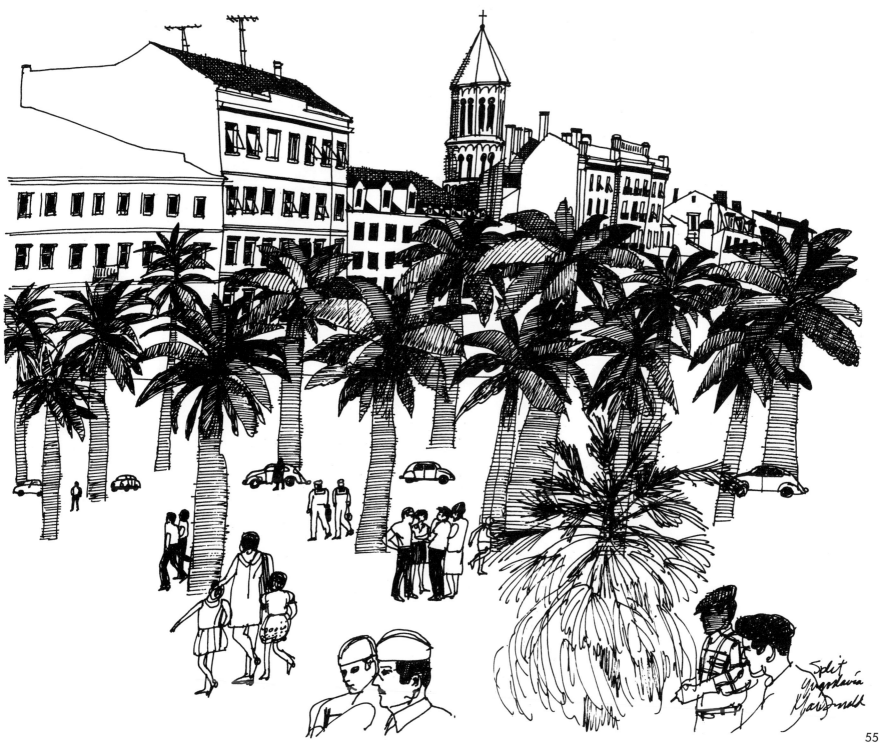

Split
Yugoslavia
[signature]

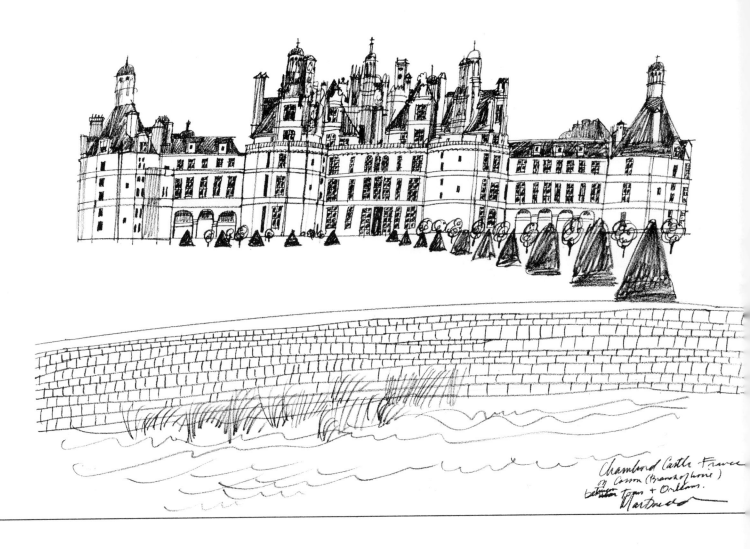

Chambord Castle France
of Cosson (Branch of Loire)
between Tours + Orleans.
[signature]

When artists later began using canvas they left areas in landscapes and still lifes where preliminary char-coal stages remained visible. I often wonder if artists did this because they realized that their **"handwrit-ing"** under the paint would some day be important to those who are moved by a record of the spur-of-the-moment inspiration. To me, such works that live and breathe as I look at them some centuries later are small miracles.

Drawings and sketches are what I like to see of an artist's work. Because the medium is so elementary, it's impossible to cover up bad work. That's why I like to see drawings by Hans Holbein, who reputedly drew people as they were without flattering them. When Henry VIII was searching for his fourth wife he sent Holbein to Cleef to paint Anne. Holbein shipped the finished portrait back to England where Anne was judged from the portrait to be a proud, intelligent and attractive woman. But when Henry met his future wife for the first time in England, he described her as stupid, ugly, wide-hipped and flat-chested.

Although a great observer of women, Henry was to see an Anne when she was without benefit of super-ficial adornments and quite unprepared to meet visitors. Holbein didn't have this advantage, so if his in-

eading the eye into the picture was my
im here although when I drew, I began
vith the background.

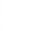

The linear effect was important in this
drawing. I had to avoid a lot of detail
to get the effect I wanted — besides, it
got dark halfway through the drawing
which prompted the decision. ➡

sight into qualities such as pride and intelligence were correct it is understandable why his portraits are held in such high regard.

Rembrandt's drawings and line work form an important part of his output and, unlike Holbein, his subjects included almost everything from sexual intercourse in a corn field to the crucifixion. He had great ability to catch a moment. Some of his roughest sketches are considered finished pieces of work. While other artists created landscapes in their studios, Rembrandt was in the country or in the street drawing on the spot. His example inspired others and it became an important turning point in the history of art. Artists and patrons of the time, tired of studio-made landscapes and props, welcomed the freshness of the real thing.

We have a good example of this today in the art of film-making. The millions of dollars needed to produce films using props and man-made backgrounds cannot equal films using real settings and locations.

Delacroix had the ability to draw on the spot. His vigorous sketches show a flare for adventure. This characteristic remains strong in his painting where he also manages to add refinement.

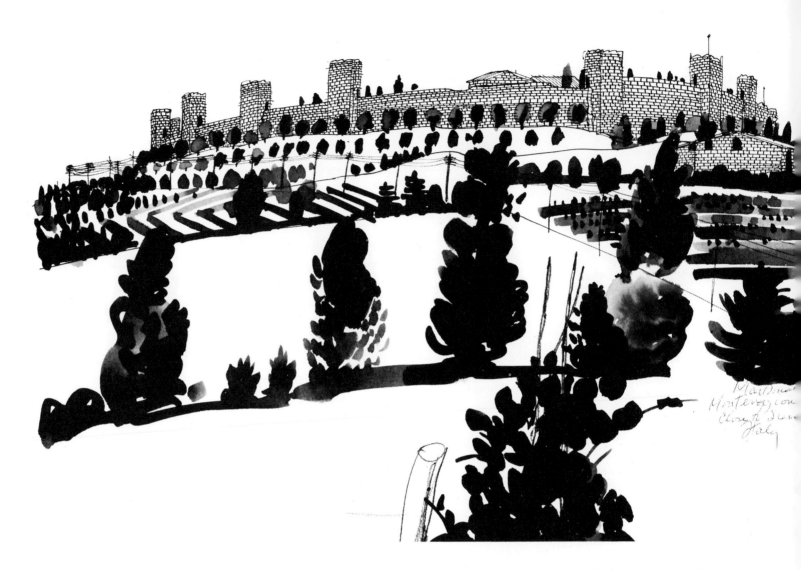

An Italian artist of the 18th Century named Piranesi was one of the first who succeeded in using architecture as a subject matter. Instead of just copying buildings, he used his knowledge of the subject and an exceptional drawing ability to create a weird world of his own. His mastery of the **right** way allowed his imagination to take him off into bizarre realms where he could deal in unreal proportions and imaginative constructions. If one doesn't know the **right** way, he can't convincingly do the **wrong** way on purpose.

Piranesi's series of imagined prison drawings in 1745 are a wonderful example of the mind guiding the schooled hand to fine accomplishments.

Imagination is not really an essential ingredient for drawing on the spot. But how wonderful when it's combined with draftsmanship! Henri de Toulouse-Lautrec was an artist who had this ability to sustain a moment and sketch it freely on the spot. His can-can dancers, brothel scenes and portraits show this ability at their greatest.

Vincent van Gogh's sketching ability is also prominent in all his work. He makes it hard to determine where sketching becomes painting. I don't think he attached any importance to separating the two. The vital point is that he was a fine draughtsman. These abilities will save one who is weaker in other areas.

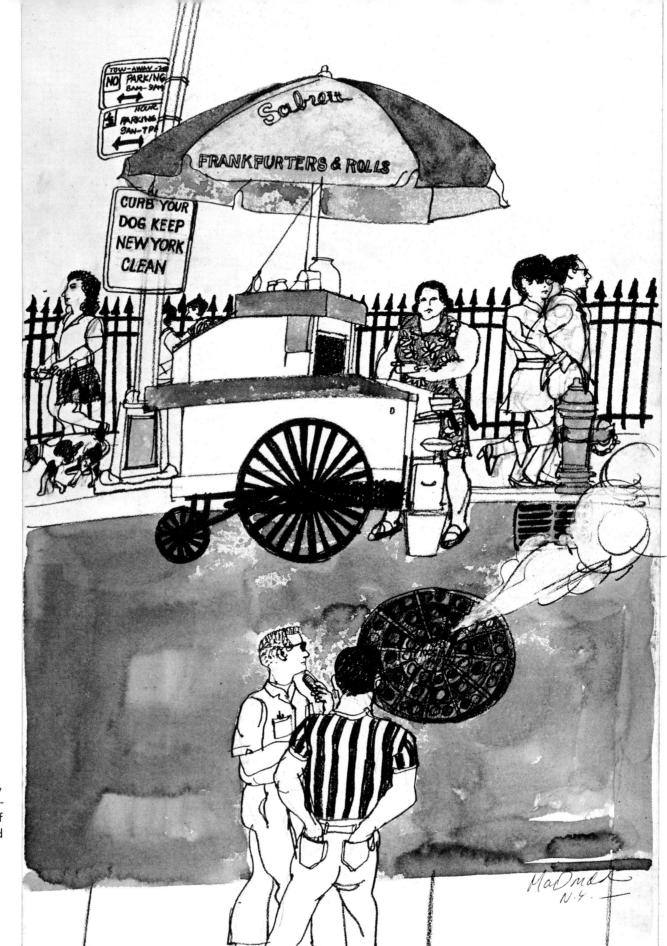

mpletely relied on repetition
pattern in this drawing but
I see that the effect of the
m climate has been lost.

This is just a quaint old subject, I guess I'm a real Norman Rockwell when it comes to things of this type. I love to discover and draw things like this.

59

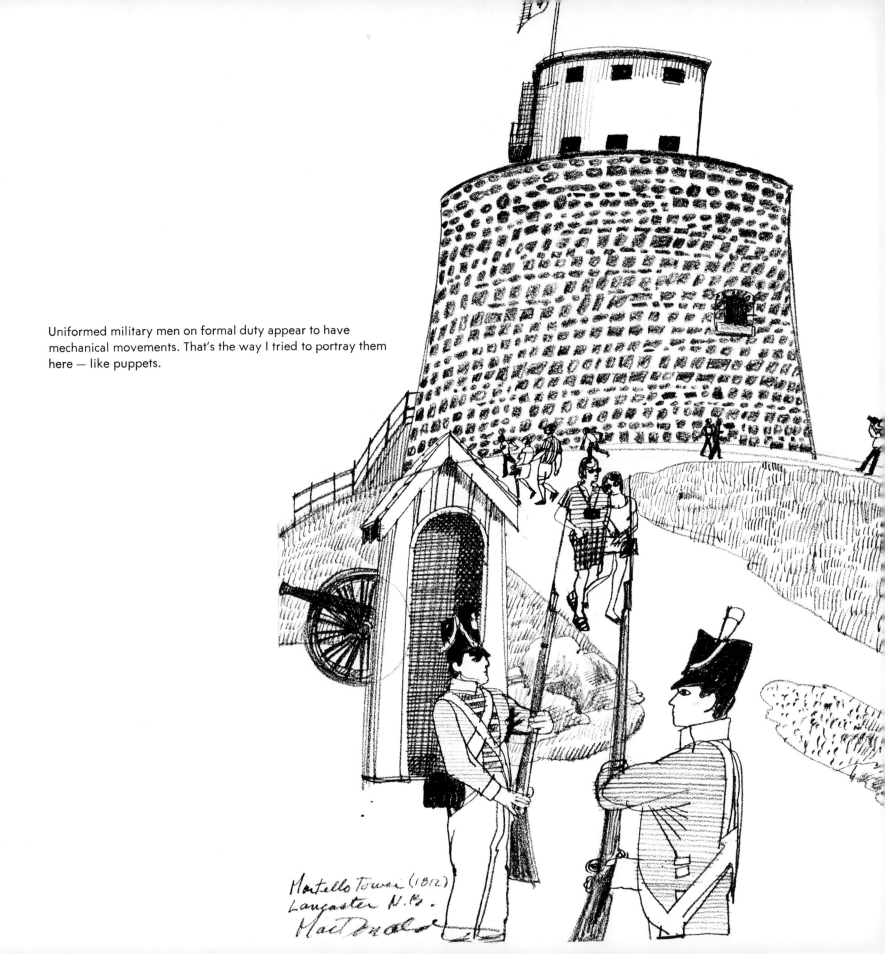

Uniformed military men on formal duty appear to have mechanical movements. That's the way I tried to portray them here — like puppets.

Martello Tower (1812)
Lancaster N.B.
MacDonald

60

I've named only a handful of great artists whose method of work is meaningful to me. Obviously their ability to go to the source and **capture** it, has also captured me.

Down through time scores of others have worked this way too — so it obviously has great validity. I admire some artists of more recent times for the same reasons.

Winslow Homer was one. Frederick Remington and Charles Russell recorded the Old West so it still lives. In World War I Kerr Eby, Harry Townsend, Harvey Dunn, George Wright and Wallace Morgan drew the soldier and his life as he lived it — or lost it.

In the next war Howard Brodie, Bob Greenhaulgh, Harold Von Schmidt, John McDermott and Jack Ruge among many others again captured man at war. Andrew Wyeth, Alan Cober, Thomas Allen, Franklin McMahon, Austin Briggs, Al Parker and Noel Sickles all can stand in a scene, feel it, and put it down.

Most recently, news media have employed sketch artists to report the drama of the courtroom, where cameras are not allowed.

These men work under great pressure and have little time. They must produce likenesses and continually create dramatic pictures in drab rooms of tables and chairs. They are endlessly inventive.

So we have come full circle. The sketch began on the walls of caves and now is part of the computerized electronic world.

The hand-drawn picture and the sensitivity of man must have merit.

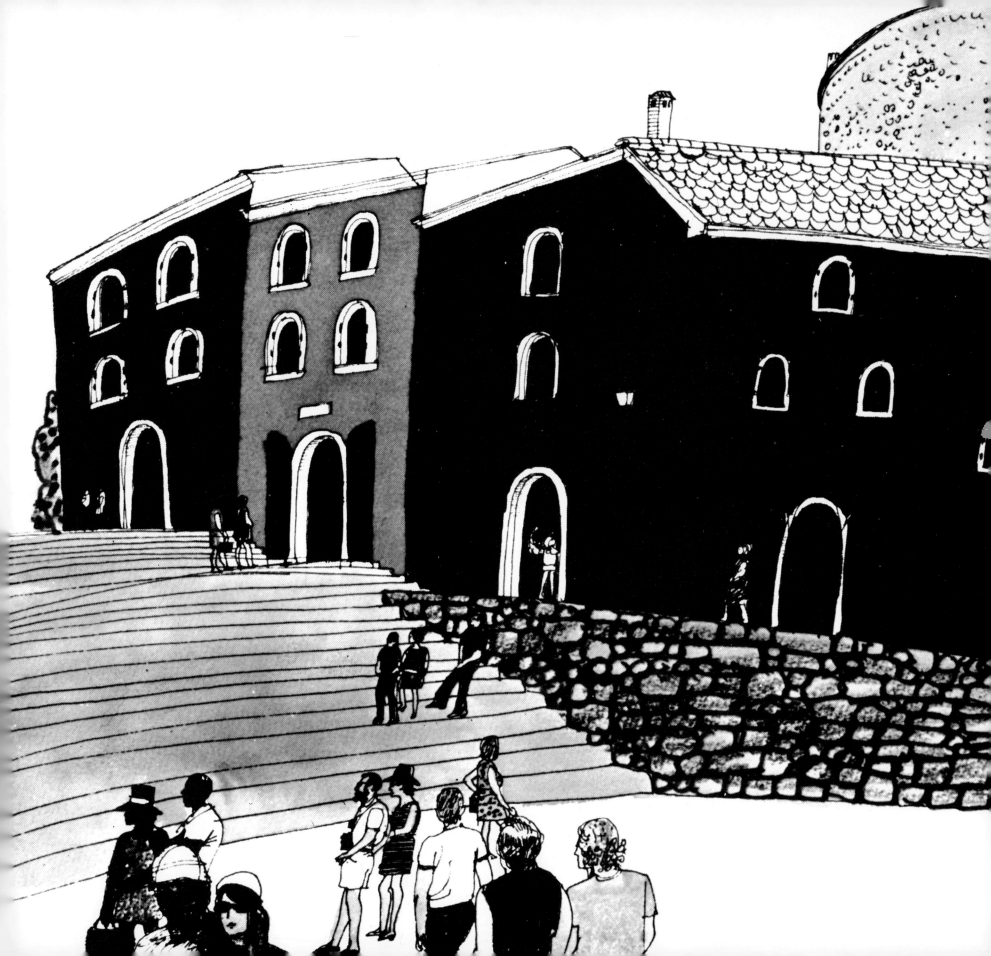

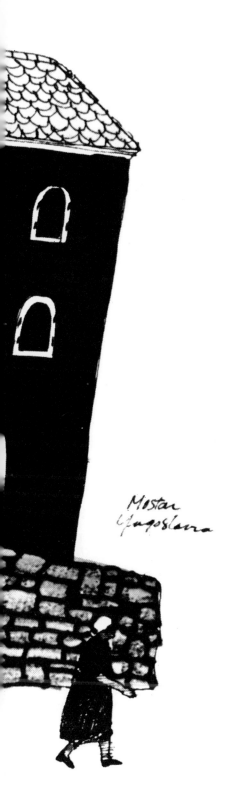

Mostar
Yugoslavia

Moving around to different positions for one picture forces you to change the perspective. This has no negative effect on the outcome of the drawing and can strengthen the individuality of the picture. Try to work this out in your mind before you begin.

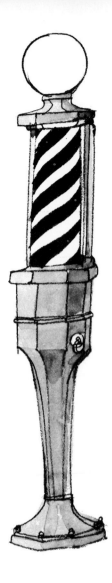

When drawing a complex subject such as a city, keep alert for tasty details such as this great old barber pole. They are wonderful in themselves — and make great foils when set against the massive shapes of buildings.

The strangest and loneliest moment for a sketch artist is when he sits and stares at a blank white expanse of paper before making that first stroke.

The uncertainty of this moment is understandable when one considers that the result is only a short while away and there is no predicting it.

The decisions an artist makes at this time are going to be important to the success of the drawing: the view-point, the elements to be included, the composition, values, etc., are all dependent on this first plunge.

This is a good time to ask yourself **why** you are drawing what you see before you. What do you seek to accomplish? — if it's merely to record, put down your pencil and pull out your Polaroid. It will do a good job with no effort.

It is to be hoped that your aim is to **interpret** the scene — to translate it like **no one else in the world can do it,** simply because you are you.

Your images of people, places and events do not resemble those of any other person. Your imagination is assembled from personal thoughts, evaluations and experiences. So in effect each individual has an imag-

continued/P. 70

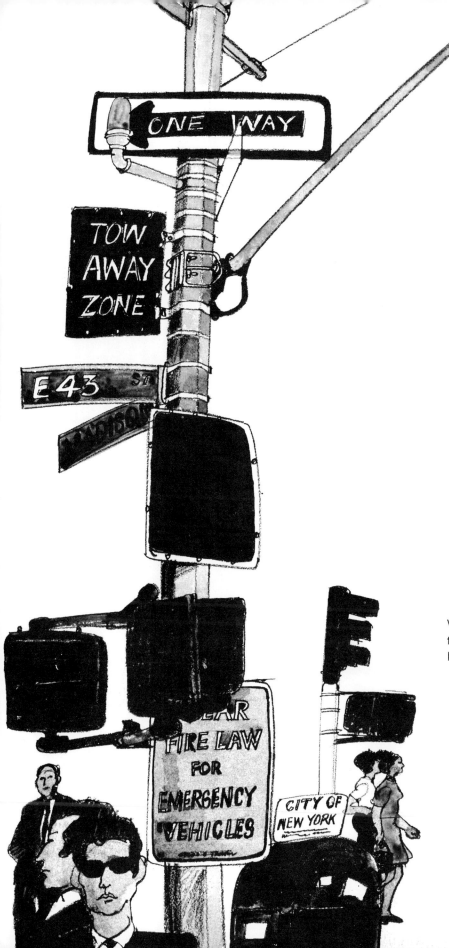

Wondering how a driver would be able to read all these signs prompted me to do this drawing. It says more to me now about New York than at the time I drew it.

65

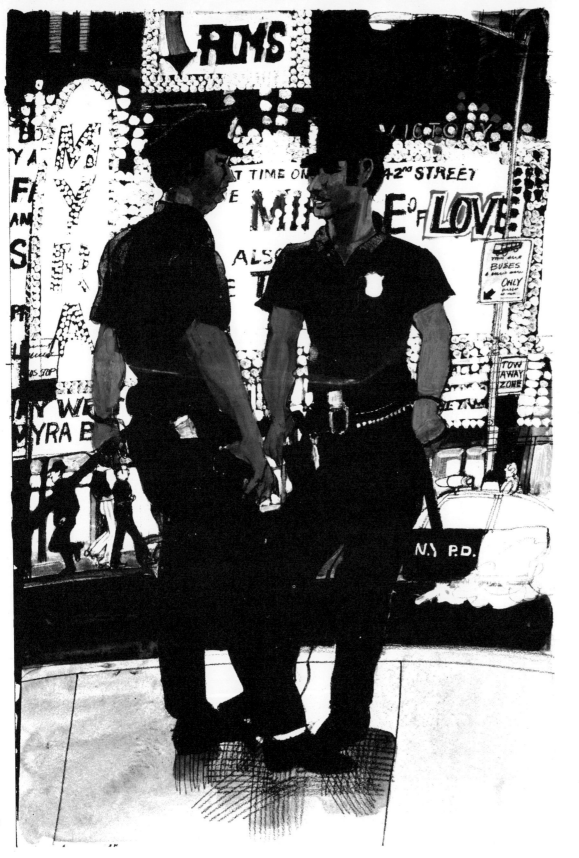

I wandered around New York for a long while before drawing. It gave me a chance to think of what impressed me the most. Here are a few simple things that did.

66

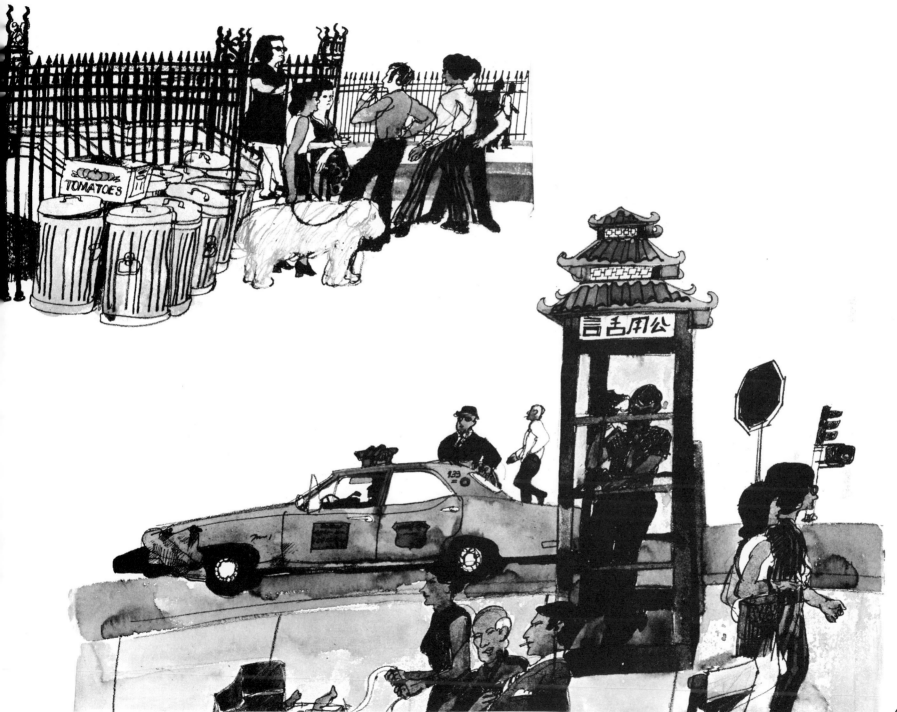

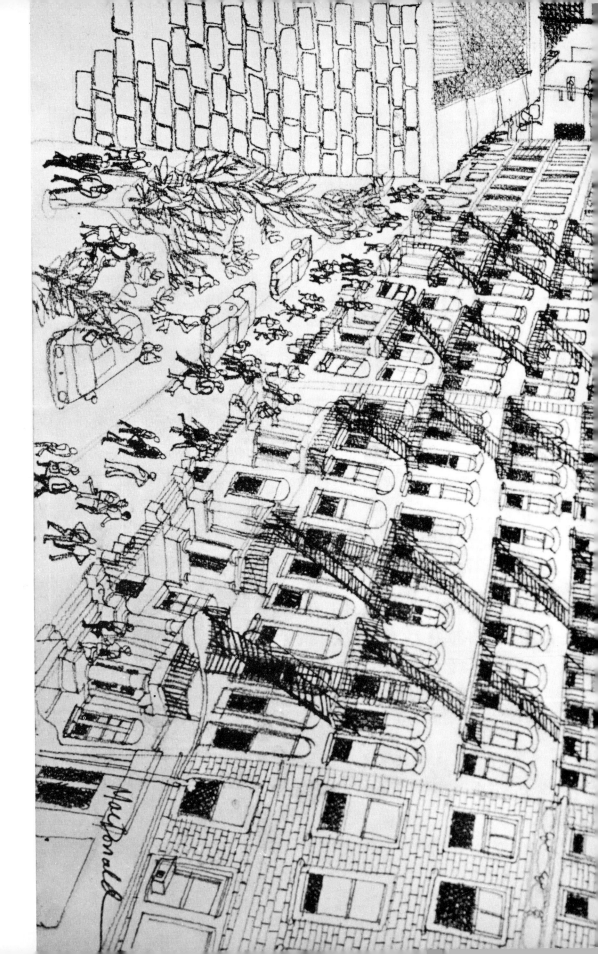

Being able to get up on a rooftop gave me a chance to see New York from top to bottom, and this is how I approached this drawing.

68

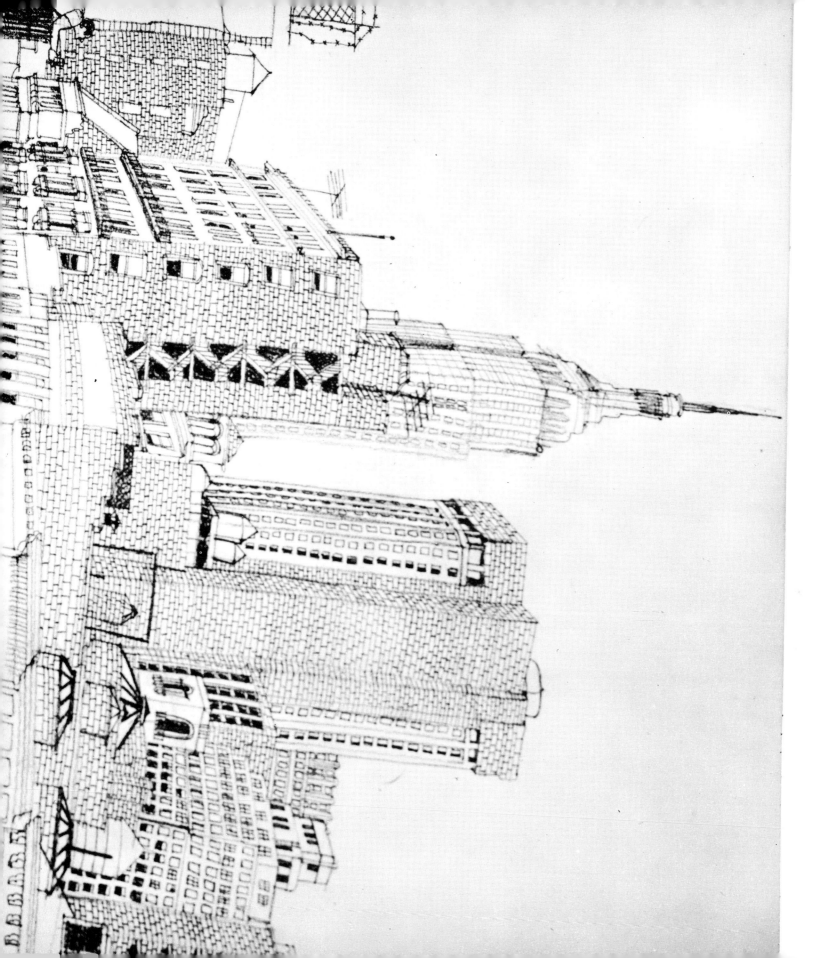

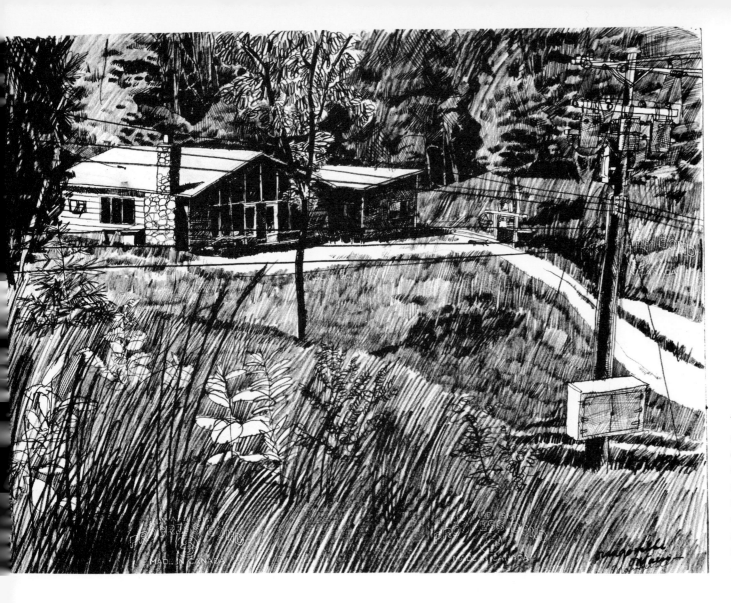

The drawing on the left is an early one and shows probably the most common of errors, the urge to overdraw and fill the drawing with everything so that it finally says nothing. The other drawing shows a more recent effort where I was more selective. What you leave out can be as important as what you put in.

ination quite different from that of anyone else. For example, writers are rarely satisfied with movies which are produced from their work. The writer's imagination has suddenly become reality, and reality is never the. equal of the imagination. Each time we begin filling that white space we are creating what no one has ever done before. So why do we do what no one has ever done before? I don't know. If we did, the need to draw would vanish with the mystery of why.

All artists are accustomed to having people say, "I wish I could draw." That's most understandable, as we well know. Drawing is an extremely personal way to express one's self. And everyone needs expressive outlets whether it be through pictures, words, music, dancing, demonstrating or flagpole sitting.

Good drawing has no relation to place, subject or technique, although these elements can have a strong attraction. Some drawings here have been executed as close as from my living room and others were done half way around the world. I cannot hold one above the other in terms of quality.

Complexity is also unrelated to quality. Simple drawings may have more impact than complex ones and vice versa.

70 If you are beginning to draw, I won't say keep it simple because the temptation to make big and compli-

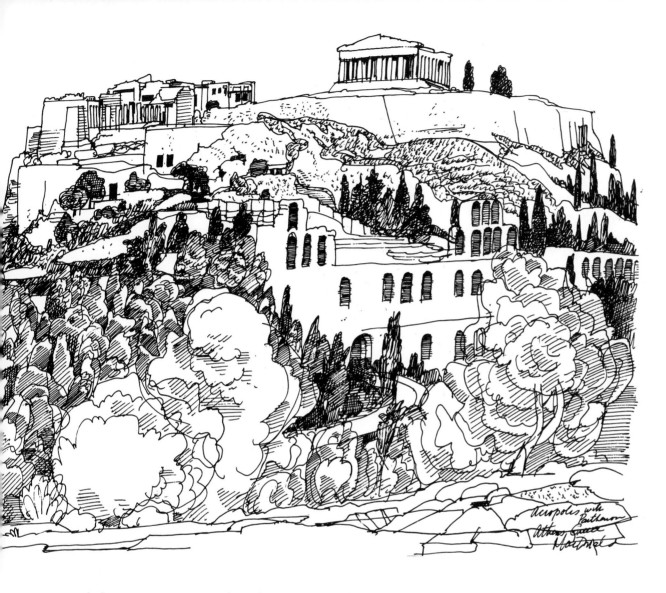

Acropolis with Parthenon, Athens, Greece MacDonald

cated drawings is strong; besides, you may have great success. If not, being knocked down is a lesson in itself.

The big advantage of drawing less complicated subjects is that it gives one the chance to observe more intensely. And observation and good drawing is all there is to it.

When you are looking for something to observe, you don't need to have something new. Remember Rembrandt was satisfied to stay at home. He preferred things around him because they were familiar to him. Try sketching objects in your home or neighborhood. Try drawing your family, neighbors and friends. You can even surprise yourself observing the weird shapes in a beer mug. Examine open school books. Observe their lines and tones and put them on paper.

Take a sketch pad with you on vacation. This will give you the chance to draw things you don't normally see.

Television can also be an interesting frame of reference to draw from. Panel shows, specials such as circuses, news events, etc., are good sources for reference. You can sketch people in restaurants, at the beach, or simply as they relax around the house. When drawing in this fashion, don't draw too much longer than your patience will allow. If you hurry, it shows.

71

Florence
Plaza della Signoria

Try to work on subjects which interest you more than others. This could be the key to developing a personal viewpoint, and being personal will make you stand out from others.

When we get to the subject of technique the only problem should be to find a tool that is natural to work with. We'll deal with this in more detail later but right now there are a few things to keep in mind.

The first choice no doubt will be pencil because we have all grown up using it for writing, so it won't feel strange. You can create a great range of values and if you don't like what you do, you can always rub it out. Charcoal is harder to keep clean and the pen can be too limiting in the beginning.

I assume that you have one or more favorite artists whose work you follow closely and perhaps even try to emulate. That's natural. And it's to be encouraged as long as you remind yourself that this is a **passing thing.** It's where you are **at the moment** — and it's by way of finding **yourself.**

I've been all through this and I'm young enough to still be going through it. But I know what I'm after and can tell by looking back at drawings of just a few years ago how I'm growing and maturing.

It's a great thing to be able to draw every day. It's a good feeling to know you draw better than a year ago and next year you will be better than today. In this respect quantity has its merits.

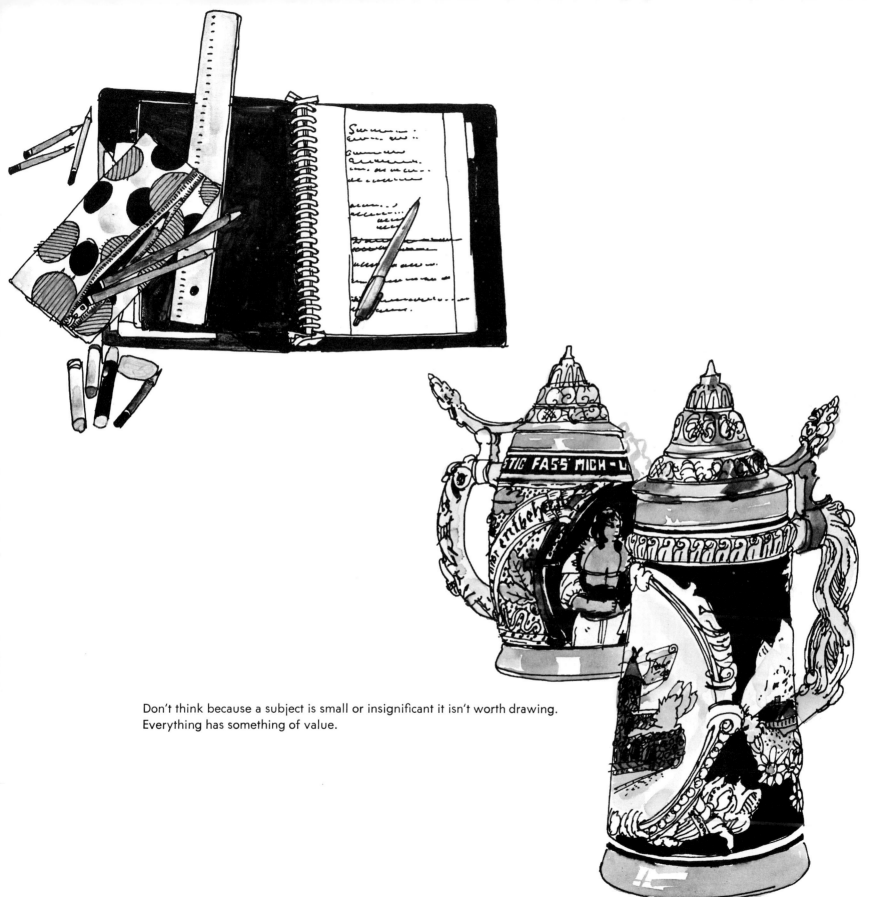

Don't think because a subject is small or insignificant it isn't worth drawing.
Everything has something of value.

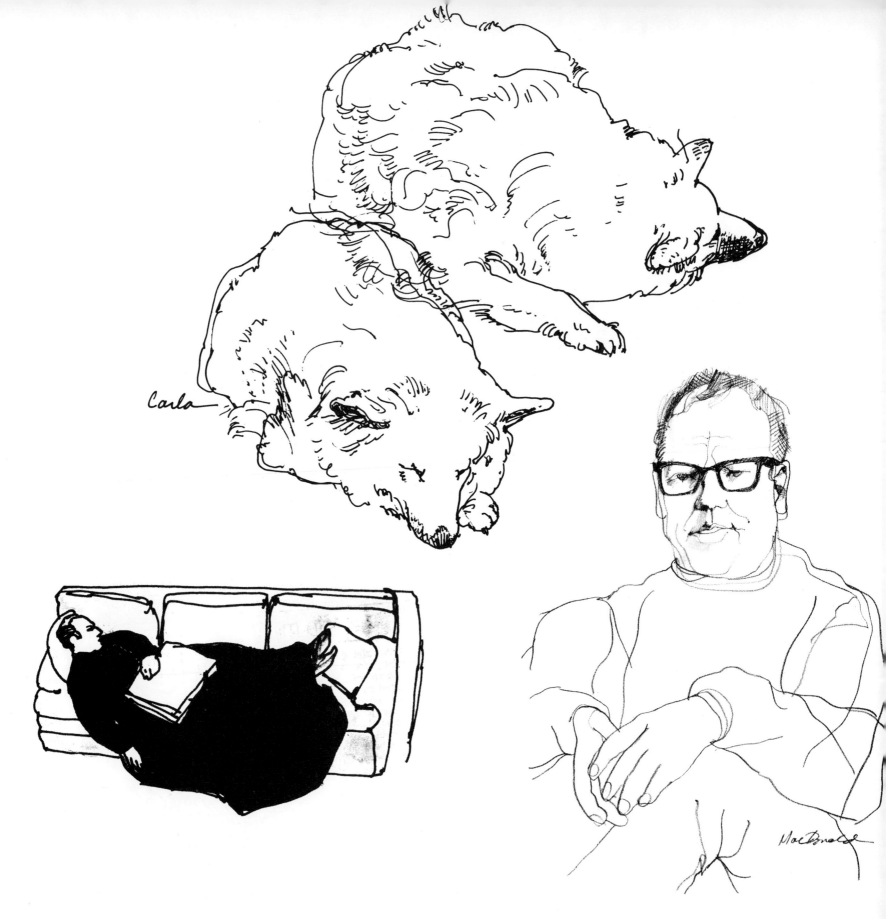

Carla

MacDonald

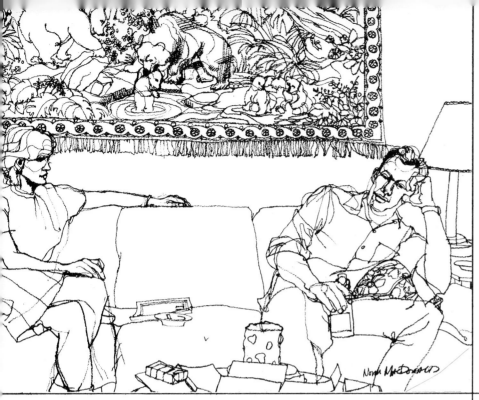

There are no rules as to when to draw. The time is when you are motivated. It's nice when familiar things close to you still move you to draw. It means you are still keen on the subject or at least not taking it for granted.

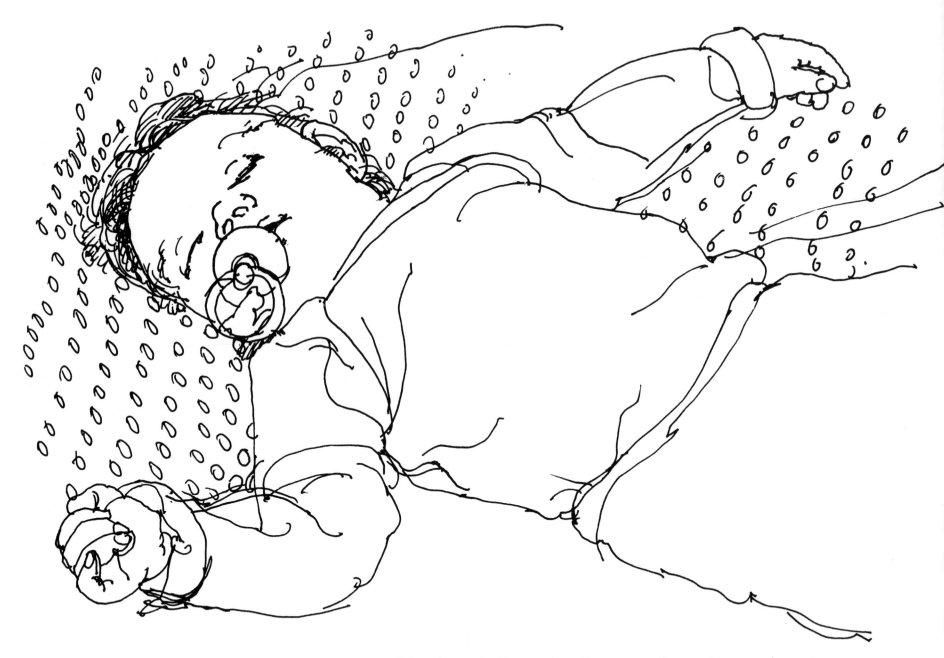

Kids make good subjects to draw. They are usually eager to pose and are not as self conscious as older people. Maybe **all** models should be given pacifiers to keep them still.

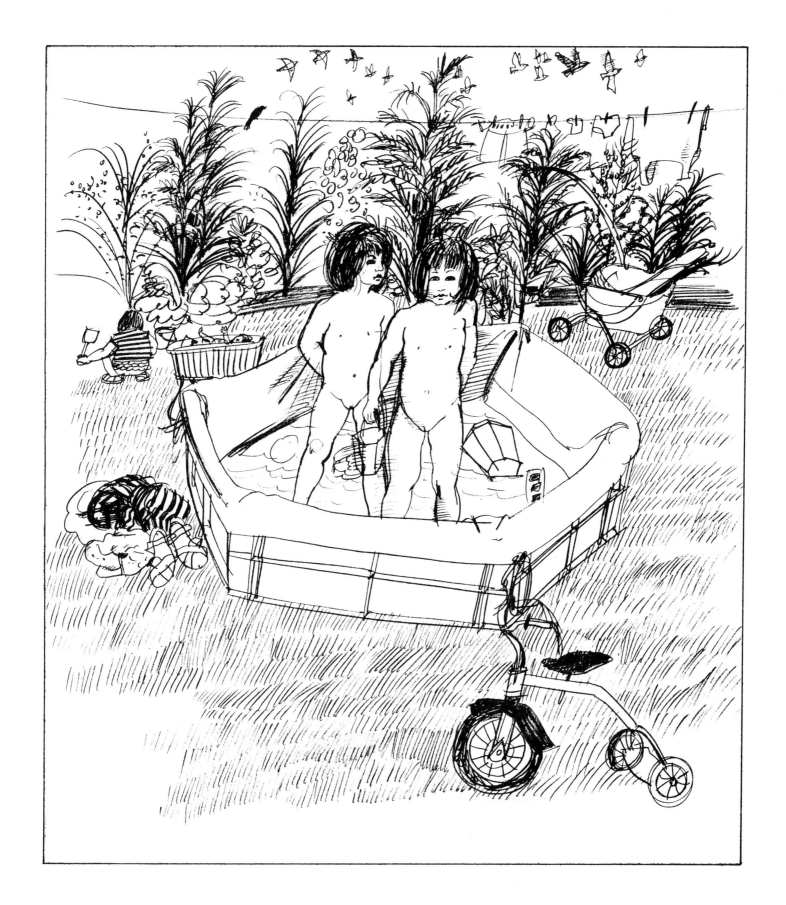

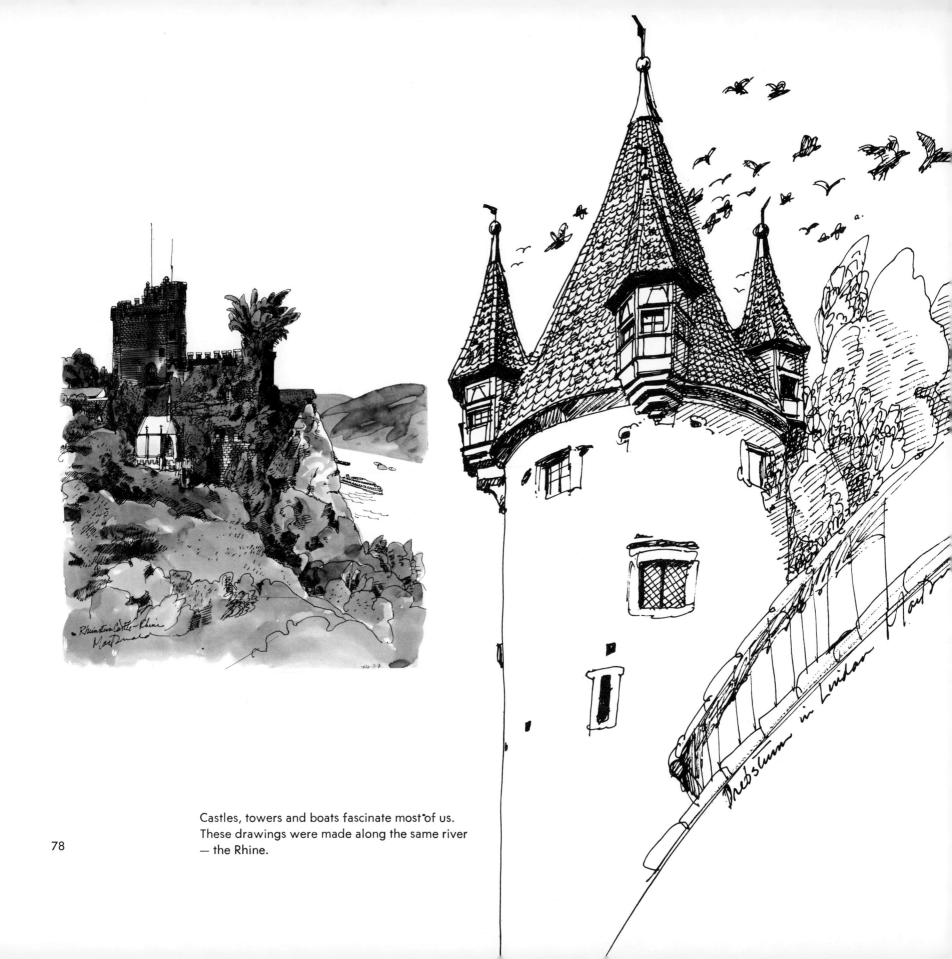

Castles, towers and boats fascinate most of us.
These drawings were made along the same river
— the Rhine.

78

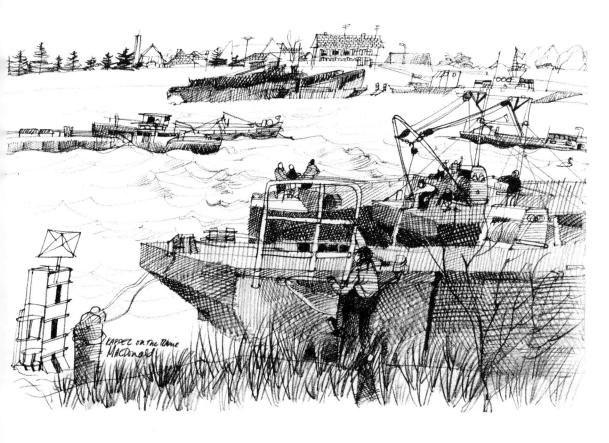

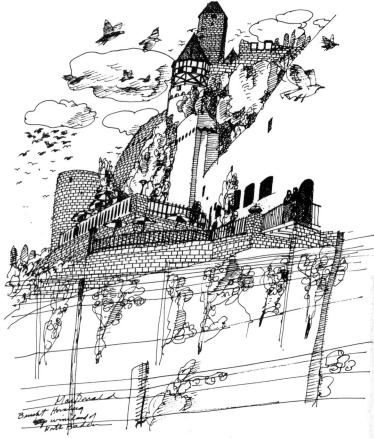

There are many personal theories concerning design and ways of achieving it.

My method of designing is to discover it through the actual **act** of drawing.

I think I'm in good company here, because a master named Ingres worked this way.

When sketching in preparation for paintings, he often changed his mind about a pose or position before the drawing was finished. In some of his sketches one notices three arms on some figures or in a corner a subject whose legs have been redrawn. I'm not suggesting that you go that far, but it is helpful to keep an open mind so you can make changes as you progress.

You may decide that the subject could be described better when shown from different angles and in the process discover a need to change certain elements. No matter how well the artist has studied the subject or prepared for the drawing, things occur in the process to give the design an unexpected "happening" that seems to be beyond one's capabilities. Be thankful when anything like this happens.

This way of working has many similarities to the Impressionists whose keen observation and recording methods were outstanding. The Post-Impressionists such as Bonnard, Munch, Kokoschka and Matisse show us the creative approach to analysis.

79

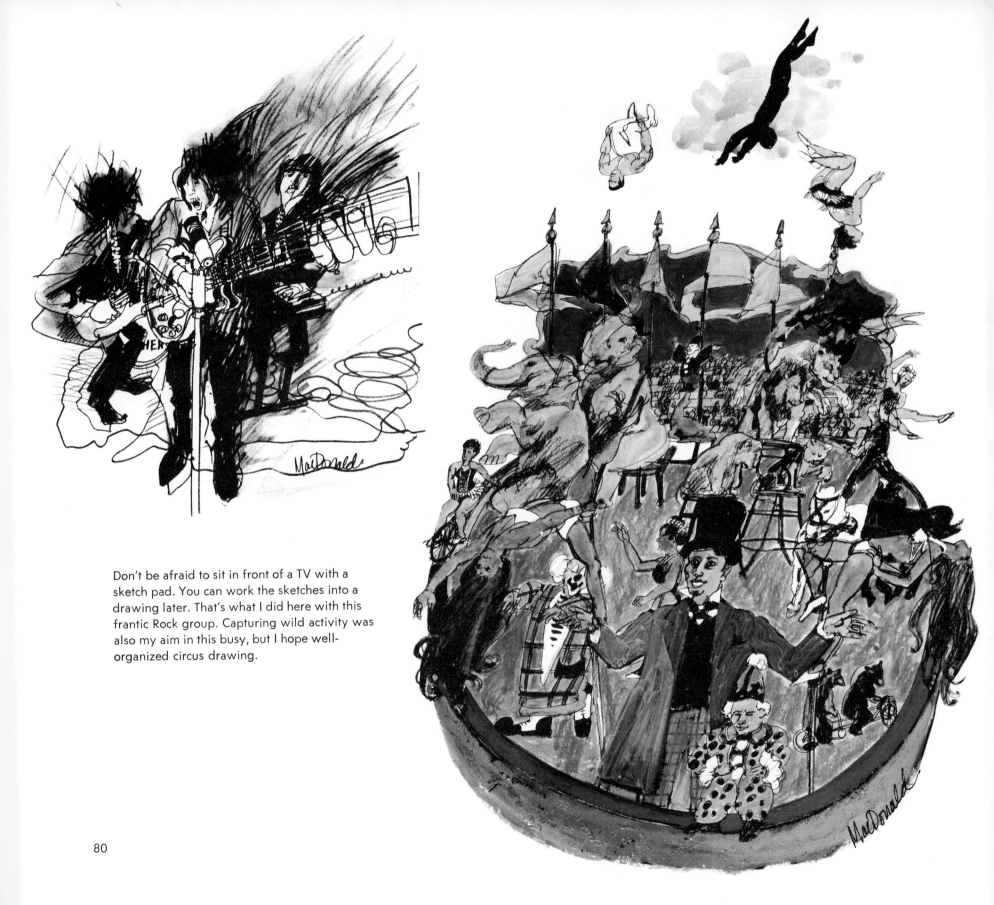

Don't be afraid to sit in front of a TV with a sketch pad. You can work the sketches into a drawing later. That's what I did here with this frantic Rock group. Capturing wild activity was also my aim in this busy, but I hope well-organized circus drawing.

While drawing one afternoon I noticed several kids fishing along a canal. I put aside what I was doing and made this. Learn to be flexible — grab the good scenes when they present themselves.

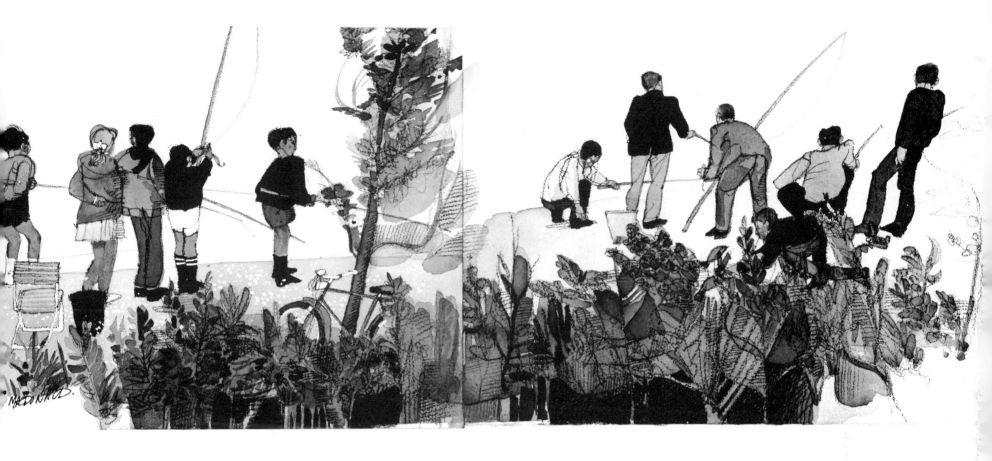

They used their creative powers to simplify shapes, intensify colors, and increase the sense of movement and rhythm in the composition, which is in effect changing and remodeling their subject to fit individual intentions and purposes.

The necessity for change and invention and trial and error in immediate sketching is also a great stimulant for developing one's sense of composition. You'll find yourself devising original ways of juxtaposing and organizing that might not occur if you consciously **set out to compose** in the studio.

This is especially true when the subject is complicated. The period of art which has helped me the most along this line is the period of Persian art (14th-18th Century). Here the elements and details are well organized. When composing, artists of this era often disregarded perspective, so objects have the effect of being stapled on top of one another. The horizons in their paintings were usually high in the composition. These two points help me to arrange the elements in my works to their best advantage and to tell a story better.

continued/P. 92

81

Remember the kids on page 21 — the variety of poses. Don't be afraid to use the same idea more than once when drawing. It can sharpen your concentration.

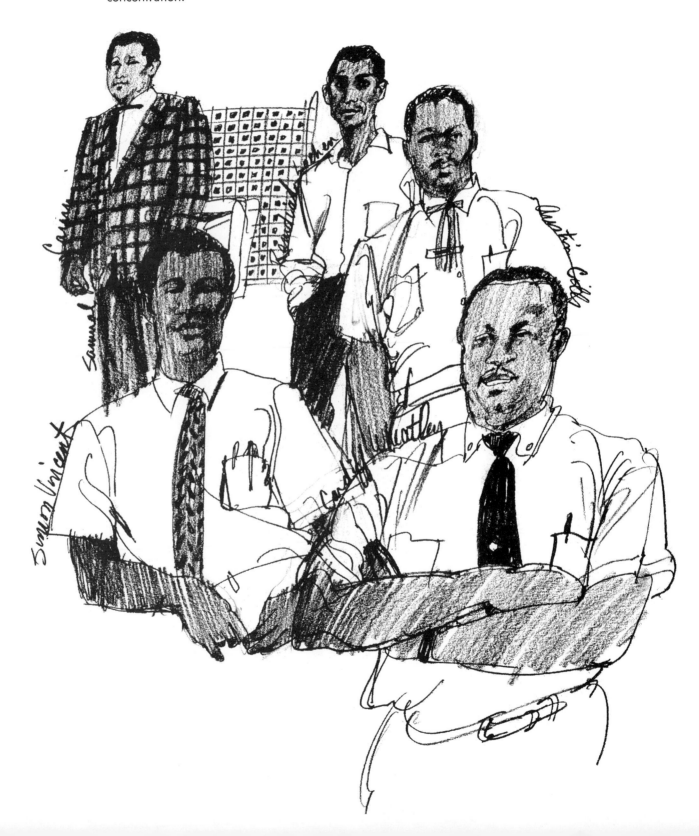

The controlled drawing of the ruins contrasted with the uncontrolled textures of rocks on the side of the hill was visually stimulating. Learn to look for this kind of contrast. It's all around you.

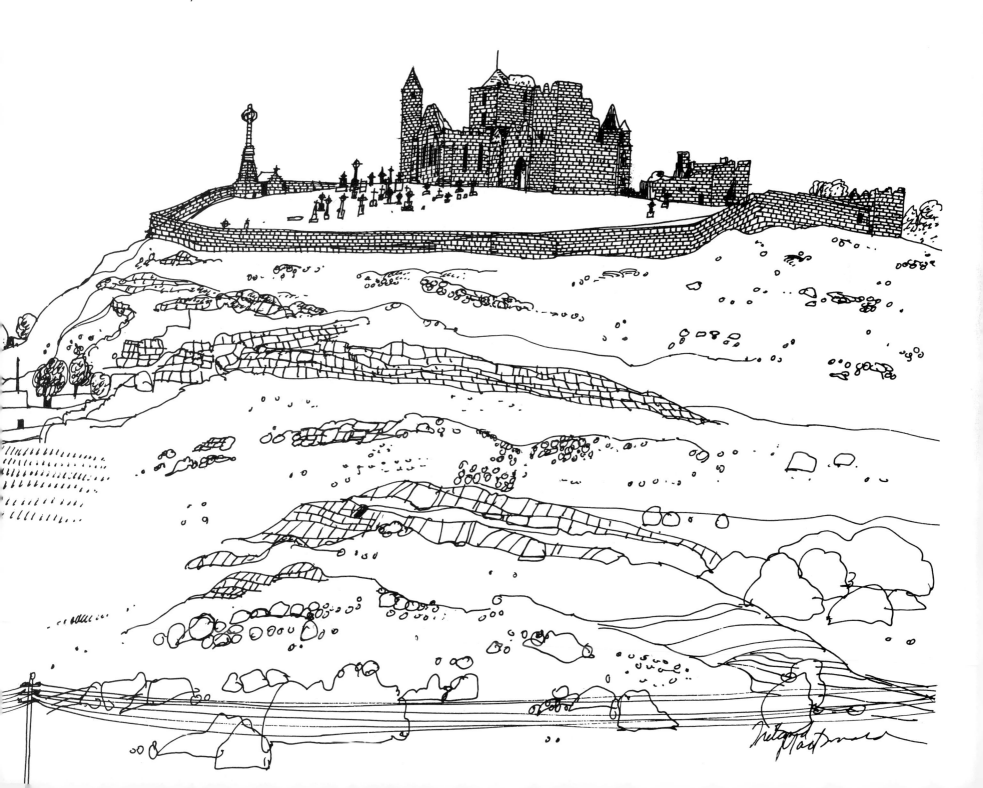

I didn't like this drawing in the beginning because the ellipse wasn't right or rather, it wasn't **true.** But it doesn't matter — it has a right **look.** I now consider it the best part of this picture which didn't quite come off. The trees were executed with magic markers.

POLA - YUGOSLAVIA. MacDonald

Belmonte Castle
La Mancha Spain

In this drawing I realized how important
black areas are when used in combination
with other textures.

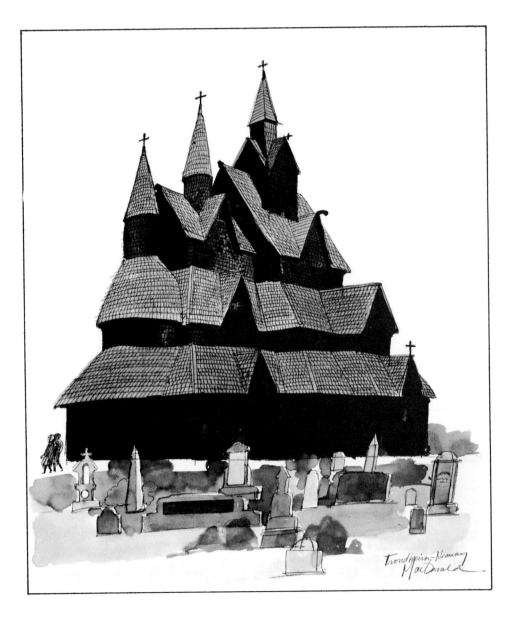

Trondheim-Norway
MacDonald

I find churches a great subject for drawing. They are not only interesting from the point of architecture, but also usually have historical value.

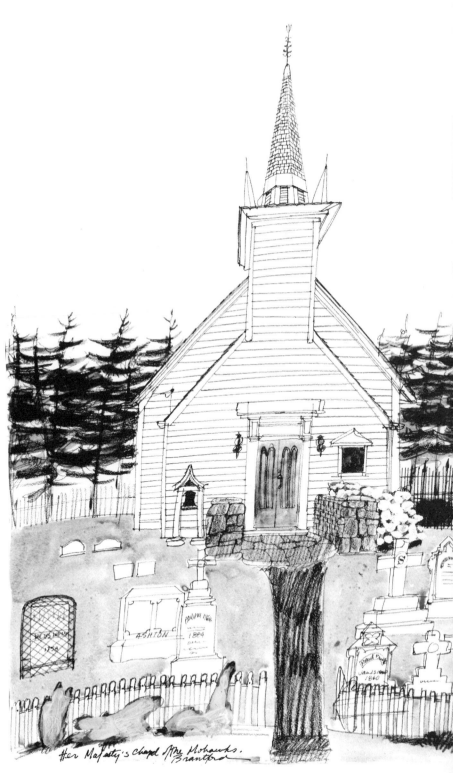

Her Majesty's chapel of the Mohawks.
Brantford

wasn't satisfied with the start of the drawing above and flipped the page. This is one of the first drawings where I used clouds as a definite form like trees or buildings. They become a real part of the picture.

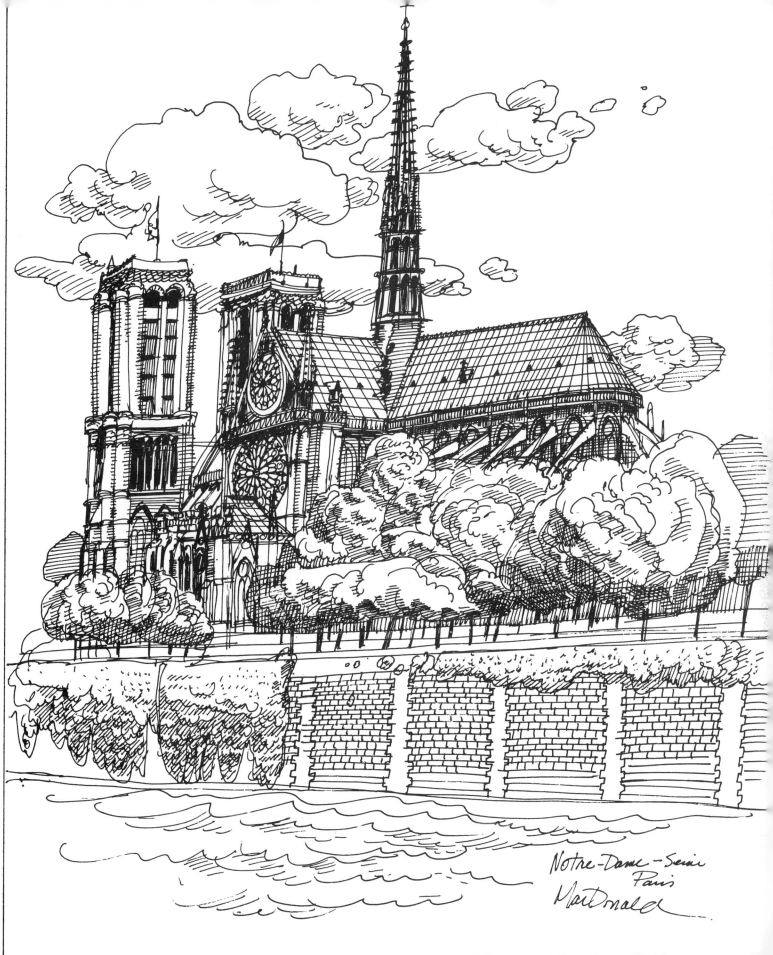

Notre-Dame-Seine
Paris
MacDonald

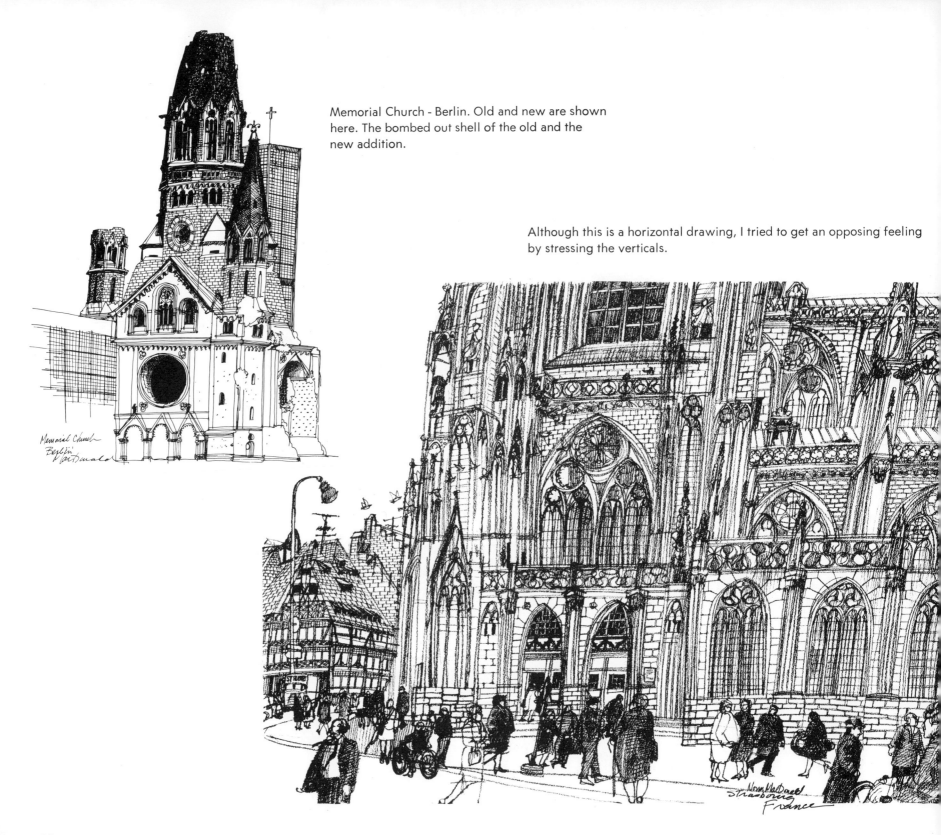

Memorial Church - Berlin. Old and new are shown here. The bombed out shell of the old and the new addition.

Although this is a horizontal drawing, I tried to get an opposing feeling by stressing the verticals.

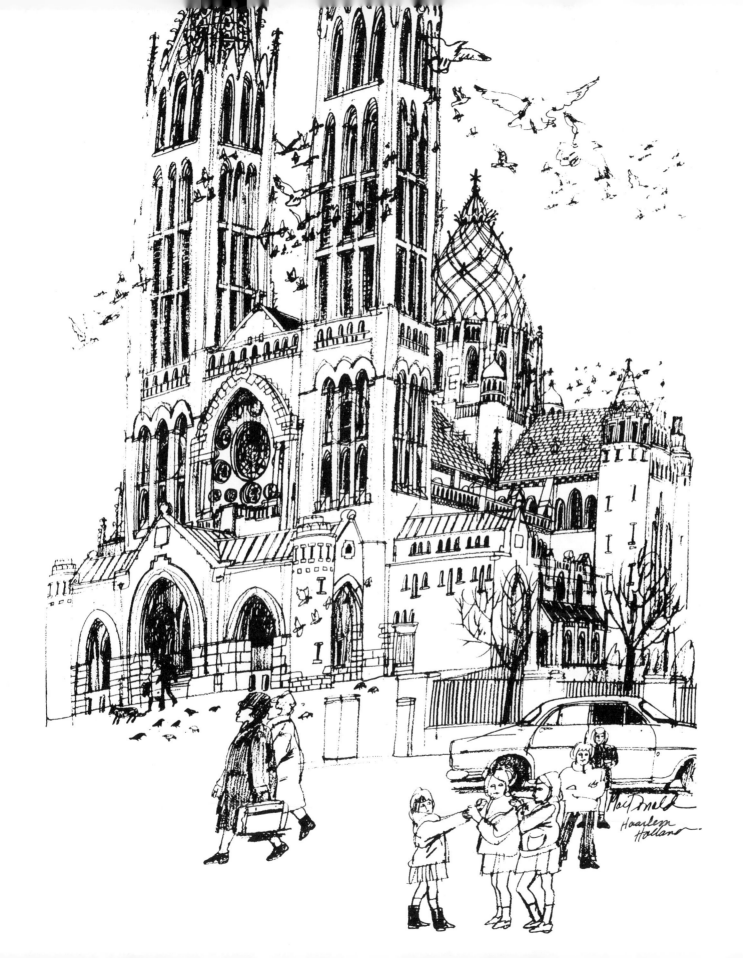

The large dome on the cathedral is a very strong shape. I felt it was too strong and decided to break it up by adding a group of birds. It has the same effect as crossing this area out with lines.

The line at the bottom of the church is important. Below the base line, the area is broken up with the irregular shapes of people and above the base, the area is contrasted by stiff mechanical shapes. You may also find that the back of a church as shown here is just as interesting as the front.

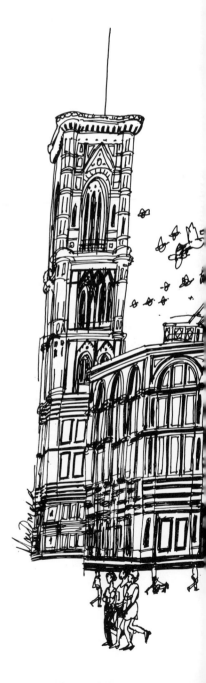

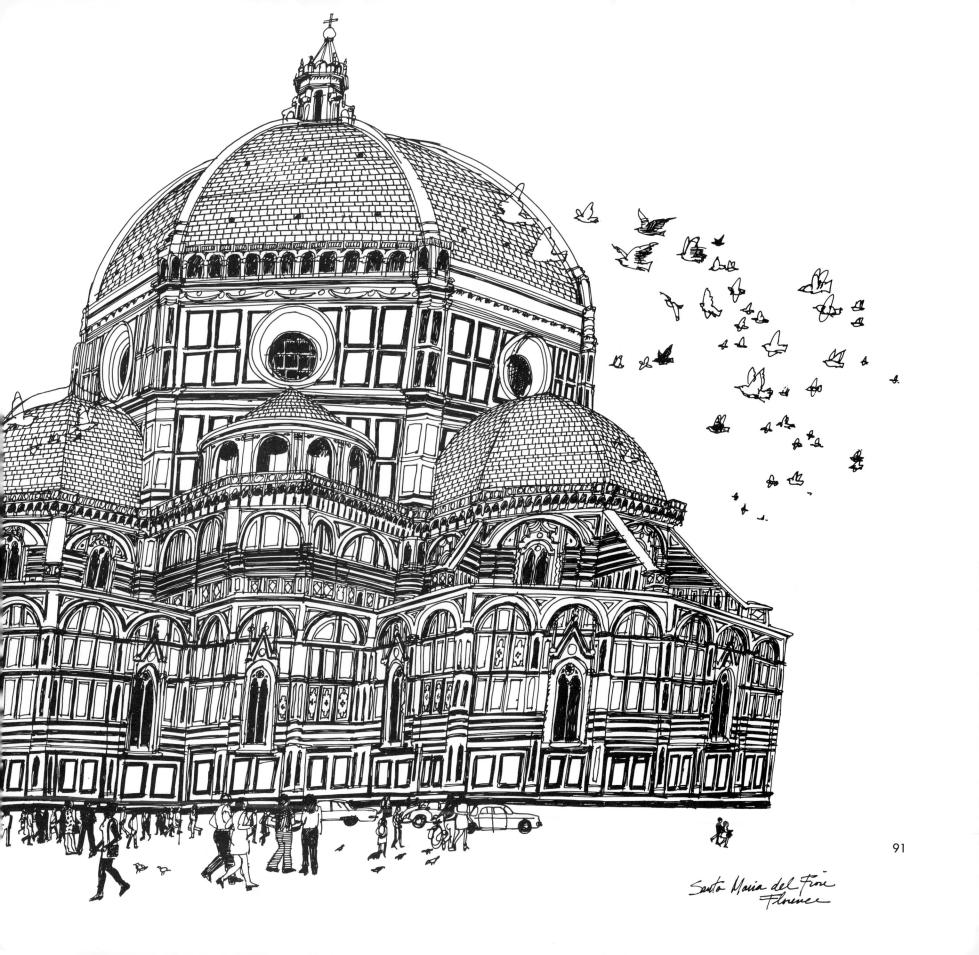

Santa Maria del Fiore
Florence

91

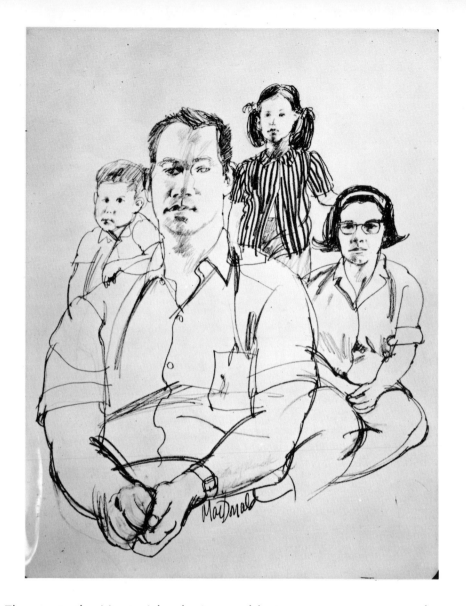

When drawing Bluebeard's Castle in St. Thomas in the Virgin Islands, I was able to overcome many problems by using this approach. Photographers tried to photograph this hilltop resort by shooting from a helicopter. The rich landscape in and around the hotel covered up too many important areas and the problem was complicated also by the fact that part of the landscaping was still under construction.

By walking up and down through the many stairways I was able to draw each building and area in turn. It was executed like a jigsaw puzzle. I was able to part foliage and nudge buildings to give the important areas the necessary exposure. The landscaping also was finished in the drawing.

I think we are a giant step ahead of photographers on this point in that we can leave out irrelevant material and emphasize important areas. The artist can rearrange and assemble at will. The subject is entirely in his hands.

The photographer, on the other hand, though no less an artist, must take the subject as it is. He can get close or stand back, but he cannot avoid irrelevant material by simply wishing it away. The camera is only a mechanical device and the photographer must work within its limitations.

The materials of the artist can do almost anything the mind conceives.

Toulon—France

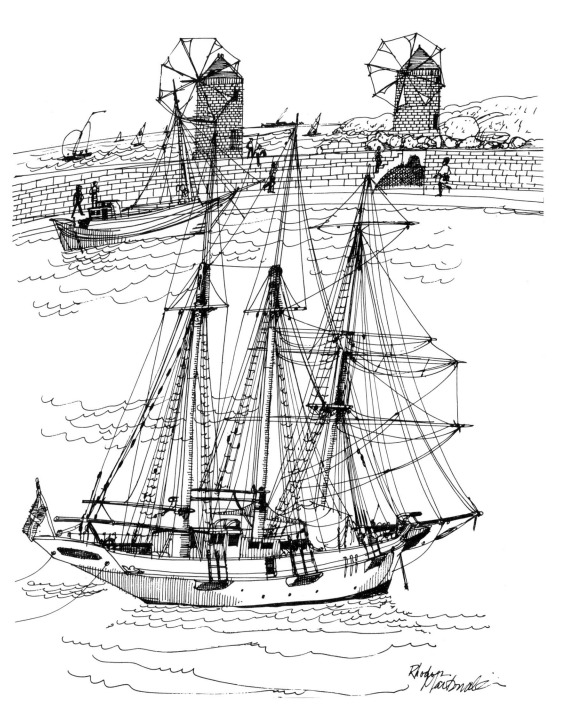

These two drawings were made a few years apart and although they are two different techniques (pen & pencil) I have tried to take uncontrolled detail and give it more discipline and design without getting tight. In other words, I am more interested in what the line **does** than in how I made it.

Rodger MacDonald

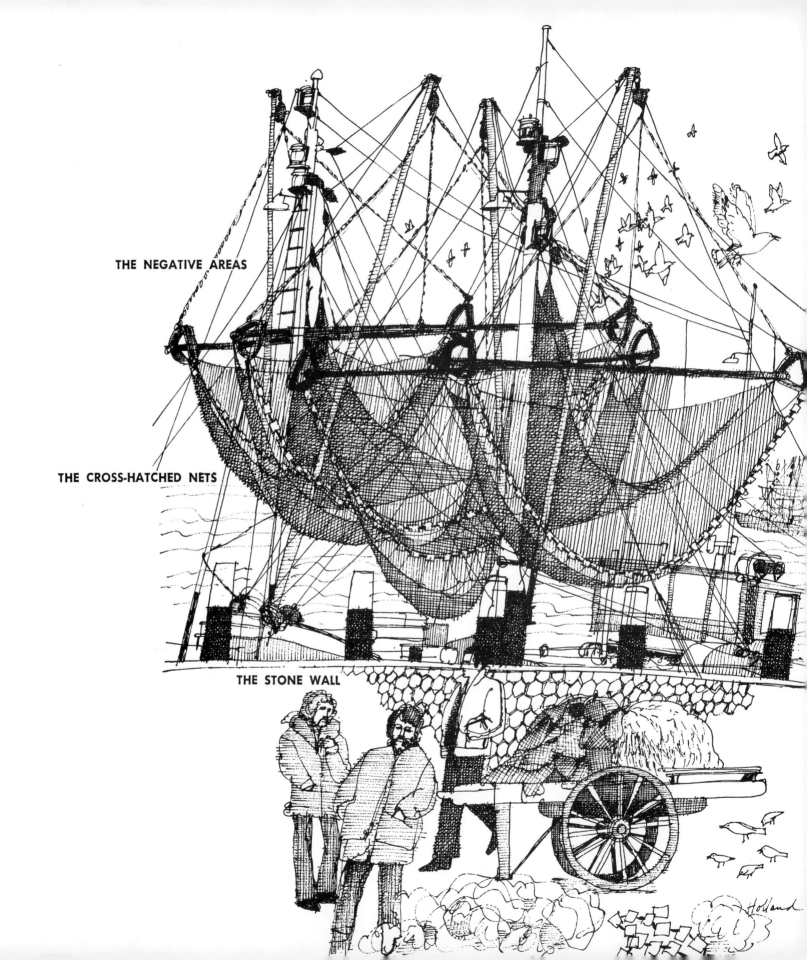

THE NEGATIVE AREAS

THE CROSS-HATCHED NETS

THE STONE WALL

94

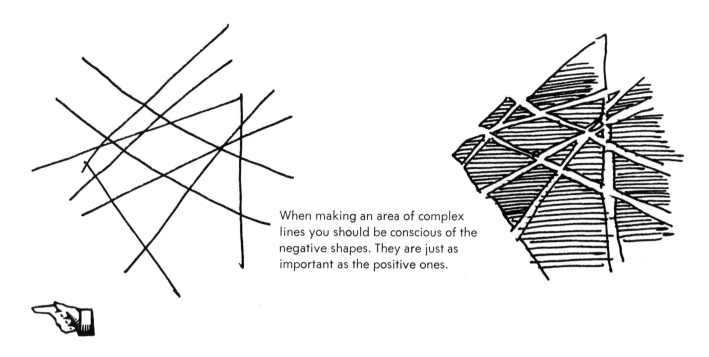

When making an area of complex lines you should be conscious of the negative shapes. They are just as important as the positive ones.

Drawing all the detail of the nets is impossible so you look for a way to simplify and show the texture overlapping. I used cross-hatching which gave me the effect I wanted.

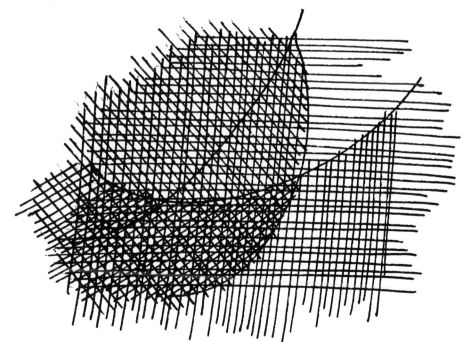

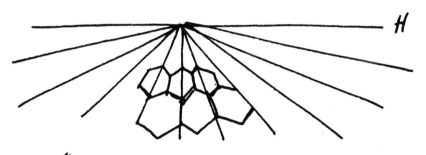

H

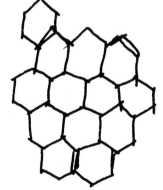

This beehive pattern shows the shape of stones used in Holland mainly for dikes and along the coast. To describe it best, I drew this area as a flat, two dimensional pattern.

95

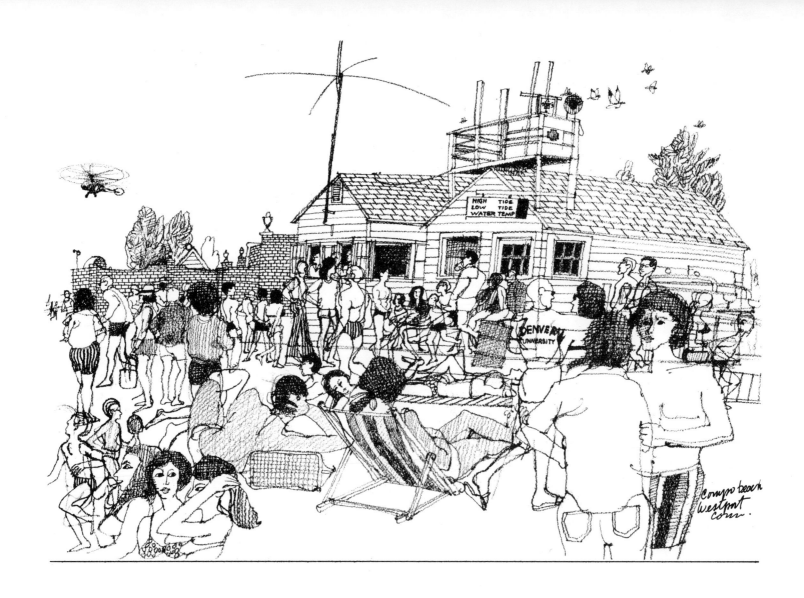

I **suppose it would be a cliche** to recite again how important tools are to any maker of **anything.**

Surely, they are especially important to the artist.

Being proficient is being professional — and we should always point toward that.

Beyond that, a familiarity and ease with materials will allow you to translate your ideas without having to stop and fight what you're working with. Making good pictures is tough enough!

Let's start with the common pencil . . .

I can rarely see that one subject is more suited to pencil or pen or whatever. I myself use pencil most of the time. This is a medium which fits my intentions best when changes are made half way through the drawing. I can erase and rearrange elements without much trouble. One also gets a good range of values with this medium. When I carry the drawing to a more advanced stage where I add washes or paint, the pencil blends nicely with each.

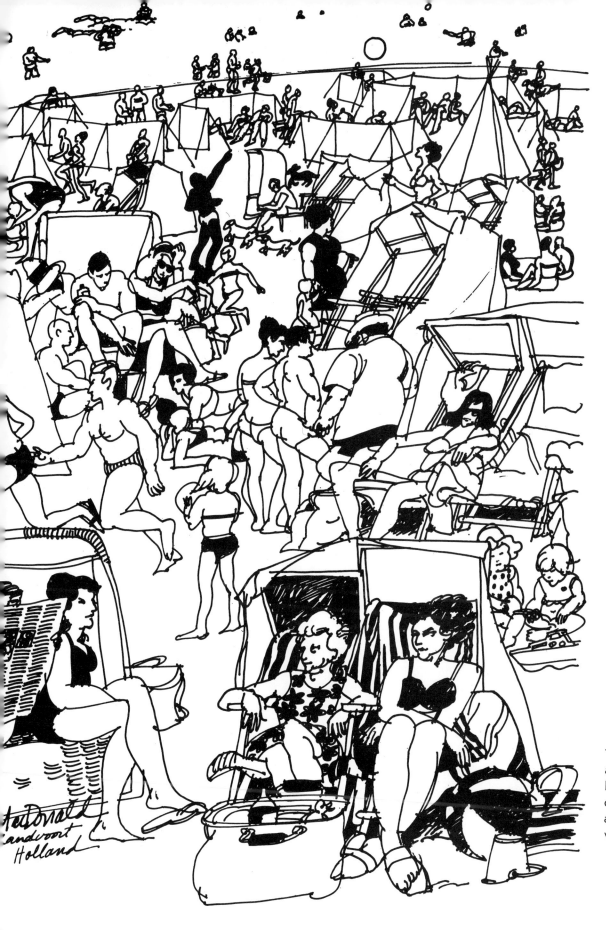

Trying to decide what technique to use on any subject can be a hard decision but don't let it weigh too heavily because even if you can use one drawing instrument better than another you should practice and experiment with all other mediums.

97

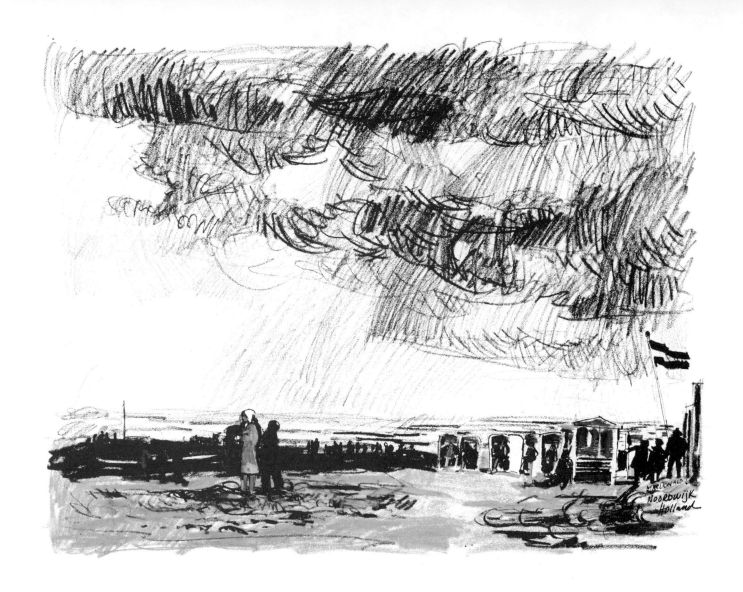

It really boils down to a matter of preference and intention, not a case of which would be better. I usually carry about 20 pencils around with me in the plastic boxes they come in. This offers protection and keeps my pockets clean. I hate to stop to sharpen pencils. Sharpening pencils is a real knack. I like to do it before I leave home where I can take my time.

I also carry a couple of hard pencils (HBH or HB) to help compose elements on the drawing surface. This I do very lightly but lately this practice has become unnecessary. More and more I just plunge in. The drawing itself is usually done with 4-6B pencils.

Another popular medium is charcoal.

When drawing with charcoal I try to avoid the bare sticks because they are too messy. I use those which are in the form of pencils and avoid the hard and soft varieties and stick to the medium grades. I find that I have to fix the drawing at different stages to avoid too much smudging. The advantage with charcoal is that it produces a very strong black line.

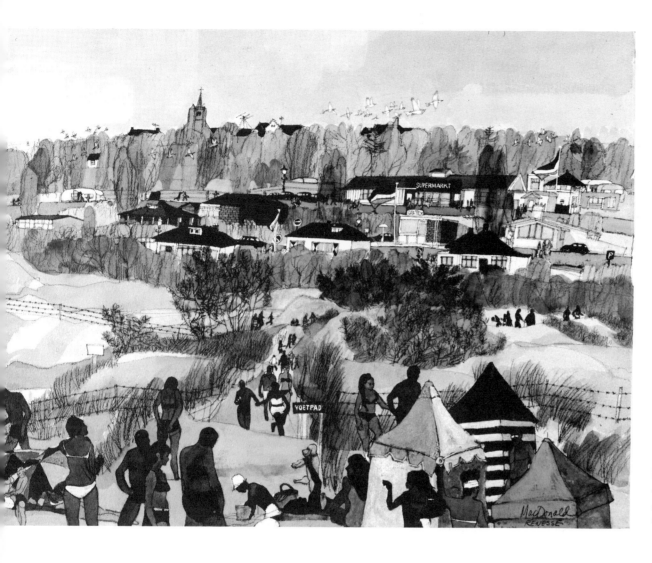

Two more versions of people and beaches — all four places were different — all the moods and techniques are different. The drawing on left was done with wax crayon.

Washes

Washes can be added to drawings in different ways. One is with transparent watercolor or India ink and the other with opaque color or a mixture of both. I add transparent washes to drawings when I draw on watercolor paper or other porous surfaces. I work always from the lightest washes to the darker ones and usually make several thumbnail sketches of values before I begin.

Pen drawings are usually executed on smoother surfaces so I use an acrylic black as the medium for adding washes. I can water it down to resemble watercolor, but I avoid loading the brush too much because the surface isn't too absorbent. As the values get darker, the paint becomes naturally thicker. You can also create textures with this medium if necessary.

Lately I've been using rapidograph pen a lot on porous surfaces. I have to draw slower because the line breaks easily, but I spend more time looking at the subject. The porous surface (usually bond pads) allows the ink to dry quickly and avoids smudging. With this kind of drawing I add color and tones with inks.

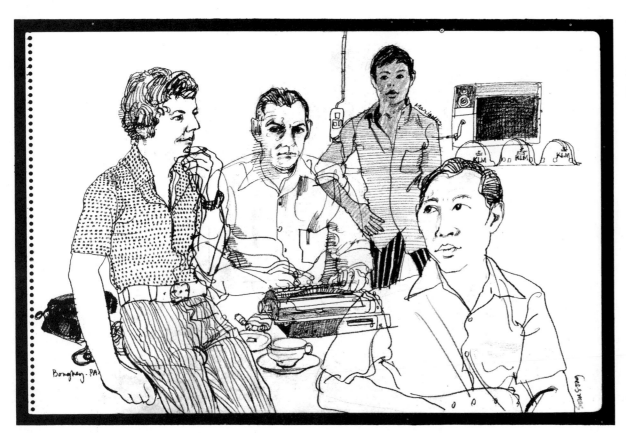

While sketching Karl Ross, a construction boss in Thailand, other people connected with the building began dropping by. The drawing soon became a group portrait.

The collage here began as a drawing on illustration board. The purpose was a advertisement for a Dutch newspaper. So I decided to turn it into a collage using printed newspaper. I made a tracing of the figures and taped it over the drawing so as to retain the features when I covered them with pieces of newspaper. The tracing was a register check while I was working.

Fixatives

Pencil and charcoal drawings must be sprayed with a fixative to keep them from smudging. I try to fix them on the spot because the drawings tend to rub against one another during transportation. If the drawing is large, it is better to fix it at different stages of development. Use a workable fixative because you never know when you may need to add something you forgot or to rework values, textures, forms, etc.

Drawing Surfaces

When you draw on paper I suggest you use pads. They usually have a hard backing which is a good support. Drawing pads can be obtained in a great variety of sizes and surfaces. The individual sheets in a pad don't rub together as much as loose sheets of paper. If you tend to work large, thin illustration board is good to use and allows you to carry more. Thick watercolor paper is another solution (640 g.). It is thick enough to support itself and thin enough to carry several sheets at one time.

When I travel I usually carry my illustration board and pads in wrapping paper or a carrying case with handles. A cheap cardboard carrying case which gives good support to the illustration board or paper is available.

I also carry a small fold-up fishing stool with me when drawing outside. This stool allows me to move around with ease and also offers the most comfort when drawing.

100

continued/P. 106

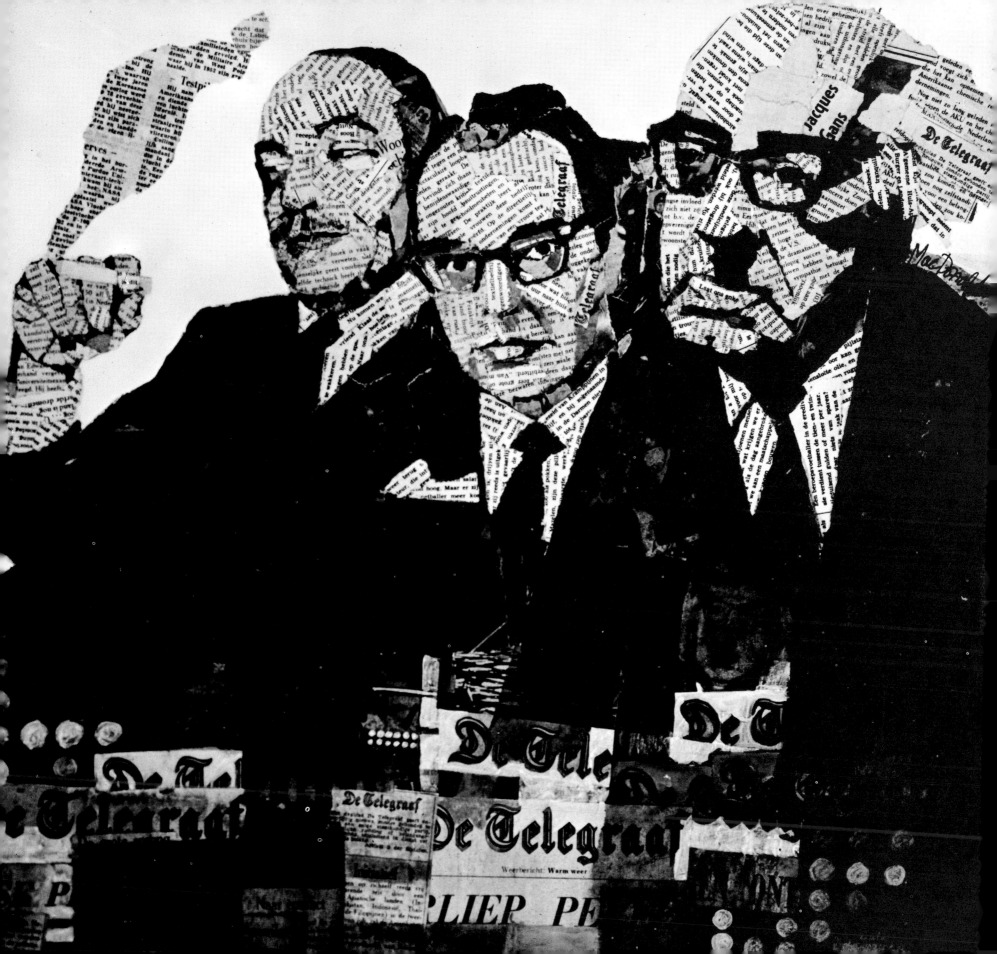

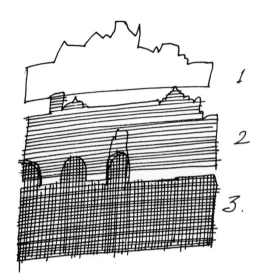

1

2

3.

To tell the viewer about Spalding, in England, I drew from 3 places which were important. The perspective gets flattened but the visual story is clear. The drawing is made over a period of time and space to fit into a visual plan.

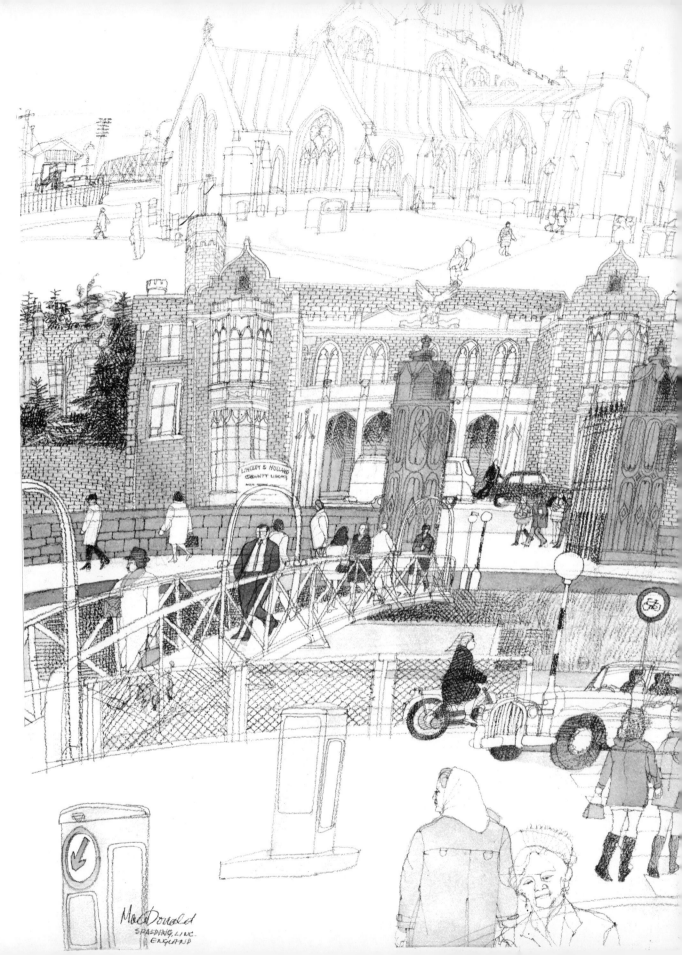

Compare the position of the Citroen in the diagram (which was visually correct) to the finished painting below. Again the perspective suffered, but it gave me the freedom to select and position many of the moving objects. The result is actually a long time exposure made by the human eye.

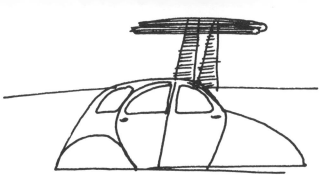

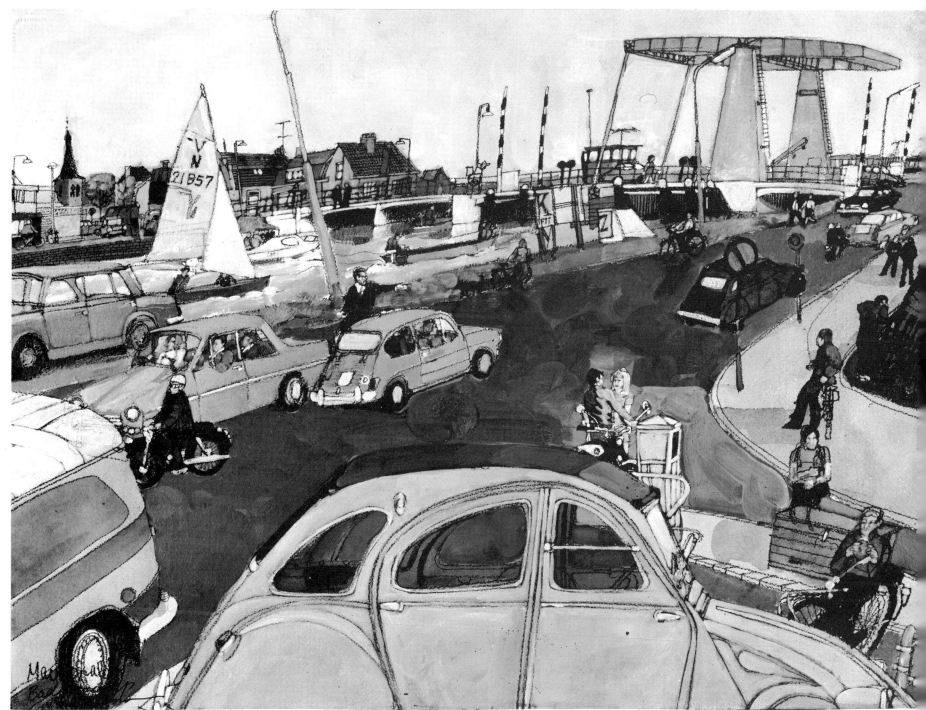

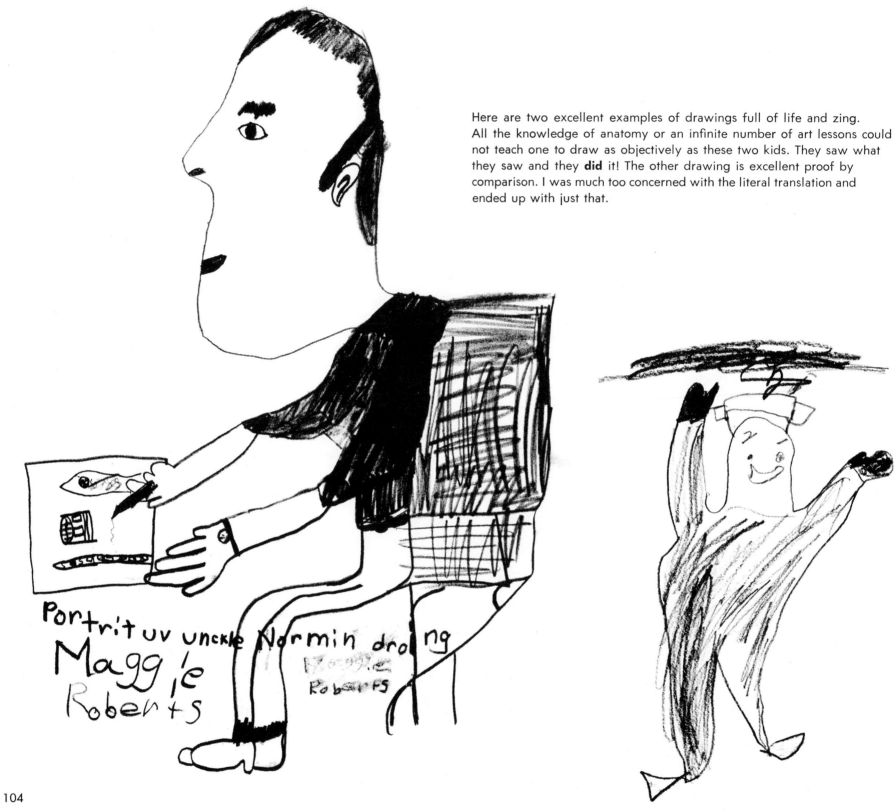

Here are two excellent examples of drawings full of life and zing. All the knowledge of anatomy or an infinite number of art lessons could not teach one to draw as objectively as these two kids. They saw what they saw and they **did** it! The other drawing is excellent proof by comparison. I was much too concerned with the literal translation and ended up with just that.

Portrit uv uncxle Normin droing

Maggie Roberts

GALILEO GALILEE

LEONARDO DA VINCI

DANTE ALLIGHIERI

Florence

Color

Any mediums which belong to the category of paint, I put under the title of color. I can't separate one type of paint from another because I sometimes use several in one picture. When I begin with watercolor, however, I like to stick with it throughout the whole painting.

My usual procedure is to paint until I get a certain value pattern set up. Then I get to the point where I start backing up and lightening some colors and then begin working on the darker values. This is best done with acrylics. You can thin the paint to the consistency of watercolor or thicken it so it resembles oil paint from the tube.

This medium also is fast drying and can be used on any surface. Sometimes I like to add crayons for texture or watercolor for glazes at this stage. I usually try to create the darkest values with pencil because I can do this gradually until I'm satisfied.

Another way I darken values is glazing with washes until the color has reached the right value.

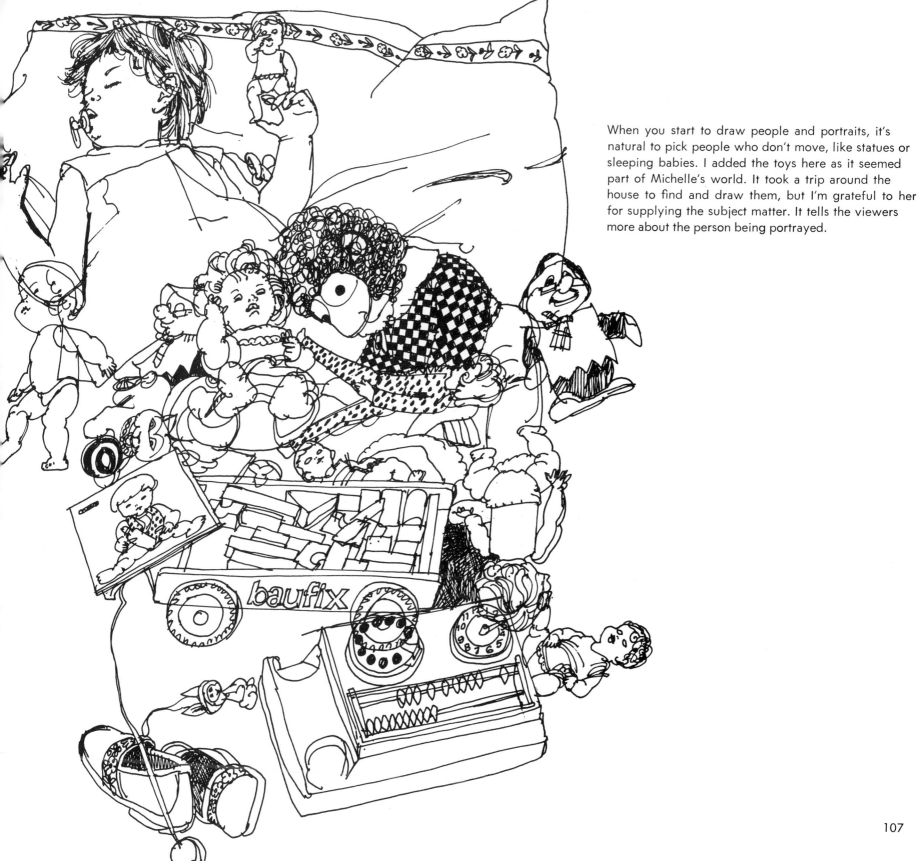

When you start to draw people and portraits, it's natural to pick people who don't move, like statues or sleeping babies. I added the toys here as it seemed part of Michelle's world. It took a trip around the house to find and draw them, but I'm grateful to her for supplying the subject matter. It tells the viewers more about the person being portrayed.

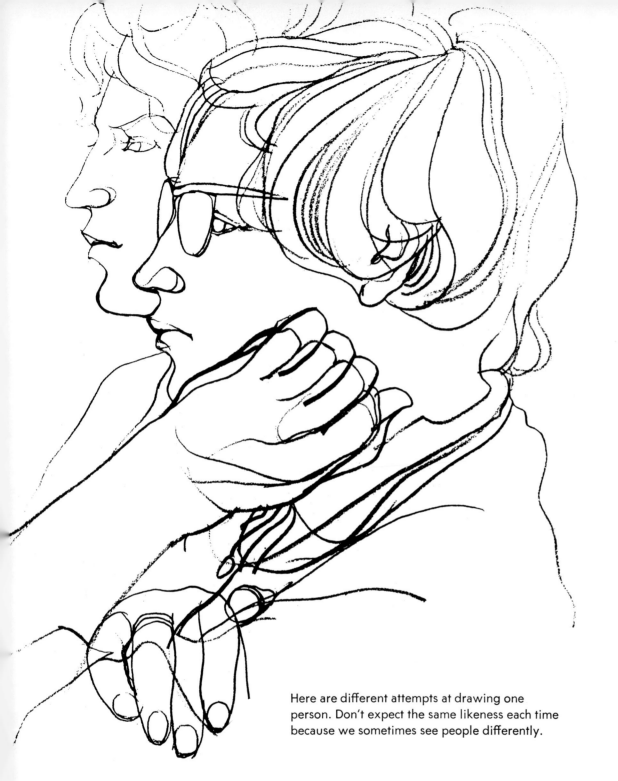

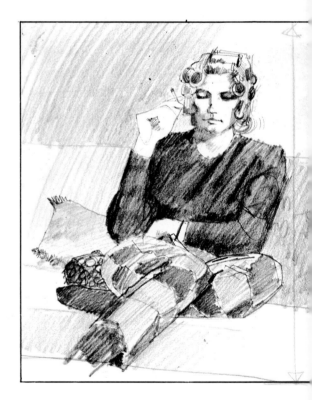

Here are different attempts at drawing one person. Don't expect the same likeness each time because we sometimes see people differently.

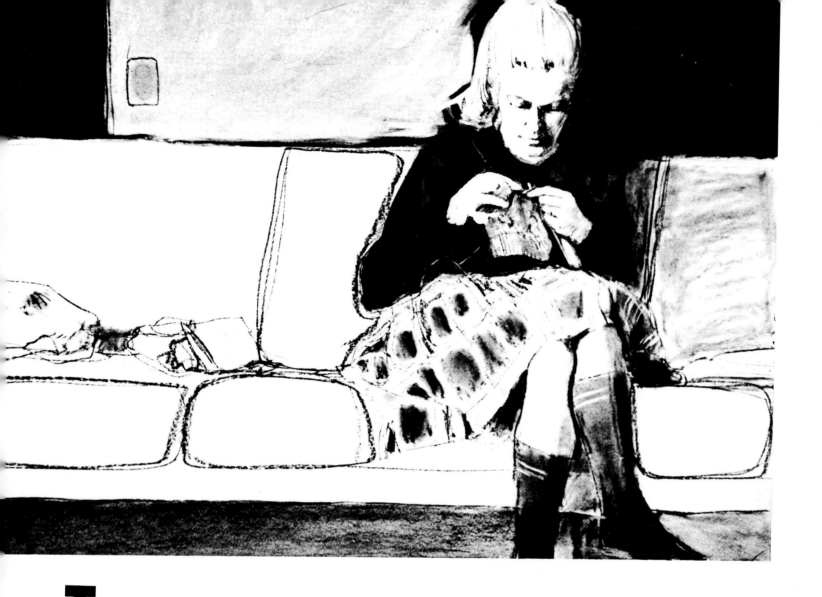

To me, drawing might be a meaningless exercise if I couldn't use it to record the world around me. The world I record is different from your world. Our private little worlds help each of us to create a personal identity. This is becoming increasingly important in an era of mass production and increased standardization.

To observe and record goes beyond the point of proficiency, although this is very important in the beginning. I believe art begins where proficiency leaves off and from this point on we are susceptible to our true inner selves. What we believe or observe we can state more surely. This has been called by many names: confidence, professionalism, talent or just "your thing." Being close to our thing, it is impossible to escape that which interests us more than it does others.

Having special interests is both natural and advantageous. Having an obsession to draw our special interests really means being a bit of an egomaniac. All artists possess this to some degree. Once, while watching speakers at Hyde Park in London on Sunday morning, it struck me that artists have a lot in common with soap box orators. They have to comment on subjects (good or bad).

Drawing group portraits of friends can be interesting because you are drawing several people in one picture and naturally trying to succeed with all. At the same time you must also be conscious of composition and other qualities of a picture.

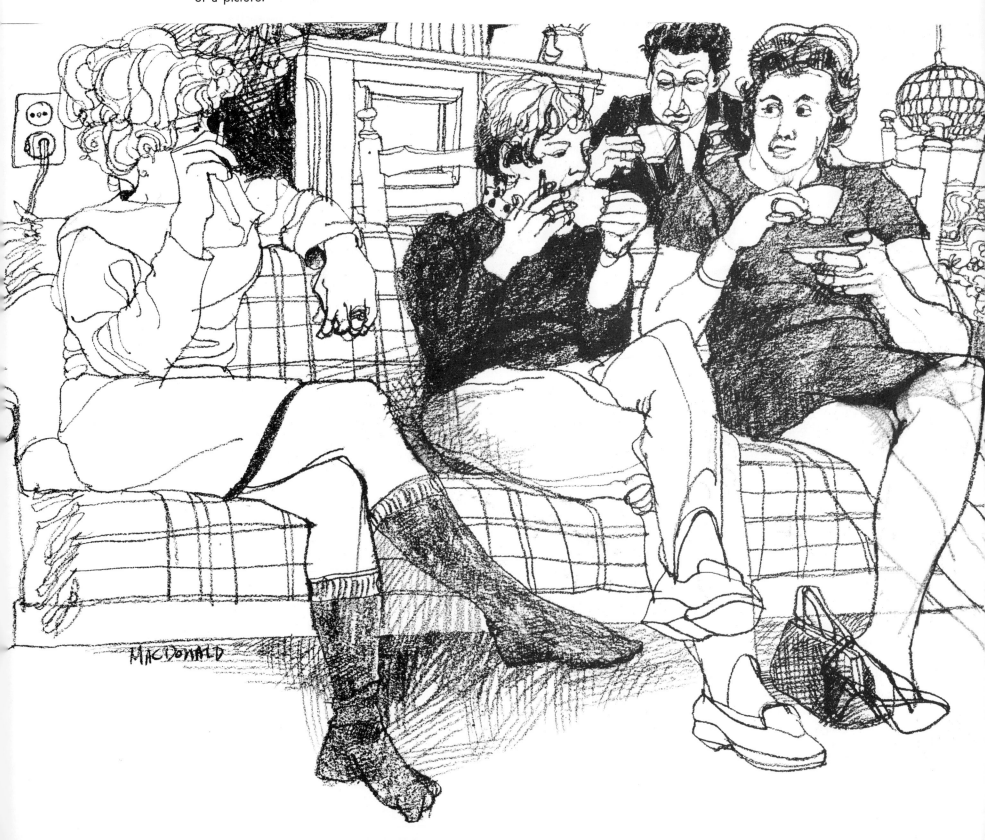

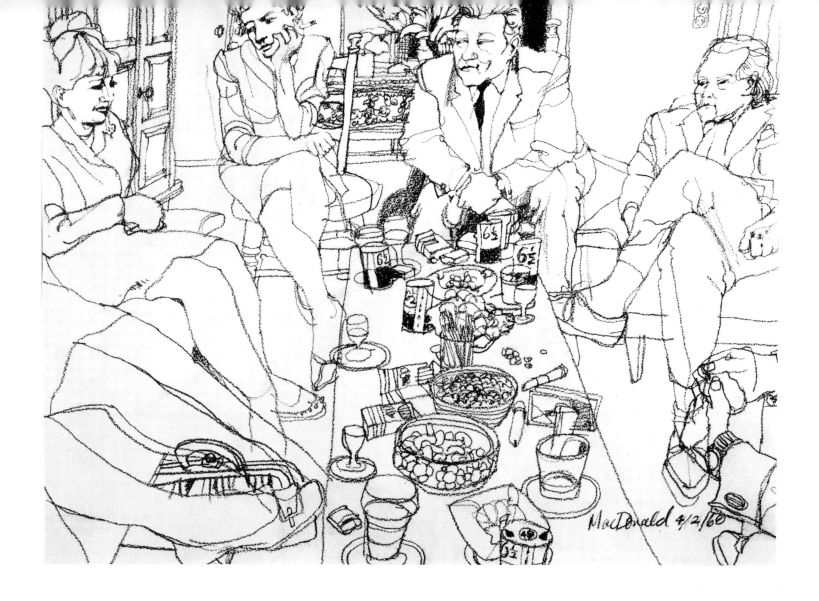

Many persons believe an artist is an individual with a God-given ability that makes anything he does good. Not so. Years of practice lie behind a good artist. Without drawing day after day, even the most talented lose their touch. Like an athlete, an artist gets out of shape by not keeping active. I find if I don't draw for a few days I have trouble achieving my usual standards.

When observing subjects I like, I really analyze how I would state it in line or color. My eye follows the shapes and textures my pen or pencil would make on paper. This may include people, faces, architecture, trees, etc. But my drawing usually comes out different than the actual image in my mind. This is my proof that theory and practice are quite isolated from one another. When drawing people in a relaxed mood, such as at the beach or on vacation, I prefer to show a general mood rather than to get too involved in detail.

With other subjects, like auto racing, I like to get close, even to the point of showing the wear and tear. I became interested in auto racing when drawing the Grand Prix in Monaco. The setting was perfect: tropical climate, fast cars, good looking women, a leading gambling center, royalty, a past that suggested international intrigue, then the Grand Prix. I really had all the encouragement I needed.

continued/P. 116

These two portraits have an important subtle addition. The area around the subjects tell a story. To the left is a portrait of my father and family. He has always worked hard and I tried to give his hands an important place in the picture. The face doesn't have to be the only element of likeness. In both drawings I wanted the eye to roam around the picture.

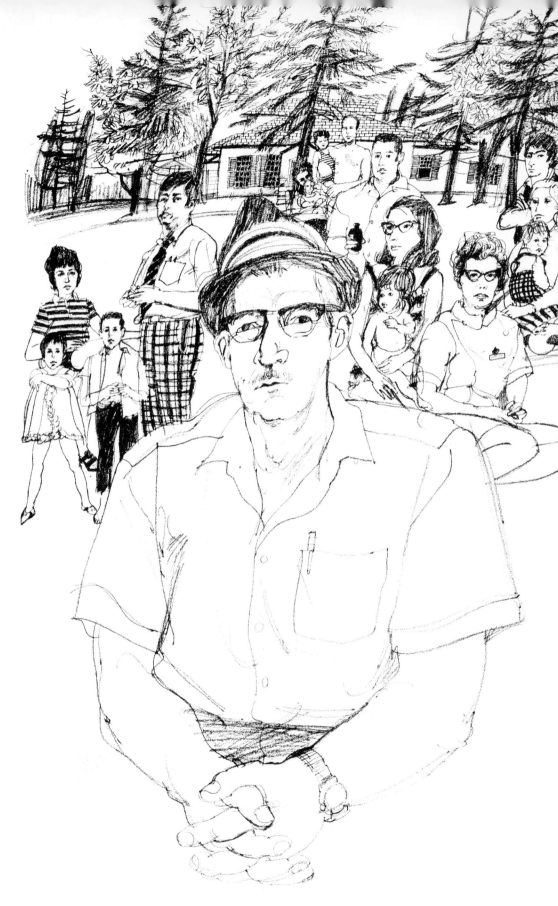

Often in portraits I make the head the focal point of the picture with background drawing. Don't think that if you are drawing a mechanic, he has to have a wrench in his hand, or a professor, an armful of books.

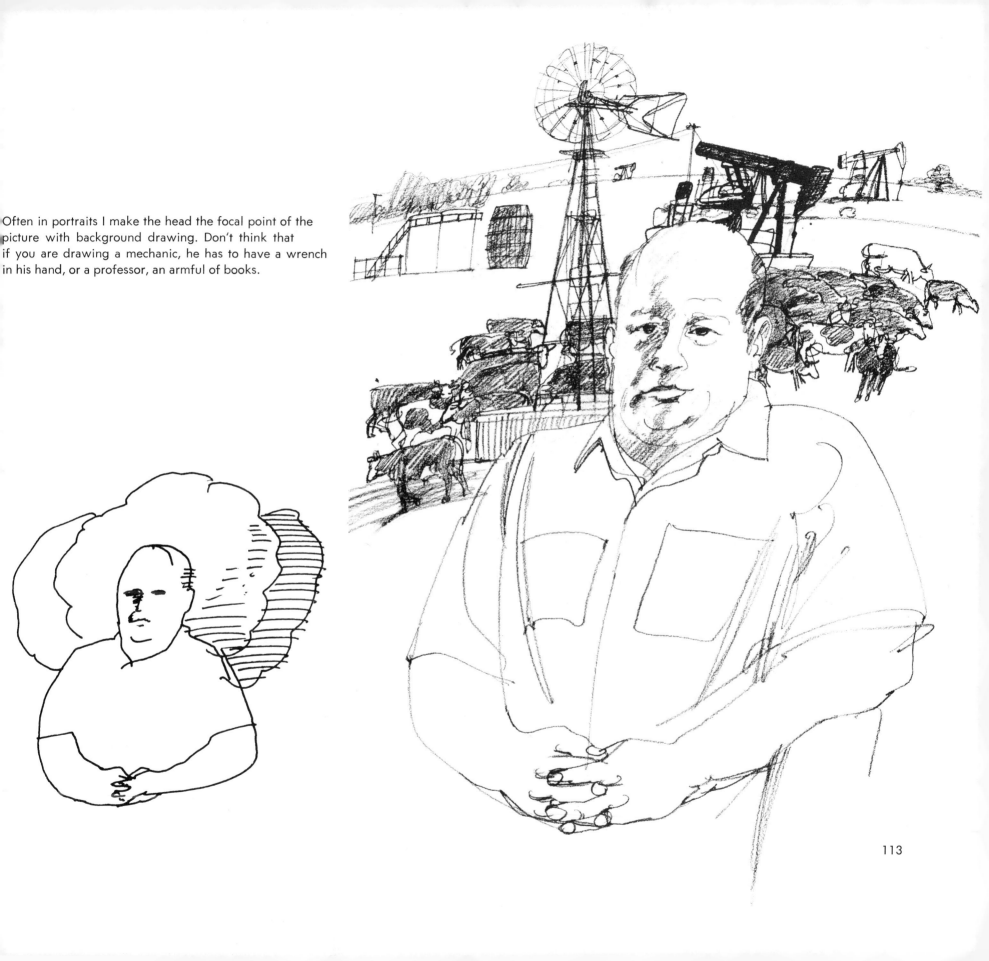

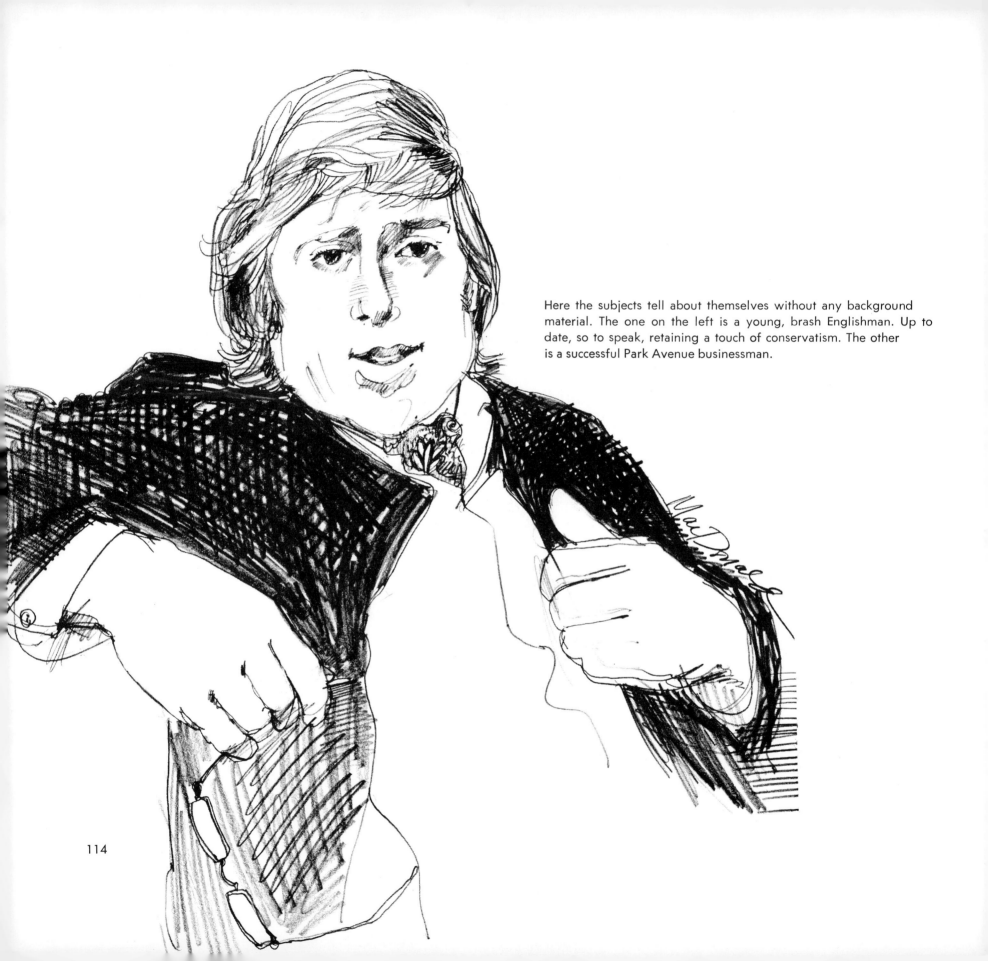

Here the subjects tell about themselves without any background material. The one on the left is a young, brash Englishman. Up to date, so to speak, retaining a touch of conservatism. The other is a successful Park Avenue businessman.

114

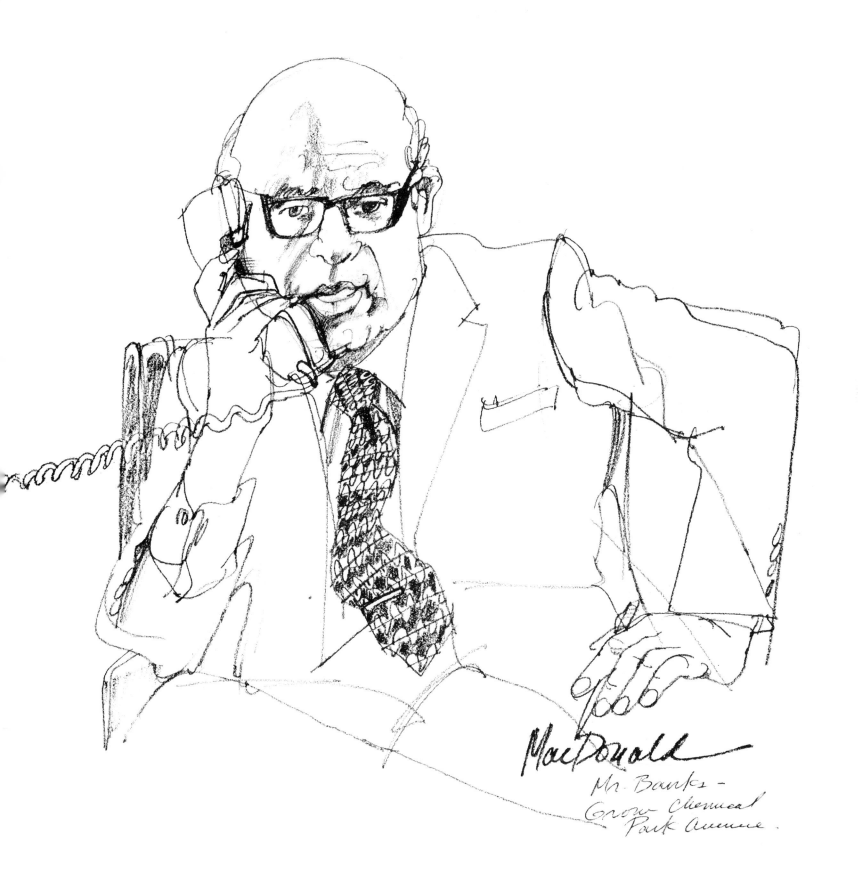

MacDonald

Mr. Banks –
Grow Chemical
Park Avenue.

115

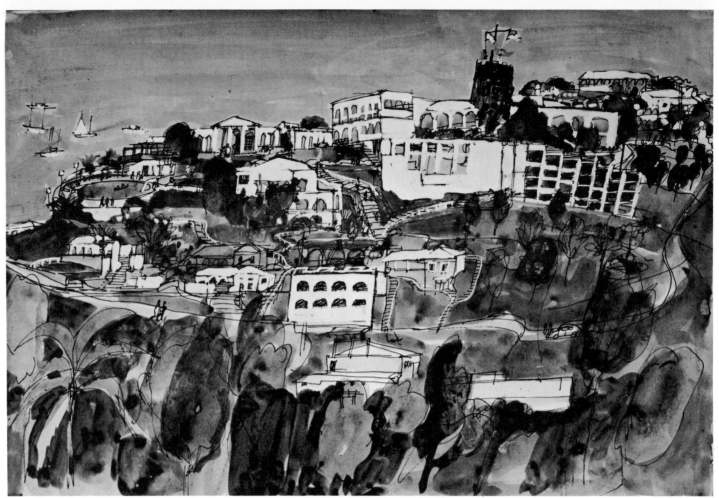

Bluebeards Castle, St. Thomas V.I.

I learned a great deal during Grand Prix races about developing an on-the-spot drawing into a finished painting without transferring from one surface to another. I learned what needed to be done at the moment, what can be jotted down as notes, what can be memorized and how to incorporate many aspects of a subject into one picture. Doing extra drawings will push us to try new things.

Experimenting has led to other on-the-spot assignments such as architecture, landscape, industrial, travel and, of course, other Grand Prix races. It also has been an important factor in subjects where imagination plays a strong role, especially biological, automation, and space assignments.

These last examples involve some kind of super mechanical or automotive processes. An artist must treat this type of subject in his own fashion, through his own private world, so to speak. I try to execute it spontaneously with as little planning as possible. I devise my own panels, wiring, buttons and shapes as I go along. The only requirement is that it convey an impression of the real thing, which the average person may have felt was complicated and confusing. The artist's reaction to the subject here is as important as the subject itself.

116

While looking for the best vantage point to draw this picture, I simply walked around and made the sketch on the left as I went along.
When I came to do the finished version below most of my problems were solved and I was able to concentrate mainly on drawing.

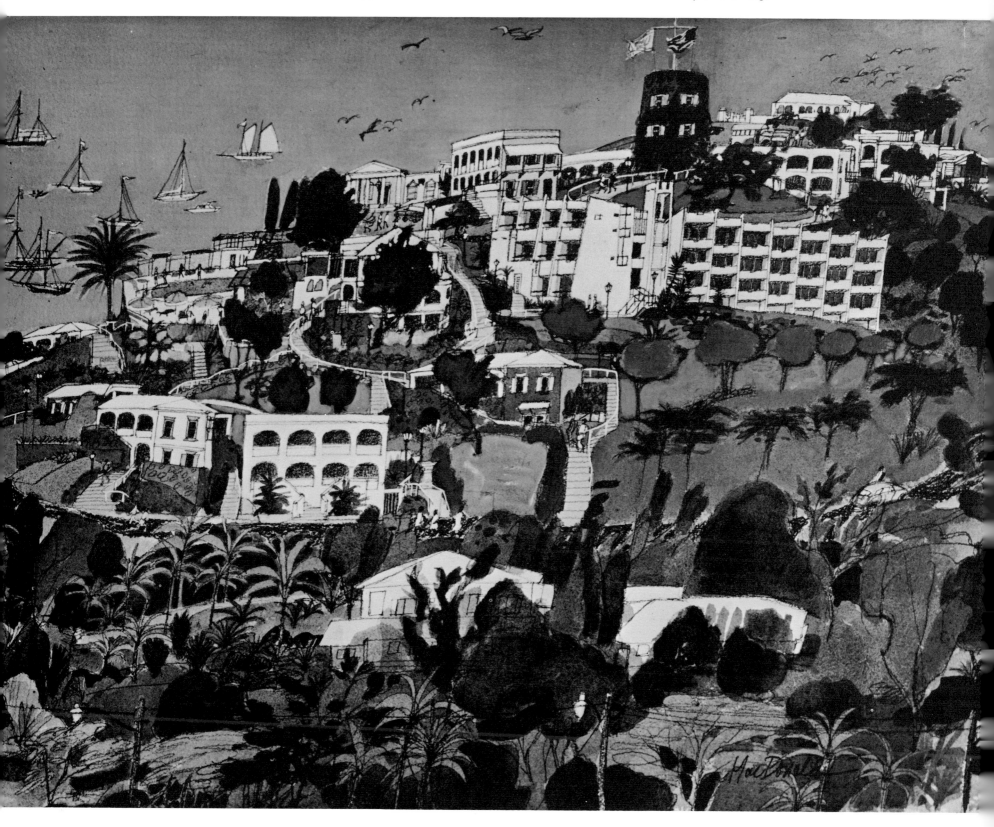

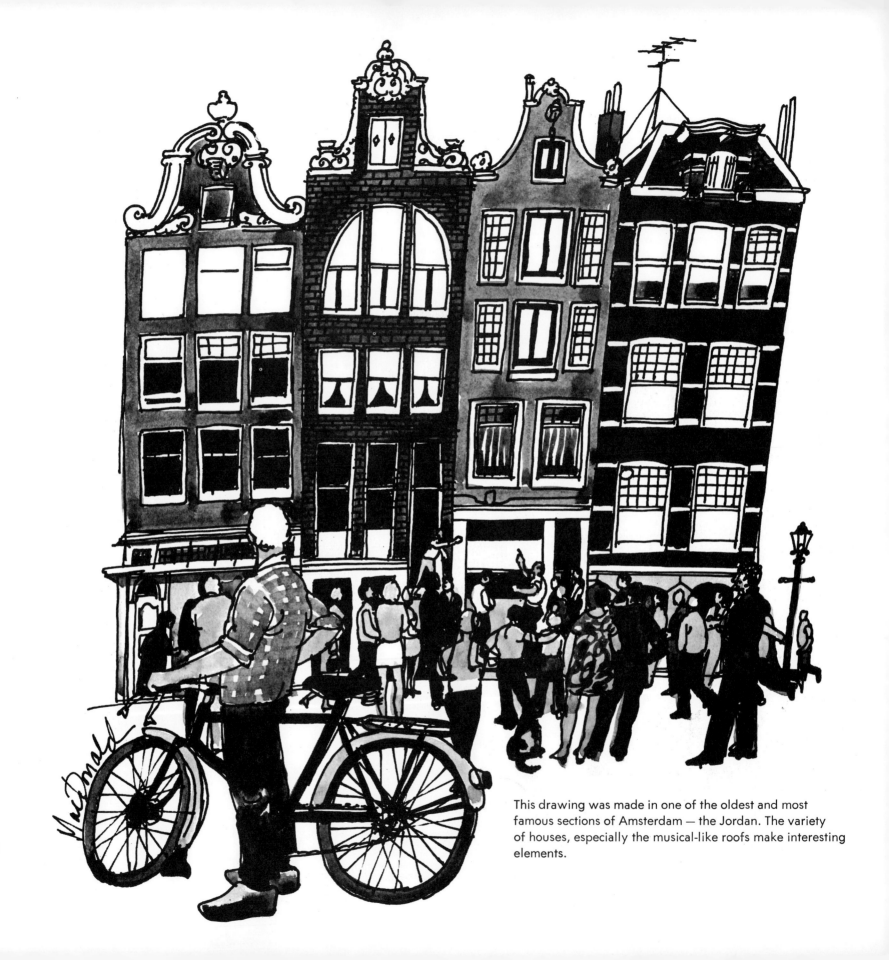

This drawing was made in one of the oldest and most famous sections of Amsterdam — the Jordan. The variety of houses, especially the musical-like roofs make interesting elements.

The form of the bridge and the gondolas gave me the opportunity to create a focal point and an idea for the composition.

When you are away from home, you have to improvise at times. The tones were added in the bathroom of a hotel room in Milan because the light in the room was too weak. It was fixed with a tin of hairspray. But I did manage to deliver the drawing on time.

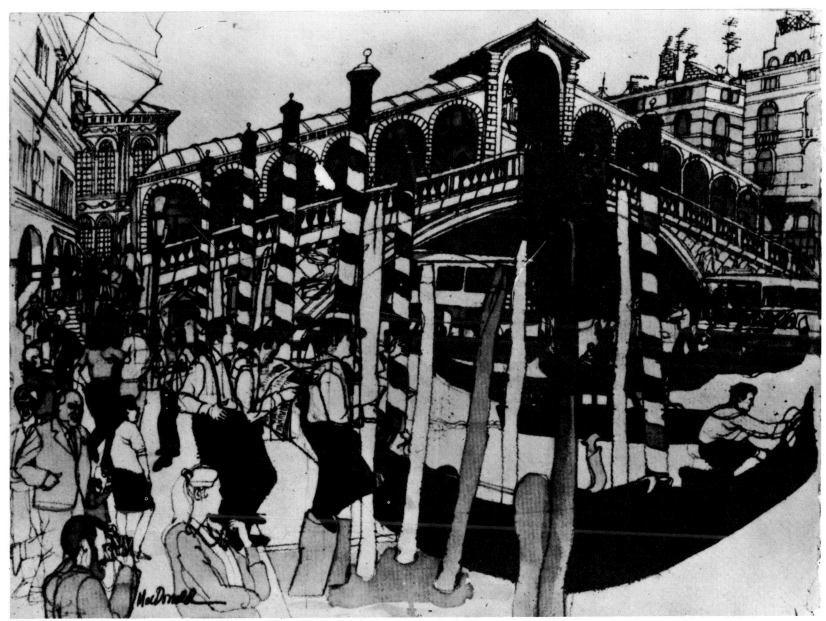

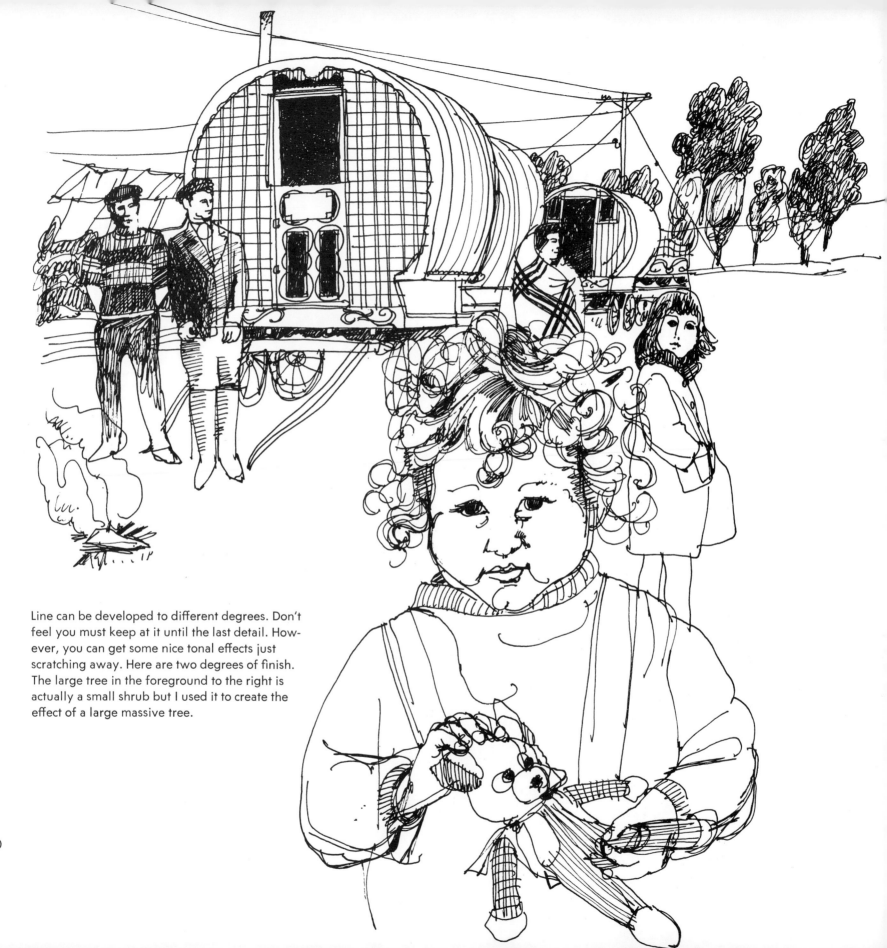

Line can be developed to different degrees. Don't feel you must keep at it until the last detail. However, you can get some nice tonal effects just scratching away. Here are two degrees of finish. The large tree in the foreground to the right is actually a small shrub but I used it to create the effect of a large massive tree.

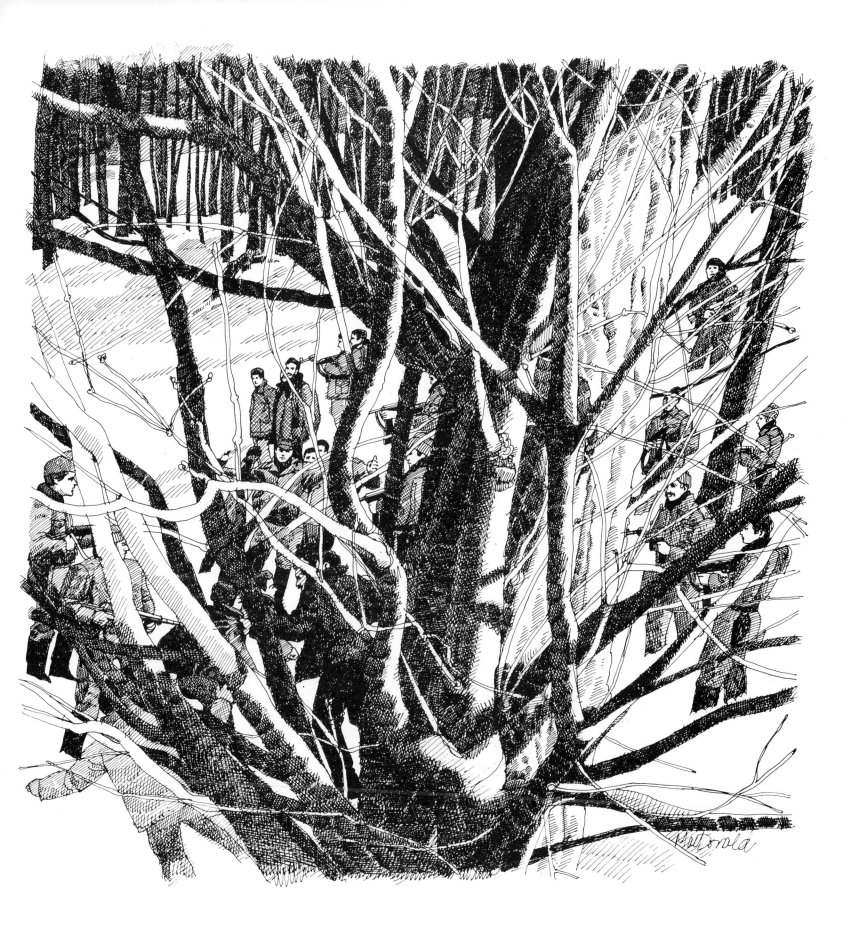

Drawing interiors should present no more problems than drawing outdoors. Try not to get caught up into making an architectural drawing.

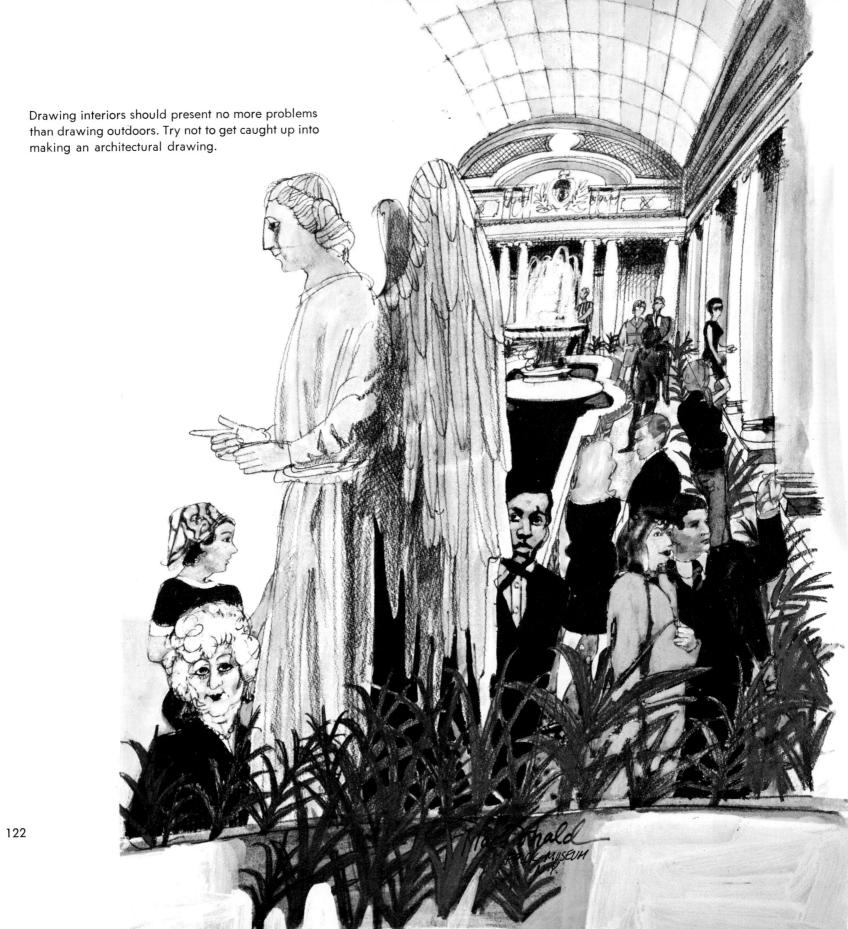

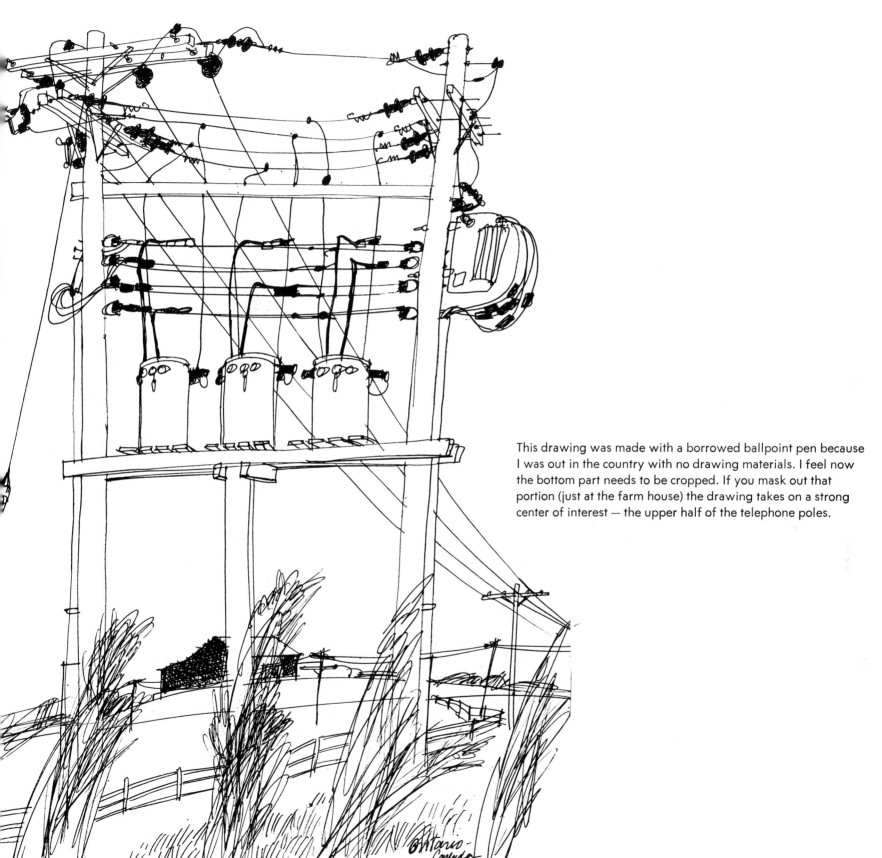

This drawing was made with a borrowed ballpoint pen because I was out in the country with no drawing materials. I feel now the bottom part needs to be cropped. If you mask out that portion (just at the farm house) the drawing takes on a strong center of interest — the upper half of the telephone poles.

123

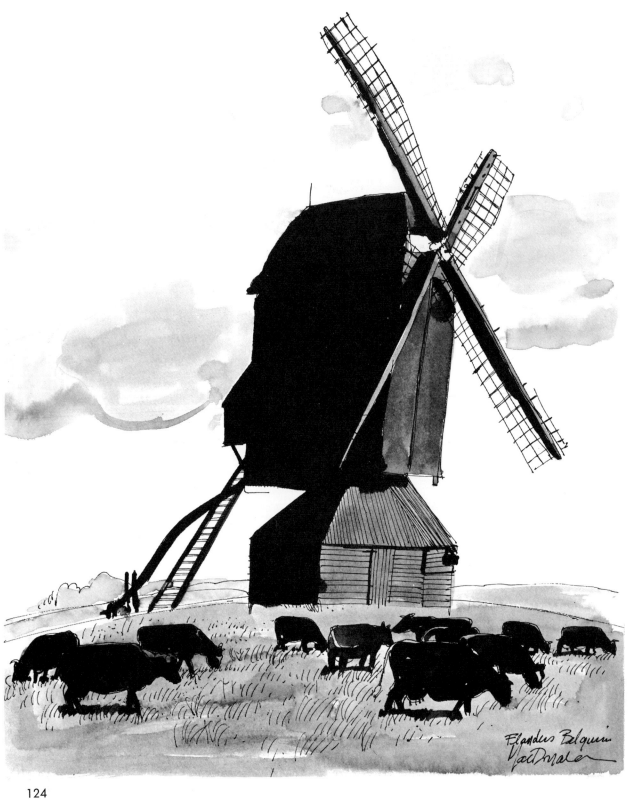

Flanders Belgium
MacDonald

124

Windmills are interesting subjects. Like churches, they have many styles. Having lived many years in the Netherlands, I've had many chances to observe them closely. Windmills are common to many countries but with the coming of electricity and electric pumps, they're rapidly becoming obsolete.

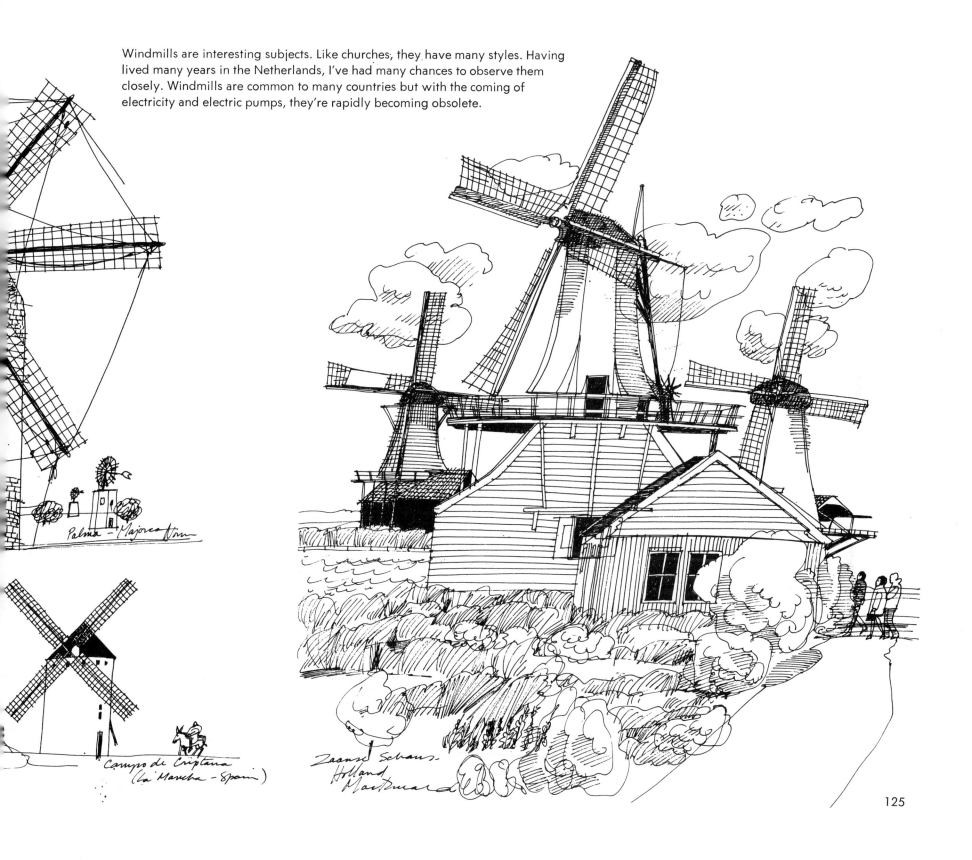

Palma - Majorca

Campo de Criptana
(La Mancha - Spain)

Zaanse Schans,
Holland
Markmaa

This, believe it or not, is a wedding card I designed for a friend. It is one of two cards. On this one I wanted to show the two together in some way. You can read the progression from the first basic thoughts to the final drawing. Designing requires a lot of refining — at least the way I do it. Now, some of the preliminary stages look as good as the finish.

127

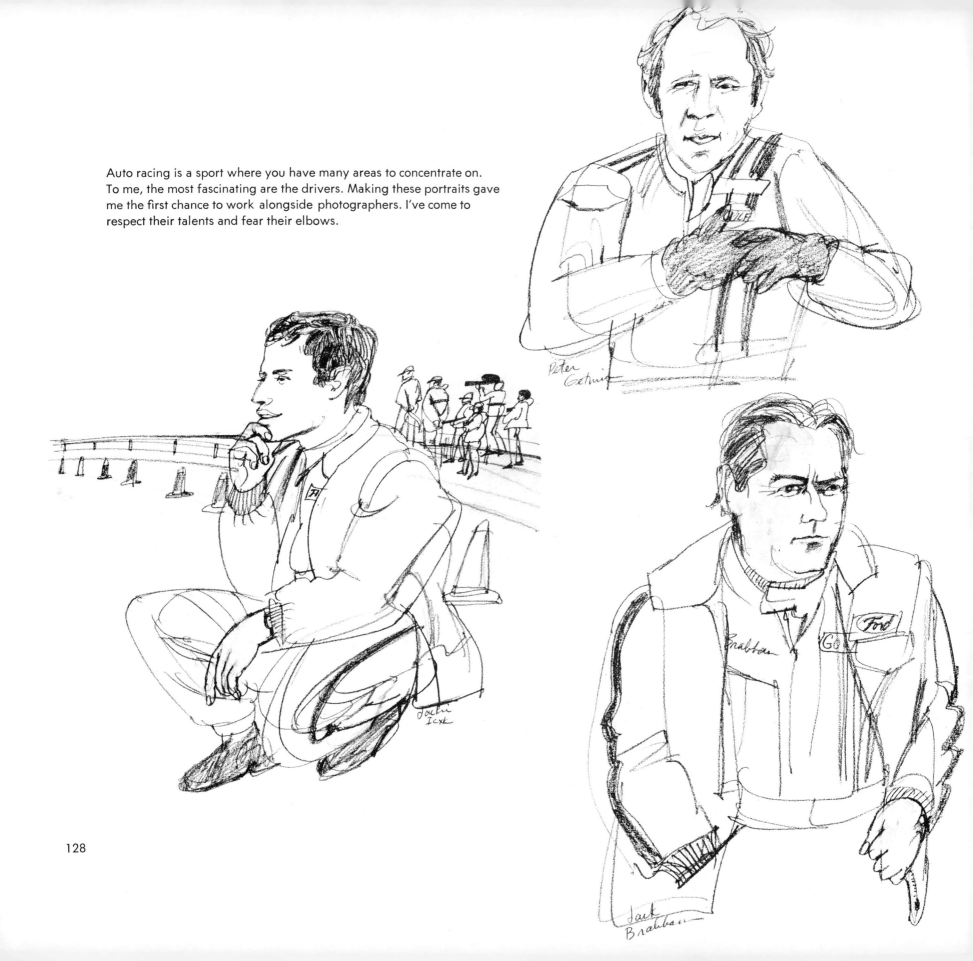

Auto racing is a sport where you have many areas to concentrate on. To me, the most fascinating are the drivers. Making these portraits gave me the first chance to work alongside photographers. I've come to respect their talents and fear their elbows.

128

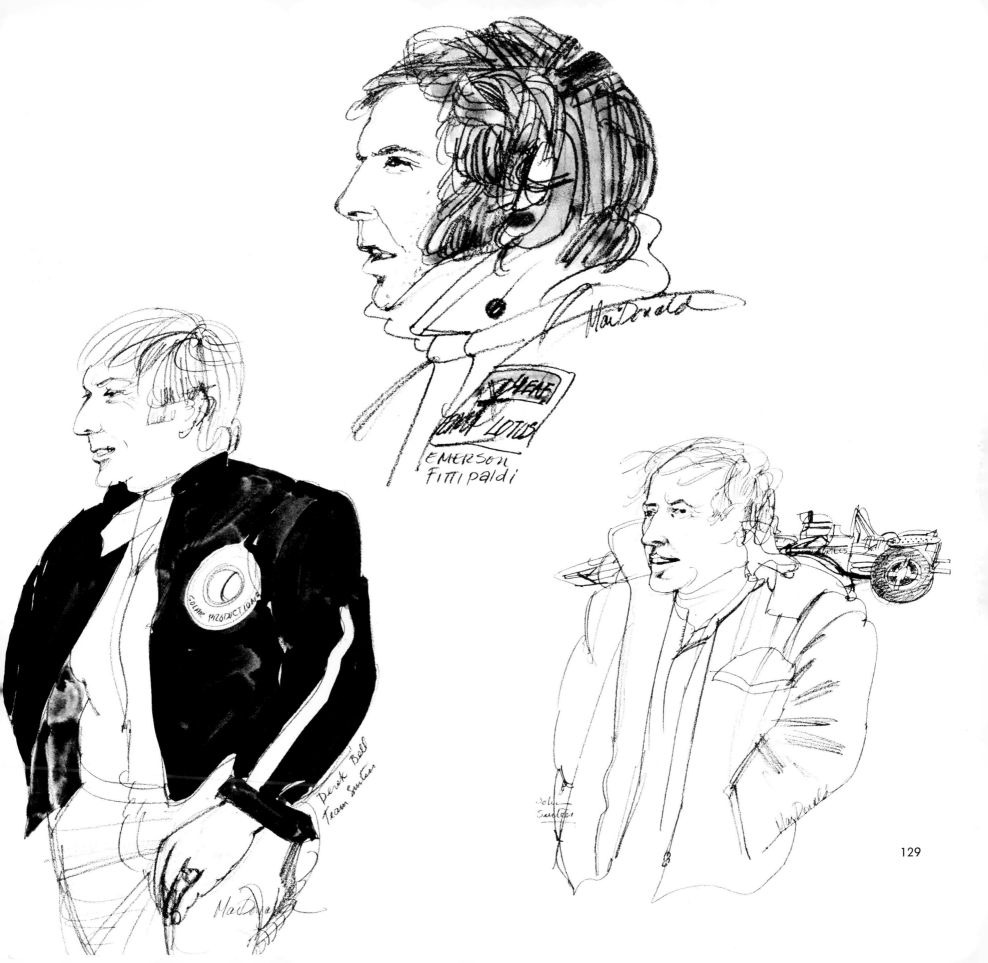

MacDonald

EMERSON
Fittipaldi

Derek Bell
Team Surtees

MacDonald

Solar
Surtees

MacDonald

129

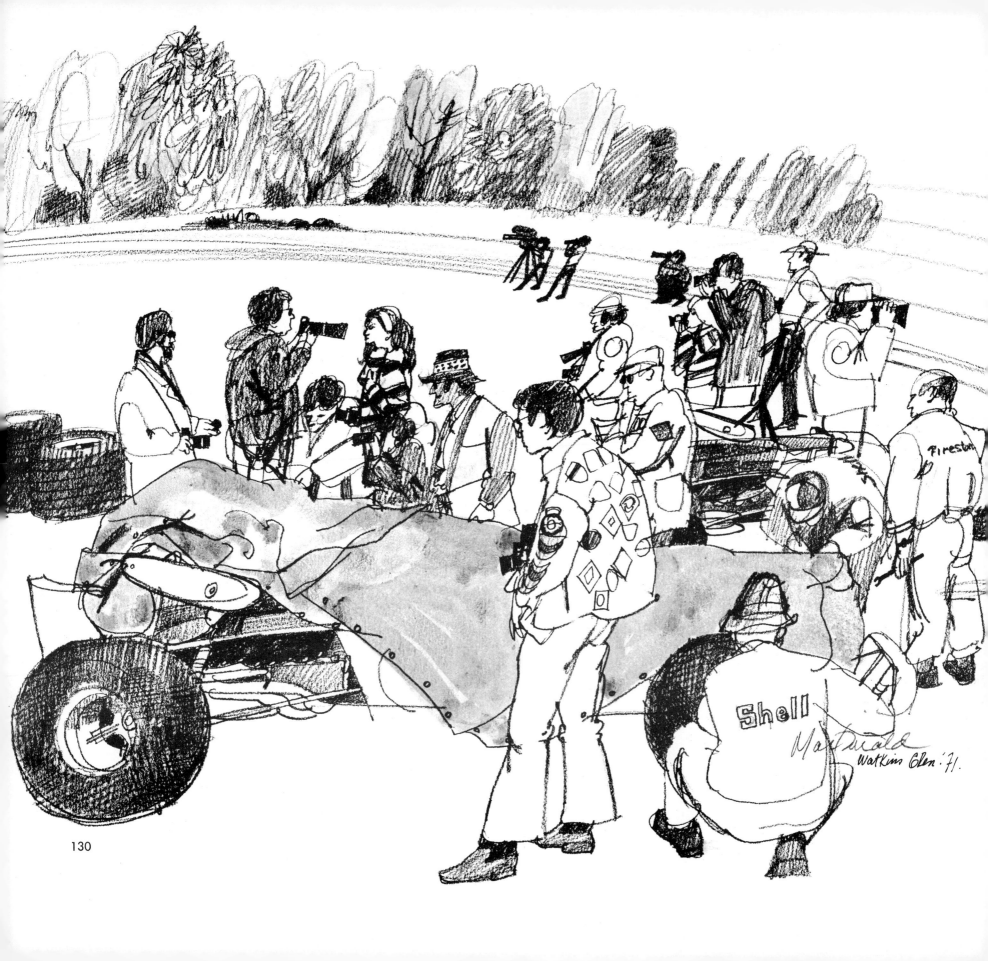

130

Although they both have sports in common, these two drawings are totally different. The pit drawing to the left stresses the literal gear and the total atmosphere of the location.

The mechanical hockey goalie is a different matter. It's an invention. Here, I picked a subject and **transformed** it to make a point for a study on artificial transplants.

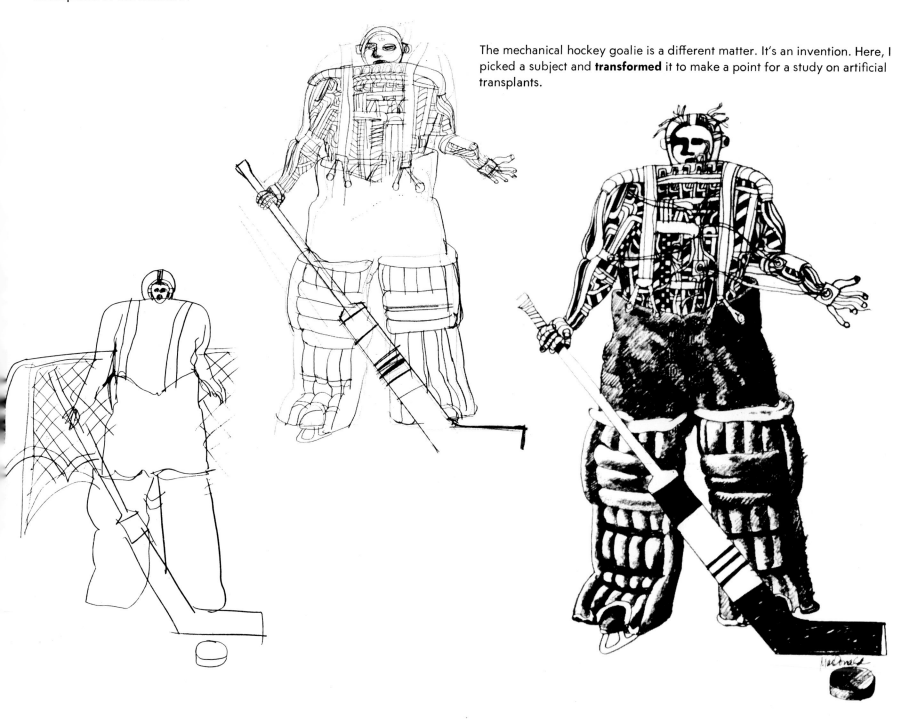

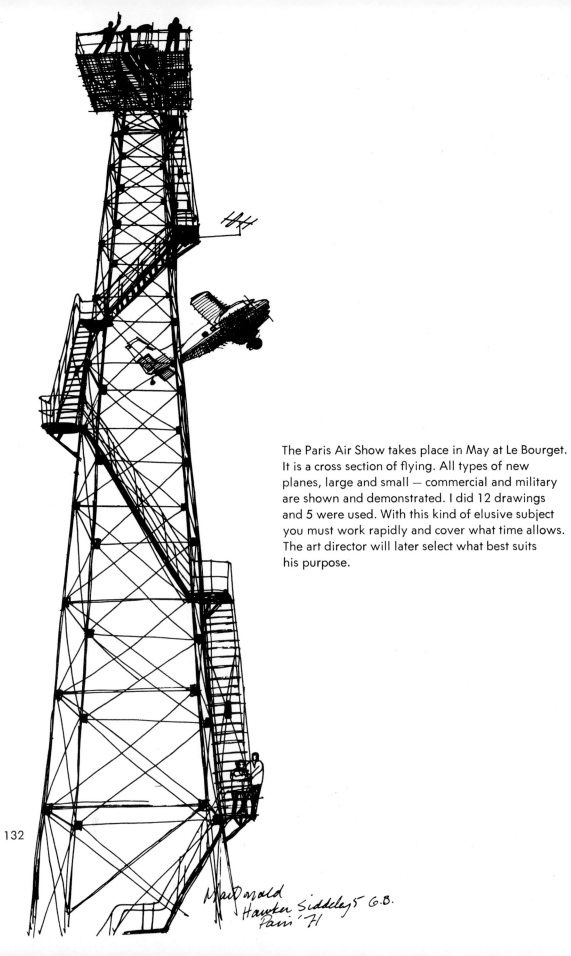

The Paris Air Show takes place in May at Le Bourget. It is a cross section of flying. All types of new planes, large and small — commercial and military are shown and demonstrated. I did 12 drawings and 5 were used. With this kind of elusive subject you must work rapidly and cover what time allows. The art director will later select what best suits his purpose.

MacDonald
Hawker Siddeley5 G.B.
Paris '71

132

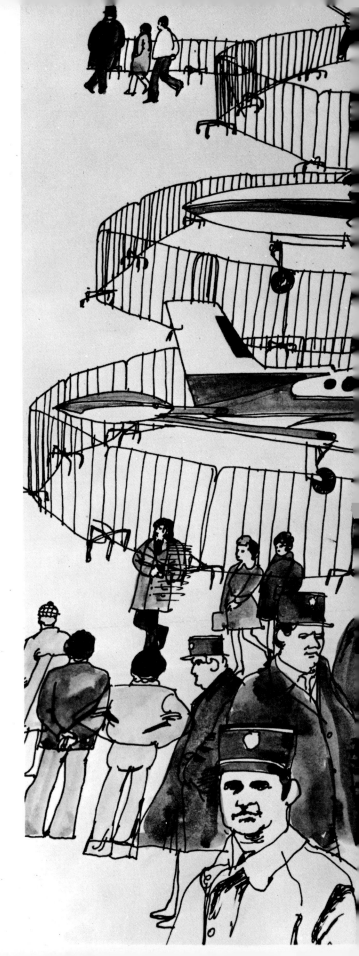

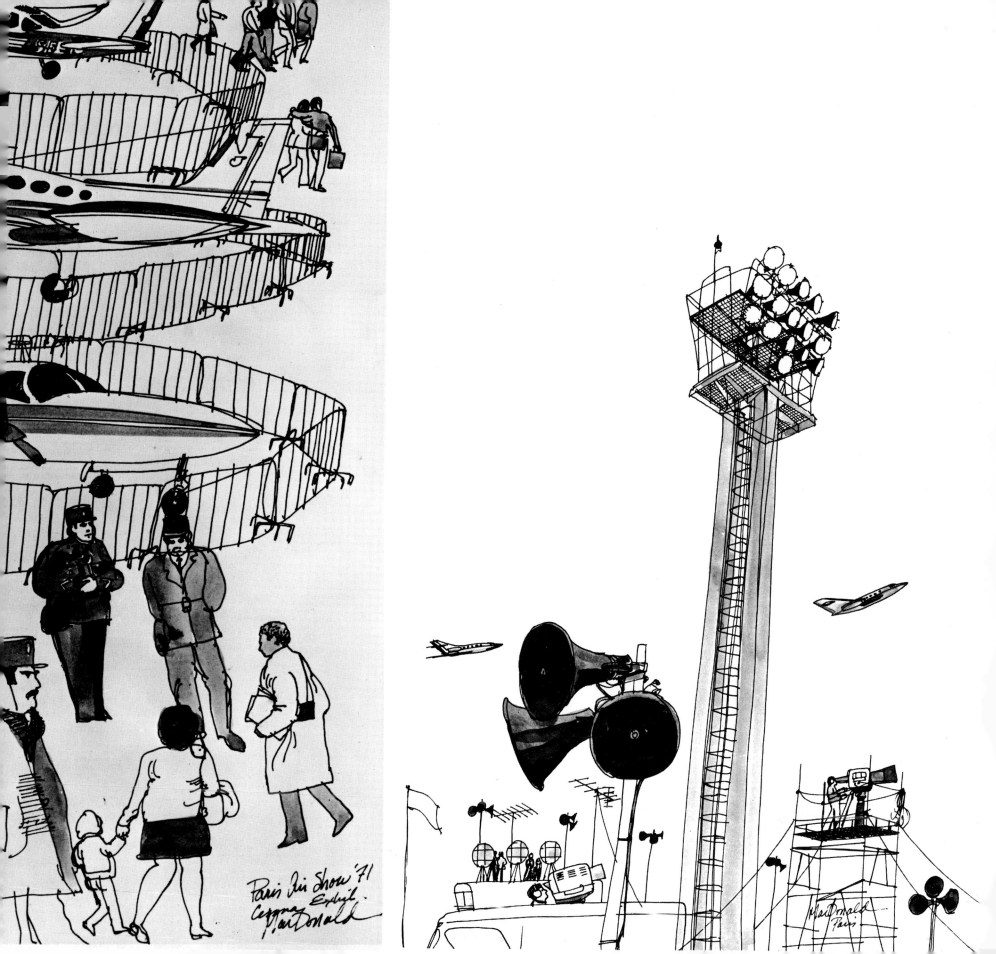

Paris Air Show '71
Cessna Exhibit
MacDonald

MacDonald
Paris

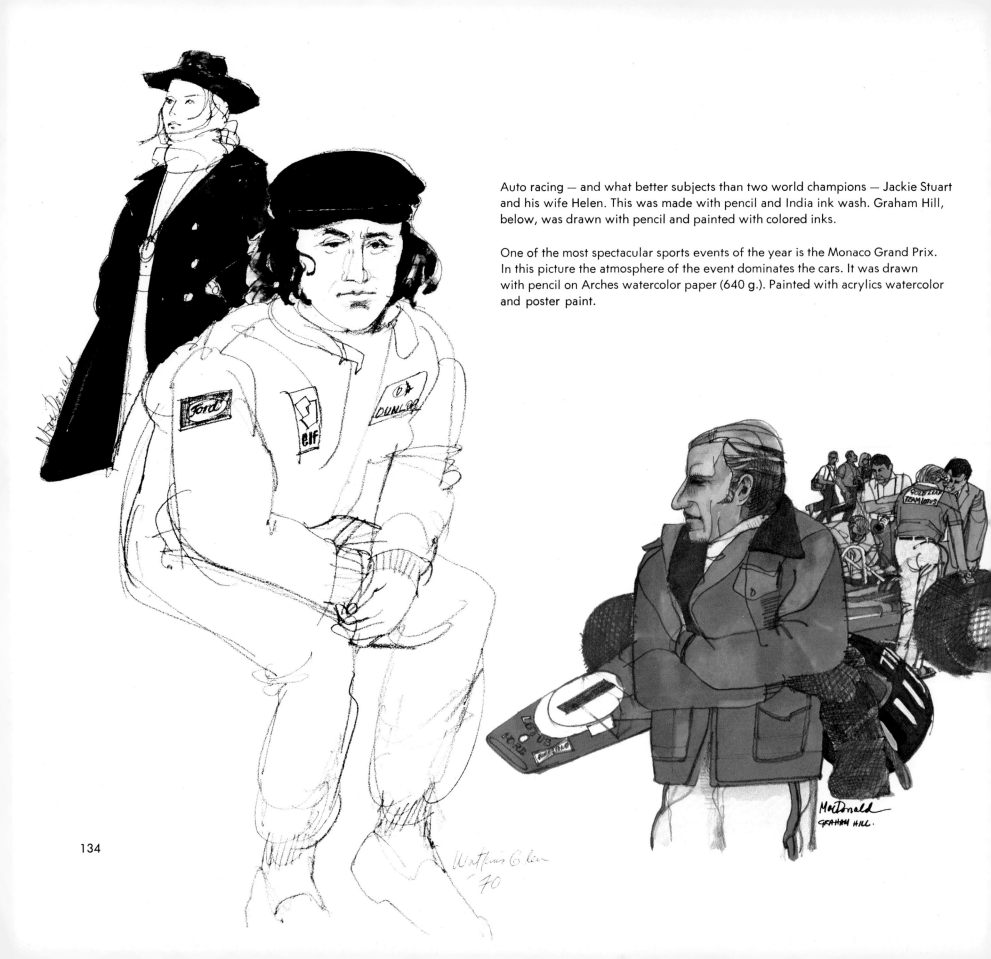

Auto racing — and what better subjects than two world champions — Jackie Stuart and his wife Helen. This was made with pencil and India ink wash. Graham Hill, below, was drawn with pencil and painted with colored inks.

One of the most spectacular sports events of the year is the Monaco Grand Prix. In this picture the atmosphere of the event dominates the cars. It was drawn with pencil on Arches watercolor paper (640 g.). Painted with acrylics watercolor and poster paint.

134

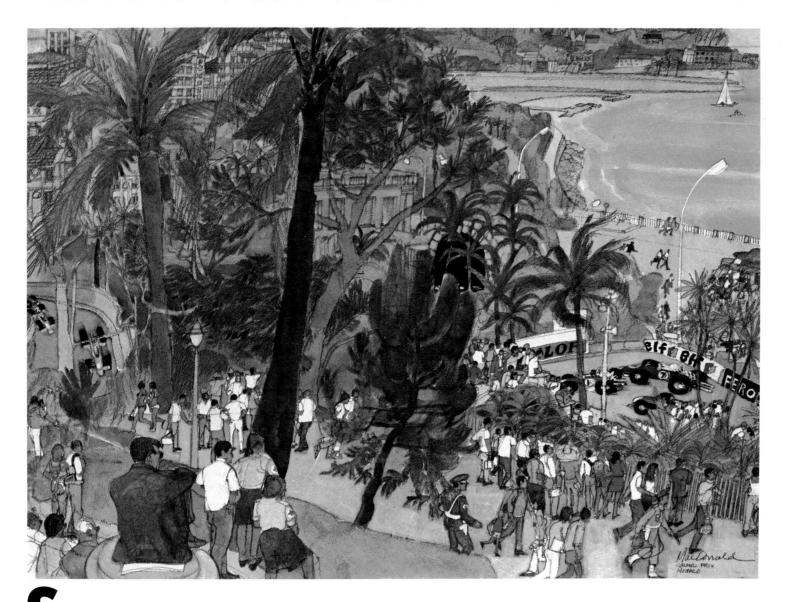

Story telling in art is as old as art itself. The cave man scratched and colored tales on stone walls to help him in future hunts.

Through the ages, other artists have recorded the world as they have seen and experienced it. Some put it down as literally as possible — others tell their story with imaginative interpretations. You are one kind of artist or the other.

Story-telling is as natural to the artist as to the writer. He can be subtle or blunt. He can show beauty or brutality. He can assume any tone of voice and any posture.

You'll find sketching is a good story-telling medium because it's spontaneous. It makes you work with emotion because there is little time to calculate as you can in the studio. It's happening — right now before you! I'm a great believer in first impressions. A great amount of my work is brought forth on this concept. If you've never worked this way, I urge you to try. Find a thing, a place, a situation, an occurrence and sit down and record it. Make a planned picture of it as you go. Rearrange, compose, push around, change — make it behave your way. Don't worry about mistakes. Don't worry about neatness or slickness or style. Don't worry about anything but the flow of things from your eye to your arm!

After you've become accustomed to this uninhibited manner of working you can begin to prepare yourself

135

The medium here is a combination of watercolor, acrylics and poster paint over a pencil drawing on Arches watercolor paper (640 g). The water was the most difficult area. Before I had the right value I had squeezed out three tubes of cobalt blue.

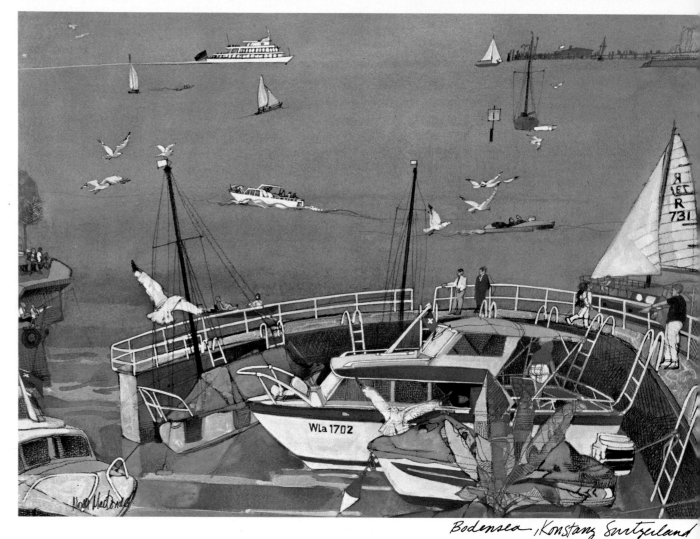

Bodensea, Konstanz Switzerland

a bit more with preplanned knowledge and information.

There are times when you should first research your subject so you will have a surety to add to your gut impression.

Everyone goes about storing "research" in different ways. Some artists keep extensive picture files. Others depend on their public library. Many rely on Polaroid or more extensive photo coverage. Some make great use of the Sears' catalog and encyclopedias. I have found the following method suits me best.

When necessary, I research as much as possible before beginning an assignment. This is usually done at the library or with encyclopedias. The majority of the drawing is done on the spot. I carry a small note pad to study the possibilities for sketches before actually beginning to draw. This is also to make sure I haven't forgotten any vital subject material and avoids wasteful drawing. While sketching, I am making notes to be used later in the studio, where I do most of the painting and refining.

When I went to art school, working with photo reference was seriously looked down upon.

I was told that by studying the construction of objects one could draw from any angle.

This alone can be limiting unless one is a superb draftsman. I do this when working from memory when I can't get a look at the real thing.

It is great fun to draw from memory, but I think one pays the price of tending to overstylize to get past the vague points.

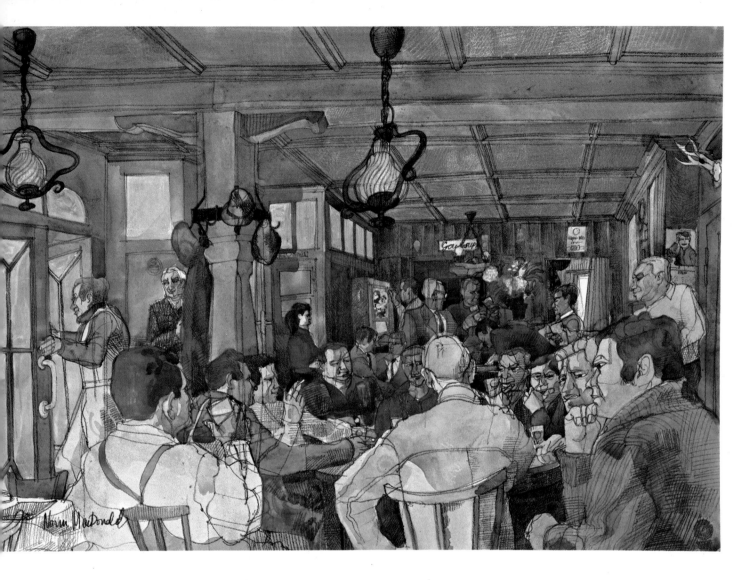

The techniques in this painting and the Trafalgar Square scene on P. 139 look superficially alike. This is watercolor, the other acrylic. I change around for the subtle difference in each — and to break routine.

All artists stylize or design to different degrees but it shouldn't be the only thing that sets one artist apart from another. It does let us see the difference between Robert Motherwell and Andrew Wyeth, but as far as drawing is concerned it means one is spending more time on generalization than on observation. Styling is part of every artist's identity but it's the emphasis on styling that is a bad habit.

This is a good time to advise you to save everything you do. I'll let you worry about space in your studio. Every artist I know suffers from the lack of it.

One reason to save your work is to compare it as time goes on. Your old stuff can be very sobering. It's great to see when you've improved — and vital to note when you have not. Apart from this, your old stuff can be a great source of research. I continually paw through old sketch books for notes and jottings I've made previously.

If I might need a group of trees or a couple of buildings as a background, I usually can locate such drawings in my box of sketches or in sketch pads. I like to observe birds, for instance, when sketching, but I draw them later from my studio window.

When people are very small in the picture and are meant to show action and life, I can draw them from memory if I choose. Things like movement and color I can recall from memory.

137

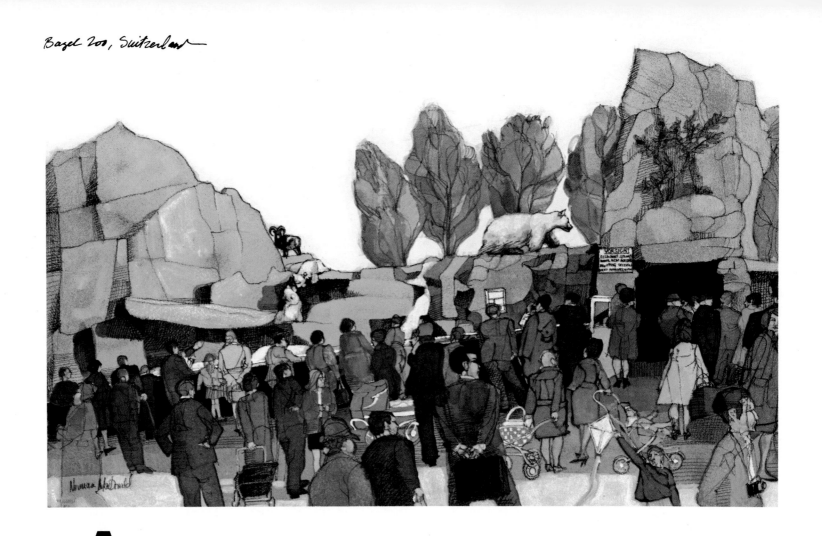

Bazel Zoo, Switzerland

As a basic need of man, drawing is regarded by some as a useless activity which serves no purpose. In varying degrees, others would add books, photography and the majority of television to this category. But consider the merits of drawing and painting. Almost every city has a museum of art and galleries. Art is the life work of numerous scholars and teachers. Drawings and sketches can make you laugh or wonder, as well as tell a story. Principles of design and color have long been used to attract buyers to Brand A rather than Brand X.

The desire to own drawings and paintings testifies to the influence of art in our society.

Drawing is a good medium to influence others. Just as a book needs a cover, the artist may need a message to push him on to greater things. Throughout history, drawing has been a strong form of demonstrating. Michaelangelo used his work to express his feelings, as have scores of artists since his time. The late Ben Shahn is a recent example.

We learn to draw by doing, and expressing our opinions is learned exactly the same way in a gradual process. Artists need to do a great deal of soul-searching and are often left with afterthoughts and doubts.

When illustrating "The Biological Timebomb," I sensed that biology would soon approach the point where man left off and something else would take its place, especially in the realm of reproduction and artificial transplants. Scientists foresee the time when the human brain alone could remain as a functioning human organ. At this point I drew the mechanical Goalie with a stylized face mask in front of the brain. This was

138

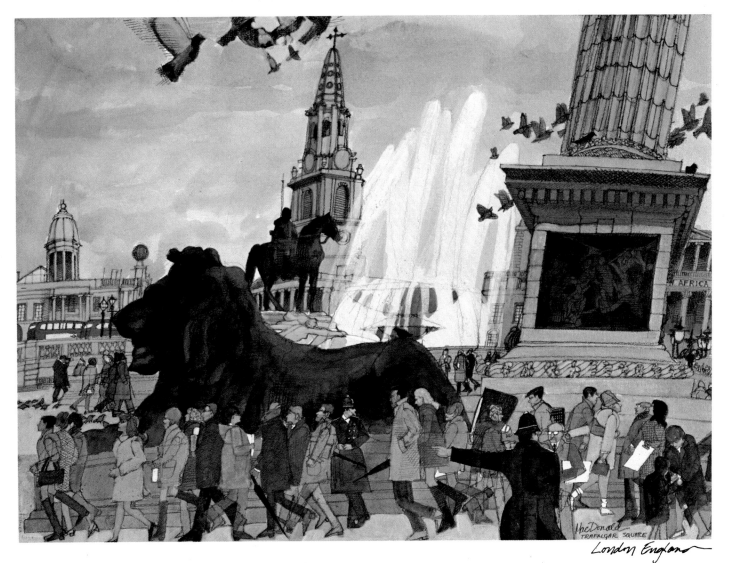

London England

When I work outdoors I make color notes and apply the paint later.

the symbol I wanted, one which bordered on science fiction.

In a computerized world I like to show an imaginary complexity rather than detailed reality. Actually, only a scientist knows the details — and, besides, I want to emphasize the statement rather than a specific problem.

During the Industrial Revolution, the individual became a part of the mass. Today the situation has changed little, but we are at least more sophisticated in our approach and reasoning. We rely on machines to do a job because we feel safer. The camera is only a machine. We know that the image it produces is a fair reproduction of what our eye sees. But the artist can interpret. He can intensify the sense of sight and mood of a subject.

Art is becoming a field of endeavor without boundaries, although the definition still exists. When an artist picks up pieces of glass from the street, puts them in a bag, dates it, and later when he has sufficient "material" dumps them in piles on a gallery floor, he substitutes his identity for a purpose. The message then becomes the art.

The artist could write dirty words on the walls of public toilets, but few would pat him on the back and say, "Great work, Baby."

continued/P. 142

No matter what technique you use, don't hesitate to experiment or draw from different vantage points if it's going to help to say what you want about any subject. It was drawn from three places along a road in the Black Forest. The painting was drawn from three places along a road in the Black Forest. The painting was painted in the studio over the actual drawing — from color notes.

The signpost for the castle was very interesting in itself so I made a separate drawing of it which I also painted in the studio.

140

Gasthaus, Black Forest, Germany

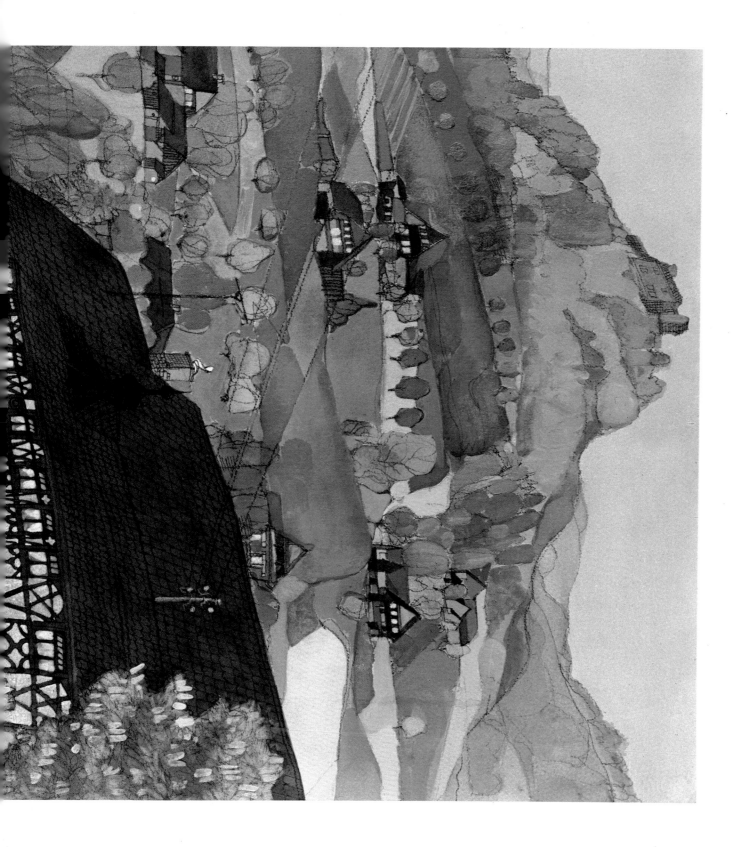

141

Here I've done what I pointed out Delacroix did — I made written field notes that I later translated in the studio. Today, when computers are common office equipment and people go to the moon, there is no improvement on this age old system.

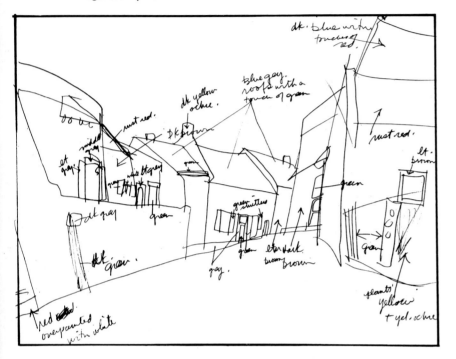

A color sketch based on field notes.

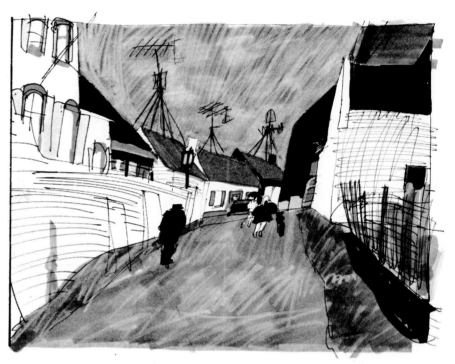

We have never been freer to experiment and express ourselves than today. The more we try to create an individual uniqueness, the more we find ourselves being confined. The person who draws and sketches shouldn't feel a need to be fitted into a category. His satisfaction should come when his Utopia is produced from inside his sketch pad.

Drawing is one of the few international languages. Movies are translated, books are translated, the dance takes on nationalistic characteristics but a drawing is understood virtually anywhere.

The art of drawing didn't spread like rock or the "mini" because it has always existed.

Art is actually an interpreter, yet more artists than writers are satisfied to stay in the seclusion of their studios to produce their works. This can be a definite disadvantage to the artist in the practical fields. Evidence of this is the extensive use of photographers today. Because he can't make a picture in the studio the art director has no other choice than to send a photographer on location.

I'm not criticizing photographers because this factor has no influence on the end result. But it shows how the artist, with his ability to work as he pleases, often chooses the privacy of the studio. If he makes it a habit he will find himself forever confined to the studio.

The artist must get out and show the art buyer the wonderful world of drawing on the spot. He has to overcome a form of discrimination produced only by himself.

142

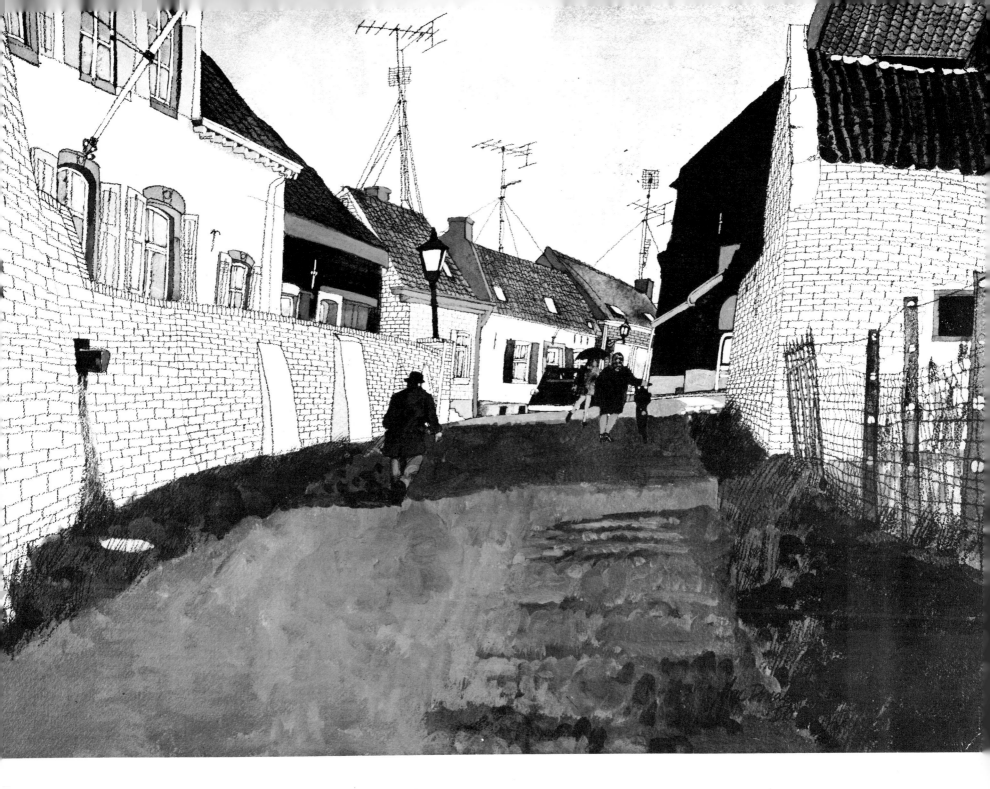

It's been said that the artist's real world is in his pictures. I often imagine myself wandering through my drawings. Here I'm the man in the trench coat trudging along, and as I go I realize that getting to be a better artist is a step by step process and not an overnight happening.